Bill Gibb

FASHION AND FANTASY

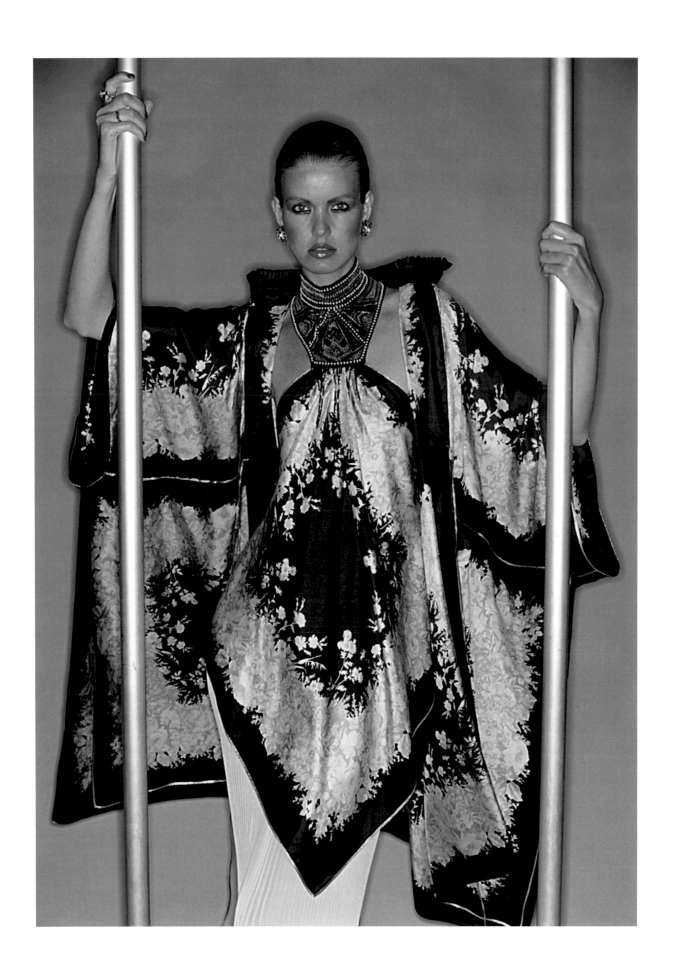

Bill Gibb

FASHION AND FANTASY

Iain R. Webb

V&A Publishing

First published by V&A Publishing, 2008
V&A Publishing
Victoria and Albert Museum
South Kensington
London SW7 2RL

Distributed in North America by Harry N. Abrams, Inc., New York

ISBN 978 1 85177 548 4
Library of Congress Control Number 2008924014
10 9 8 7 6 5 4 3 2 1
2012 2011 2010 2009 2008

Art Direction: Barney Wan
Design Layouts: Rob Skipper
Copy-editor: Denny Hemming
Indexer: Vicki Robinson

Additional photography by Richard Davis, V&A Photographic Studio

Front jacket illustration: Printed leather and sequin outfit by Bill Gibb, Autumn/Winter
collection, 1972 British *Vogue*, 15 September 1972 / **Clive Arrowsmith**

Back jacket/cover illustration: Woodland-inspired printed dress by Bill Gibb, Autumn/Winter
collection, 1972 *Brides*, September 1972 / **Snowdon**

Frontispiece: Printed silk-scarf kimono and beaded dress by Bill Gibb, Autumn/Winter
collection, 1976 British *Vogue*, August 1976 / **David Bailey**

Endpapers (front): China-blue jersey dress with bumblebee buttons by Bill Gibb,
Autumn/Winter collection (detail), 1972

Endpapers (back): 'Lovat', a design based on the work of Claud Lovat Fraser by Susan Collier
for Liberty, 1973. Gibb used this print in his Spring/Summer collection, 1974

Printed in Hong Kong by Printing Express

V&A Publishing
Victoria and Albert Museum
South Kensington
London SW7 2RL
www.vam.ac.uk

Contents

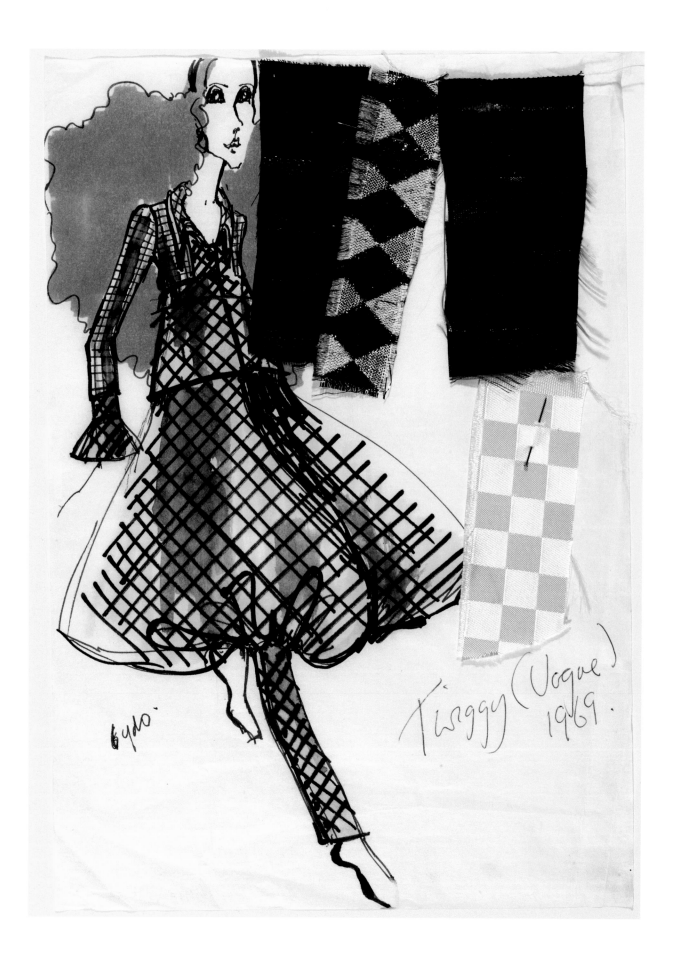

6 yd⁰.

Twiggy (Vogue)
1969.

Foreword

Bill was my knight in shining armour. We first met in 1967, on a snowy London day, when my car – a little purple Mini – got stuck in a snowdrift. As I was struggling to get it unstuck this young man, with his soft Scottish burr and big beard, came to offer help. Car rescued, he invited me to tea. It turned out we were neighbours, and thus began a lifelong friendship.

Bill was not only an incredible talent but also one of the sweetest, most modest people I have ever known. I have wonderful memories of going to Scotland with him to visit his family on the farm where he grew up, of my mad Afghan hound chasing his grandad's chickens and sitting, laughing, with the family that were so proud of their boy.

And so they should have been – Bill's talent was enormous. In the age of the miniskirt, Bill gave us new romantic, renaissance-inspired dresses, long and swirly – pure fantasy clothes in extraordinary fabrics. Bill made me the most beautiful outfits, which always made me feel like a princess and which I still treasure. He was unique and ahead of his time, the forerunner of some of our great designers today.

So yes, Bill is up there as one of the greats, but more than anything, for me, he was a loving friend who made me laugh. I miss him.

Twiggy Lawson – London 2008

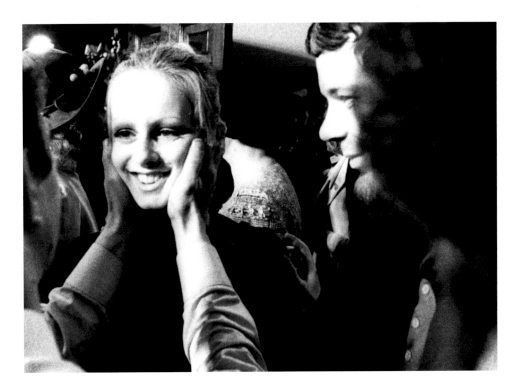

Backstage at Gibb's debut show at the Oriental Club, London, 1972 Twiggy (left) with Bill Gibb (right) / **Richard Imrie**

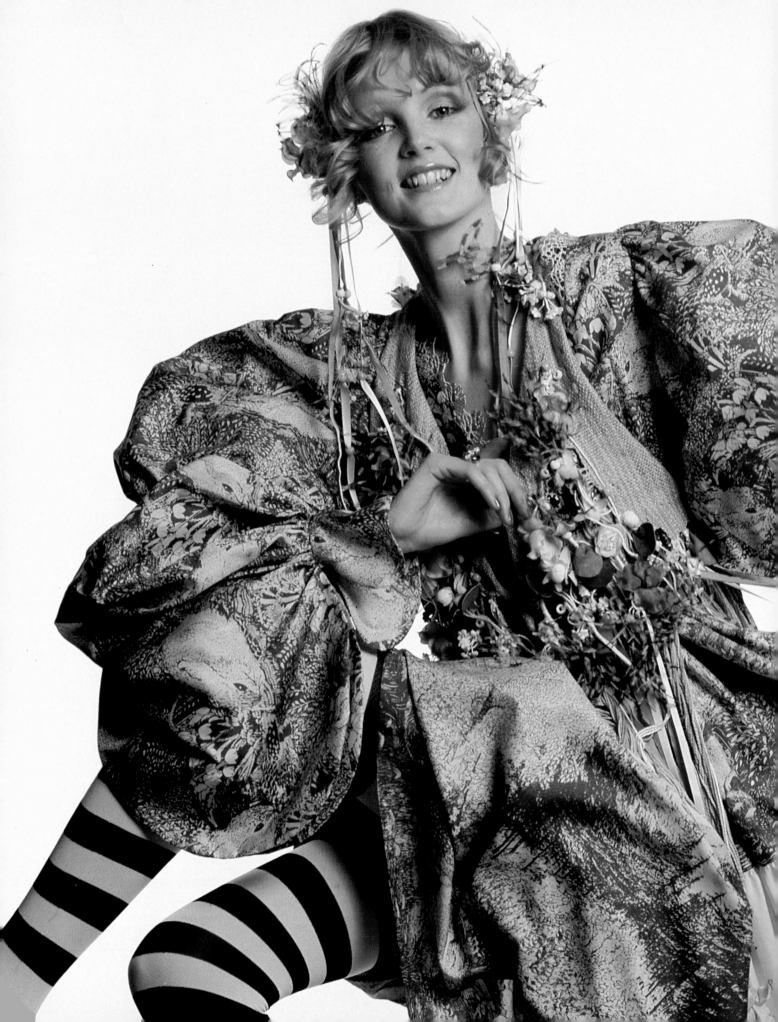

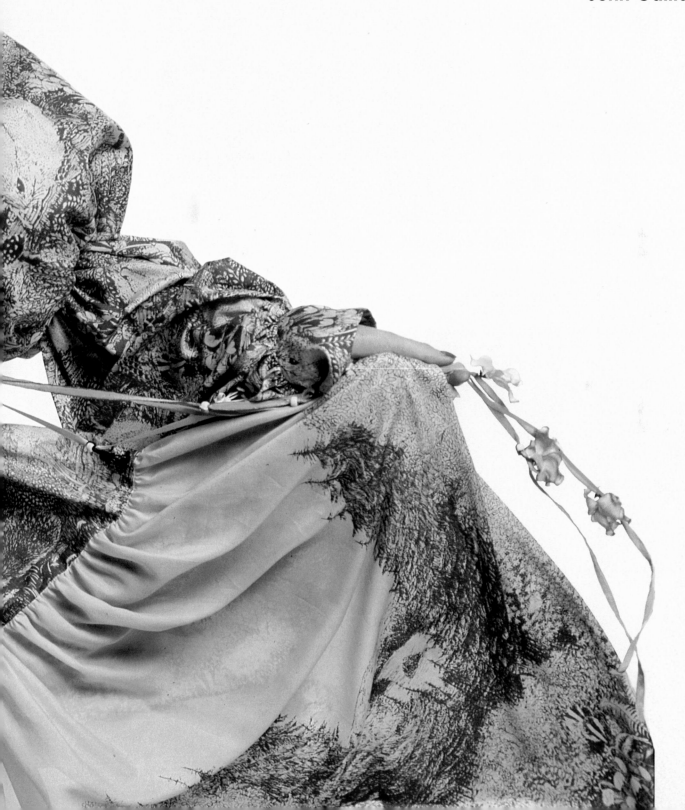

'British designers are story tellers, fairytale tellers, dreamers and I think this was really the essence of the romance behind Bill Gibb.'

John Galliano

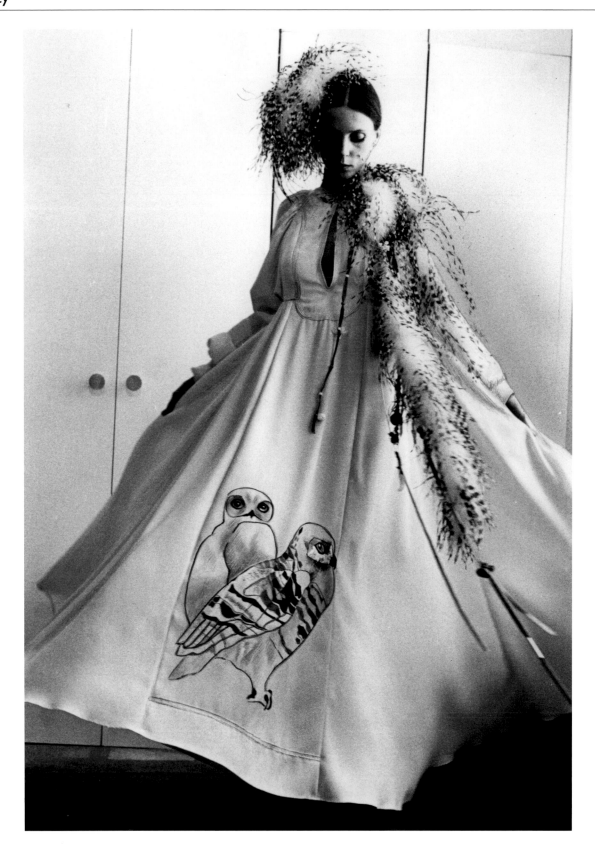

Cream silk dress by Bill Gibb, Autumn/Winter collection, 1972
The handpainted and embroidered 'Snow Owl' design is by Valerie Yorston / **Julian Allason**

The legacy

'I love anything with that kind of drama, anything that is sculptural and structured. And all his pieces are beautifully done. I love the execution of them, be it the handpainting, the patchworked fabrics, the tapestry knits, the little quilted butterflies and shells, the embroidered bees, the gold bee buttons.' In his studio in east London British fashion designer Giles Deacon, Designer of the Year 2007, is talking fervently about one of his biggest style heroes, the late Bill Gibb. 'He obviously had a love of organized chaos', Deacon continues, 'getting all these quite random things from here, from there – a bit medieval, a bit of nature, something ethnic. He turned it all around and there it goes, down the catwalk. These are very artful clothes.'

In 1970 British *Vogue* crowned Bill Gibb with the same Designer of the Year title, even though the fledgling fashion designer had been out of college for barely two years and was yet to launch his own eponymous line (he was, at the time, working under contract with the now defunct Baccarat label, owned by Monty and Clare Black). His impact, with just a handful of designs, was so astonishing, his ideas so revolutionary, so unique, that his legacy can still be detected in the work of the boldest stars of contemporary fashion design such as Deacon and, indeed, the much-lauded iconoclast John Galliano. Both designers are indebted to Gibb as Galliano readily admits. 'I have been inspired by his collections, his colours, as much as by his journey and his own story', he says with a customary flourish, 'as we both use chiffons, laces, frivolity and the exotic to create beauty and seduction for our generation's butterflies.'

Exploring the design archive of Bill Gibb, respectfully curated at the Aberdeen Art Gallery in his native Scotland and lovingly cherished by those who were personally acquainted with the designer, it is not difficult to identify the very same aesthetic DNA that is inherent in the best of a long line of British fashion talent: the love of romance, the soaring flights of fantasy, at times a seemingly unfathomable eclectic approach and a defiantly devil-may-care dynamic. Gibb's fashion career was sadly short-lived. Although he was prolific and, at his best, truly visionary, his finest work spanned little more than 10 years. None the less he was the embodiment of the quintessential British fashion designer. His love of story telling – no doubt cultivated in Gibb as a boy in the Highlands – and a flamboyant flair for decoration and dramatic effect illustrate clearly recognizable parallels with home-grown style icons that reach from Cecil Beaton (a front row guest at Gibb's first fashion show) to Vivienne Westwood and beyond. 'British designers are story tellers, fairy tale tellers, dreamers. And I think this was really the essence of the romance behind Bill Gibb', affirms Galliano. Assuming the role of narrator as if to emphasize the point he is making, he

Preceeding pages: Hedgerow print and embroidered dress by Bill Gibb, Autumn/Winter collection 1972 'Miles of untouched forest', British *Vogue*, 1 October 1972
Penati

Over the years Gibb's designs have inspired new generations, as seen in the work of both John Galliano and Giles Deacon

Dress by John Galliano, Autumn/Winter collection, 1985
Chris Moore

Dress by Giles Deacon, Spring/Summer collection, 2005
Chris Moore

continues: 'Once upon a time he started at St Martin's [School of Art] and went on to mix romantic with ethnic, colour with prints, in some really exciting collections. His damsels were beautiful, nostalgic yet street savvy – chic.'

While Gibb may not be a familiar name outside the fashion industry, he has continued to be held in high esteem by its insiders – young and old alike. Those who knew and worked alongside the designer become genuinely misty-eyed as they reflect on his passion, on the unstoppable, unrelenting creative driving force that propelled him forever forward despite one business misfortune after another (an experience that has been all too familiar for many British designers, most notably

Galliano) and the personal warmth, wit and generosity of the man himself. Most remarkable is that a myriad variations of his groundbreaking designs can still be found in high-street stores throughout the United Kingdom while many of today's top-ranked fashion designers continue to find inspiration in his back catalogue of work.

Christopher Bailey, creative director with the fashion house Burberry, is one example among many but perhaps more closely linked with Gibb than most, having received a special scholarship set up by Gibb's parents to pay for tuition fees at the Royal College of Art in London – another of Gibb's alma matres. 'I'm a huge fan. He was somebody who understood all the components of real fashion design – drape, fabric, texture, cut, knitwear and even branding with that little bee', says Bailey, referring to the emblematic bumblebee motif that became Gibb's trademark. Bailey is effusive: 'He was a strong, all-round designer with a very personal point of view that was identifiable immediately. The way he put the different prints, colours and textures together to make a design sing – that's not easy. I think he had a really modern approach and totally captured the mood of the moment.'

A proud Yorkshireman by birth, Bailey also recognizes that Gibb's momentous journey, from the furthest north-eastern reaches of Scotland to the epicentre of the fashion scene in London and on to international acclaim, was not purely coincidental. 'I think it was crucial that he wasn't from London originally', he explains. 'That's quite important because he came to the fashion business without any preconceptions. He had no restrictions, no real parameters. He was all about exploring and finding himself through his work.'

Gibb's travels certainly took him far beyond mere geography and at the sunset of the 1960s he began to enter previously uncharted fashion territory. In part seduced by the freedom and unfettered imagination, not forgetting the colourful dressing-up box appearance, of the emerging hippie generation and inspired by the encouragement of American artist Kaffe Fassett, who was to become his life-long friend and collaborator, Gibb began to break away from the fashion pack and make his own unique mark.

Fassett had taken up knitting following a visit to a Scottish wool mill with Gibb. 'Kaffe and I became great friends', says Judy Brittain, then editor at *Vogue Knitting* magazine. 'He told me he lived with someone who was a dress designer, so I said, "Why don't you get together?" as knitting by itself was not such an easy thing to sell.' Brittain remembers how Gibb eventually came into her office with a clutch of drawings, all with bits of knit swatches attached. 'They were absolutely brilliant. I ran up to the fashion room with a bundle of them and there was almost a fight', she says. 'We got them made up by Baccarat and even stitched some ourselves. They were astoundingly new, a completely new trend. And this was his first collection.' The designs were featured in British *Vogue*, American *Vogue* and *The Sunday Times* – simultaneously. Brittain recalls the prevailing fashion:

Bill Gibb, 1969 / **Stanley Devon**

'Try to imagine the look at that moment – plain A-line dresses, double-faced jersey with channel seaming, Mondrian blocks of colour. This was utterly different', she says. 'It changed everything.'

It is perhaps difficult to imagine quite how shockingly new Gibb's designs appeared in 1969. The wildly eccentric combinations that he patchworked so boldly together – checks, tartans, stripes, spots, spriggy Liberty floral prints and Fair Isle knits – may not seem quite so unexpected now because there have been endless reworkings on the theme from designers and high street alike. It is a look that has been embroidered upon, literally at times, over and over again down the decades. Marit Allen was working as a fashion editor at British *Vogue* when she first experienced the Gibb magic. 'It worked very well with the idea of love and peace and revolution. Those political aims and that way of life were so much a part of the whole fabric of everything at the time', she explained. 'And Bill just had that talent for knitting it all together. I'd never seen anything like it before – tartan and flower fabric and knit, all muddled up and looking gorgeous', Allen reflected. 'I remember being thrilled almost to the point of feeling ill. It was so

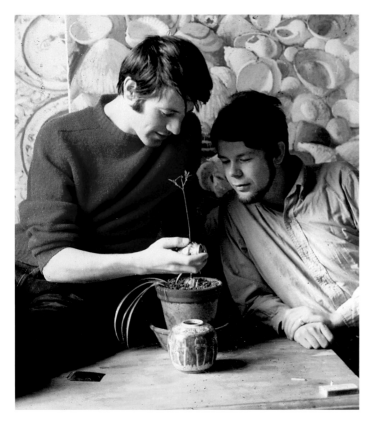

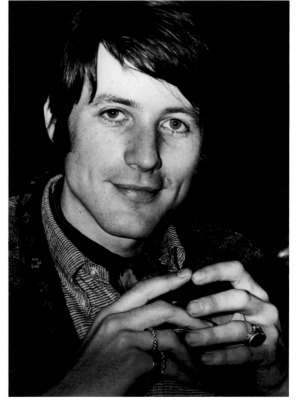

Kaffe Fassett (left) and Bill Gibb (right) c.1967 / **Steve Lovi**

Kaffe Fassett, c. 1969 / **Stanley Devon**

exciting to be able to take the designs in to Beatrix Miller [then editor of British *Vogue*] and say "This has to be a story."'

At first Miller was equally startled by what she was being shown and her immediate reaction was to enquire if there was anything else that they could feature in the magazine instead. Allen persisted, insisted, as only passionate fashion fans who believe categorically that they have discovered the Next Big Thing can, that *Vogue* had to do a story about Gibb because he *was* the news. 'Where is he sold?' asked Miller. 'Well, at the moment, nowhere but let's fix that', replied Allen – and thanks to *Vogue*, they did.

Fassett remembers that Monty Black, the man behind the Baccarat label, hadn't been at all enthusiastic when the pair first suggested producing these outlandish-looking designs. 'Often a dress would have several different patterns, then it would have embroidery and then it would have ribbons. Gibb was building up a patina', explains Fassett. In the late 1960s, however, reproducing variants of designs shown by the Paris fashion houses, or whatever outfit the stylish Jackie Kennedy happened to be seen wearing, was the bread-and-butter of the industry.

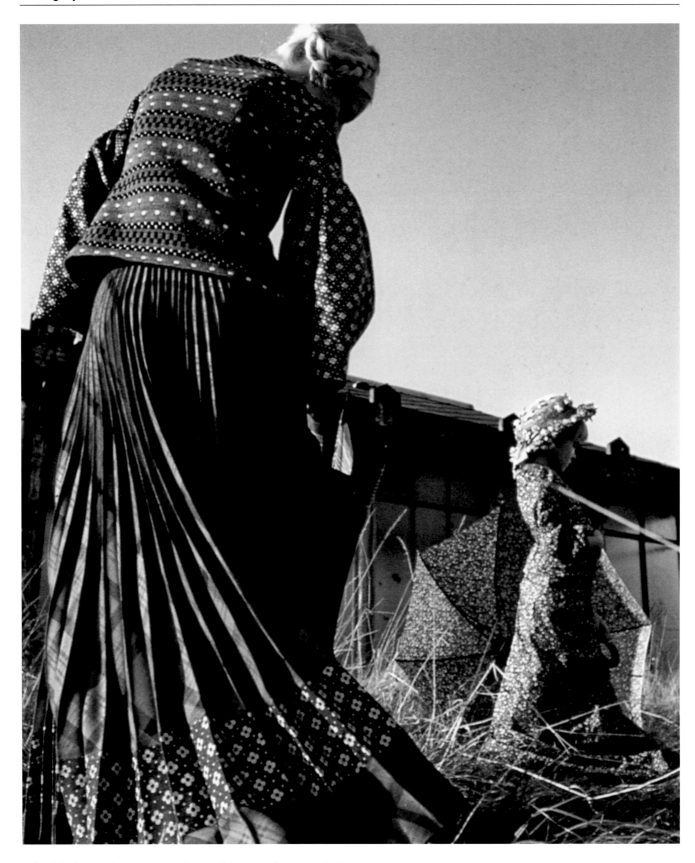

Bill Gibb designs for Baccarat, Autumn/Winter collection, 1969
'Glorious confusion', British *Vogue*, January 1970 / **Sarah Moon**

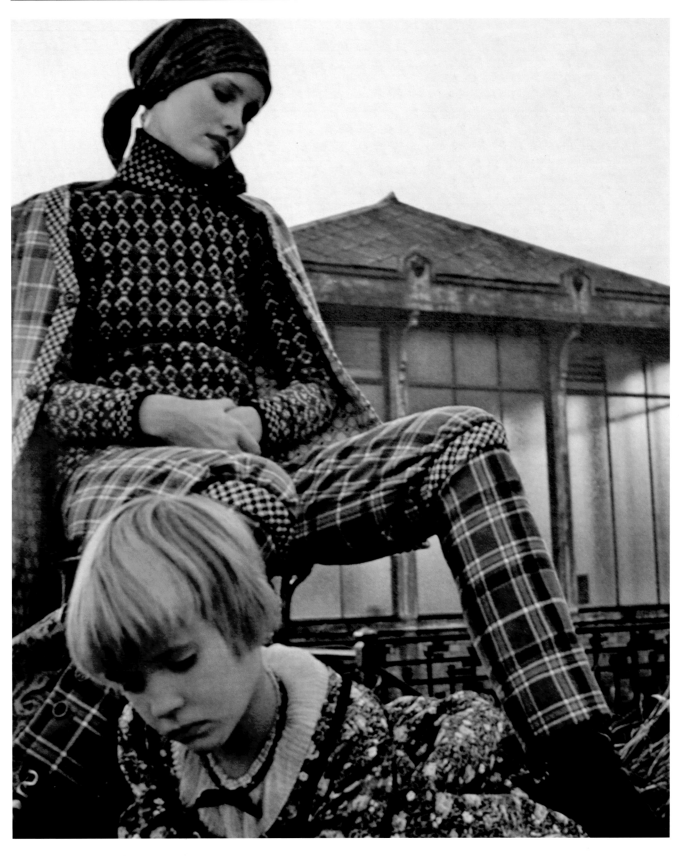

Bill Gibb designs for Baccarat, Autumn/Winter collection, 1969
'Glorious confusion', British *Vogue*, January 1970 / **Sarah Moon**

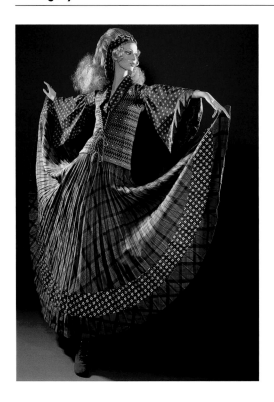

Bill Gibb's hippie-inspired outfit for the Baccarat label was proclaimed Dress of the Year in 1970

'That's what he was excited about', continues Fassett. 'But we said, "No, no, no! We want this very romantic look."' The positive reaction at British *Vogue*, along with the promise of a four-page feature, soon changed Black's mind. 'He said, "That's worth £10,000 per page. You're on. I'll make the clothes." But he still maintained that he would only make one of each because only crazy kooks at *Vogue* would buy the stuff', says Fassett.

The resulting fashion story, atmospherically photographed by Sarah Moon (a rising star in her own medium), was devoted in its entirety to Gibb's designs and appeared in the January 1970 issue. It was befittingly titled 'Glorious Confusion'. 'For me that signified the birth of the Seventies', said Allen. 'It was that moment when you realized that something groundbreaking was happening.' Each page featured a different look. The first picture showed a model wearing wide tartan trousers and a swing coat, lined with flowers and edged with a band of black-and-white checkerboard fabric, underneath which was a skinny Fair Isle sweater. On the page opposite was a bell-sleeved flower-print blouse and knitted waistcoat, teamed with a floor-sweeping sunray pleated tartan skirt. With a wide stripe of contrasting floral-printed denim inserted a few inches above the hem, the skirt was a miraculous technical feat in itself. Miller consequently nominated this outfit for the prestigious Dress of the Year Award at the Museum of Costume in Bath. 'The Dress of the Year scheme had only just begun [it had started in 1963] when the legendary editor of *Vogue*, Mrs Miller, chose the work of fledgling designer Bill Gibb as the selection for 1970', says Rosemary Harden, curator at the now renamed Fashion Museum in Bath. 'This outfit has become one of the most iconic, most often referred to and most loved selections of the subsequent 40 years and more of this Hall of Fame award', she continues. 'What gives Gibb's ensemble a particular edge is that all the practical elements that went into making it "bold", "new" and "original" have continued to have a resonance with fashion designers and makers up to the present day.' On the following double-page spread were two more interpretations of a trouser suit that brought together ever more unlikely fabric combinations. 'Forget rules, you make them, you break them', *Vogue* proclaimed, welcoming a new decade, a new beginning.[1]

One of Gibb's 'gypsy' dresses for Baccarat (detail), *c.*1970
Mike Davidson

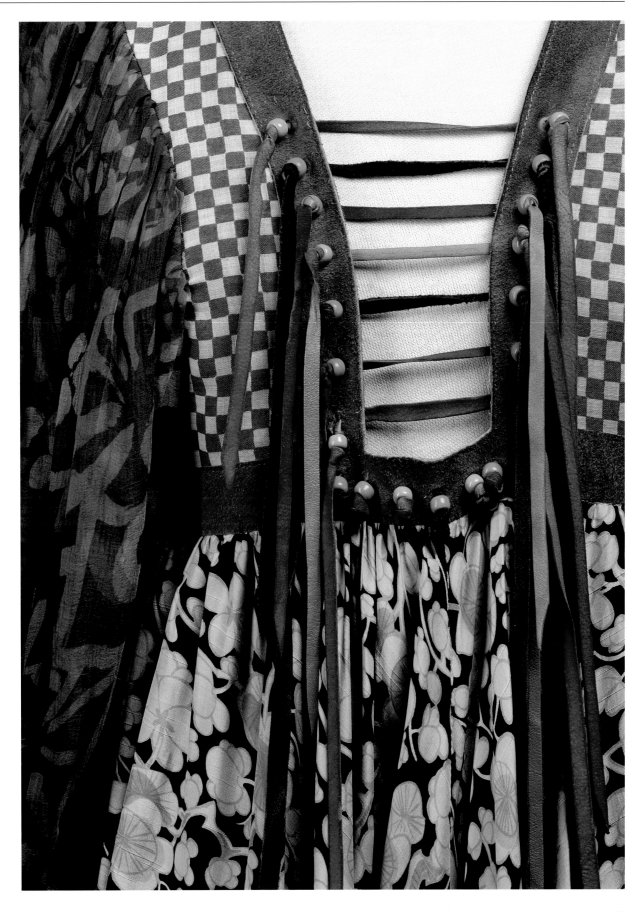

Album cover for the musical *Hair*, *c*.1968. Sleeve design by Paragon Publicity

It is perhaps revealing to note that a few pages further on, the magazine showed an outfit by the young Yves Saint Laurent, the French fashion designer who was later to be fêted as the inventor of the modern-day wardrobe and hailed as one of the most important designers of the twentieth century – if not the most important. Saint Laurent's design was a two-piece that also featured a long skirt, which chimed with the new mood of the times. The young Parisian designer, however, could not quite shake off his bourgeoisie roots and teamed his hippie skirt with a matching blouse.

Gibb and Fassett were fixed on following their feeling for a magpie-like eclecticism. They were excited by the exoticism of Indian saris, embroidery, sequins, jewels and textures. Embellishment and rich colour were their raison d'être. 'Of course it was the hippie time', says Fassett, 'so all the kids were going down to the market, taking an old bedspread, a piece of embroidery from the 1920s and something else from something else and sticking it all together. We were delighted by that; we were doing the same thing ourselves. You'd even buy a dress and turn it into a shirt. It was very free and expressive.' Gibb himself said: 'I love the look of the kids in the markets around London. Just seeing them makes me feel good. My things are more sophisticated versions of the costume look the young British wear.'[2]

This new sense of unbridled liberty and rebellion against the orthodox had its roots in the final years of the 1960s. It was noted and, more important, welcomed by the First Ladies of the fashion press: the ones whose job it was to tune in to the zeitgeist. Two events gave them food for thought. For three days in August 1969 the Woodstock Music and Art Fair in upstate New York was the place to be. A rock festival like none other, an estimated 500,000 young people let their hair down (and there was a lot of it) to musicians such as Janis Joplin, Jimi Hendrix, Jefferson Airplane and Joan Baez. Woodstock became a symbol for the emerging counterculture, embracing the utopian philosophies of peace and free love. The event was listed by *Rolling Stone* as one of its '50 Moments that Changed the History of Rock'n'Roll'.[3] Just a year earlier the musical *Hair* had opened in London, the day after censorship of the theatre was abolished in the United Kingdom. Billed as 'The American Tribal Love-Rock Musical', *Hair* was described as a 'happening', and the freaky costumes of the cast, when not naked, were making fashion pulses race.

Bill Gibb's striped and floral dresses for Baccarat, 1970
British *Vogue*, July 1970 / fashion illustration by **Antonio**

Opposite: Peach and green
tartan tweed,
all set about and frilled
with cotton lace tie dyed
in the same summer pastels.
A long and willowy suit
with a long and willowy
knife-pleated skirt.
This page: Long peach and golden
tie dyed smock of lace,
one beautiful big butterfly
handpainted on the yoke.
And a dress of natural linen
billowing yard upon yard,
threads drawn out by hand,
panels of lace sewn in.
All by Bill Gibb at Baccarat
£89, £69, £90
at Fifth Avenue, Regent St,
King's Rd. Cotton lace
tied and dyed by Valerie Irving.
Apron and cap crocheted
in string by Kaffe Fassett.

ANTONIO

Ernestine Carter, c.1969

There can be little dispute that at the end of the 1960s Ernestine Carter was the absolute doyenne of fashion journalism and with her lacquered helmet of hair and chic suits she appeared the epitome of respectability. 'She was fabulous', says Fassett, 'but I thought, "Oh, she's so old she won't understand what's going on." Yet what I loved about her was that she looked at our work, she came to the fashion show and she said, "This is the first time in years that I've seen work that has a handwriting." She just got it, she absolutely got it. And then she wrote the most brilliant article. That was very, very exciting.' Carter's article, titled 'The Mixture As Never Before', appeared in *The Sunday Times* on 21 December 1969. It couldn't have been a better Christmas present for both Gibb and Fassett. The story was full of praise for the young designers, for Black and Baccarat ('an unusual venture as modern in its outlook as its décor') and even for the hippies who had inspired the look: 'Reflecting this mood is the new collection designed by Bill Gibb and Kaffe Fassett. What gives it its special distinction is the delicate but firm control with which they express the new freedom … disciplining their combinations of pattern and texture into an almost classic order, and adding a new dimension to knitwear.…'

Both Carter and the copywriters at British *Vogue* referred to a new and exciting kind of 'fashion anarchy', and it wasn't long before others picked up on this momentous prevailing change and were providing their own commentary, invariably using Gibb's designs to illustrate their point. In May 1970 Prudence Glynn, who was to become one of the designer's most voracious champions, described the spirit of the day in *The Times* as 'Peaceful Co-Existence'.[4] Below a photograph of one of Gibb's dresses, 'made from four quite different fabrics', she wrote: 'Nothing illustrates better the breakdown of accepted fashion rules … What a release from the tyranny of what went with what in colour, texture and fabric design.' Praising the designer's subtle hand and disciplined eye, she went on to explain that, 'Harmonious discord is one of the hardest techniques for a designer to handle.' Glynn ended her story with a warning to her readers: 'Just before you start exalting your new found fashion freedom and putting on your spots with your stripes with your snake print and your geometrics, do get your eye in by looking at successful examples of the anything-goes-together look … We are not all as talented as Bill Gibb – unfortunately.'

Appliquéd smock and knickerbockers by Bill Gibb for Baccarat, Spring/Summer collection, 1971
'Wear print on print … wear a peasant smock', British *Vogue*, February 1971 / **Clive Arrowsmith**

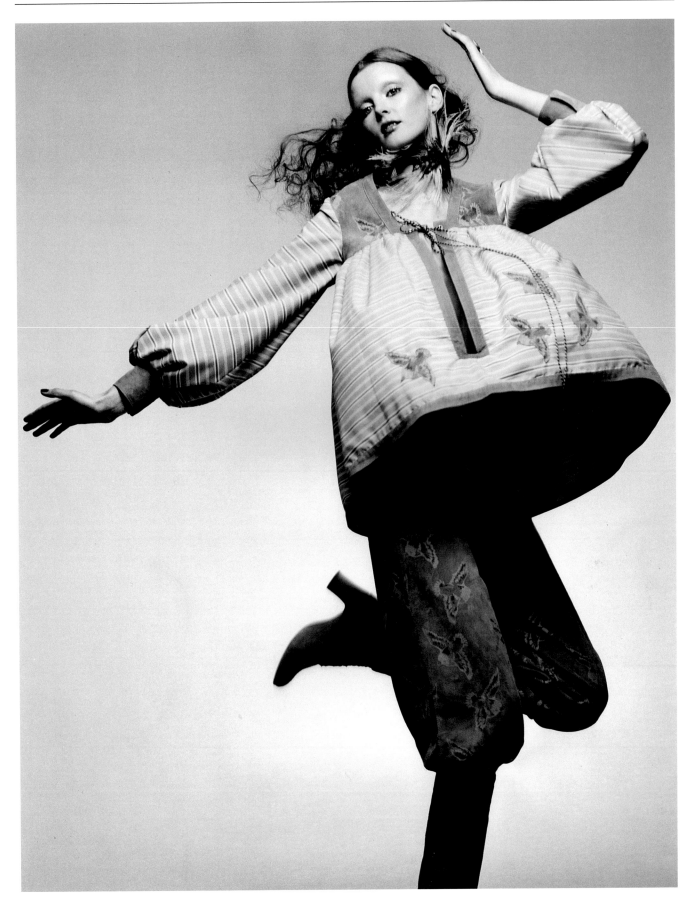

Zandra Rhodes, c.1969

Less than a month later more pictures of Gibb's modern take on patchworking appeared in the June issue of *Queen*, but this time accompanied by a somewhat more challenging article headlined, 'The Politics of Sex and Fashion' by Gloria Steinem, the *New York* magazine columnist and respected political pundit. The enlisting of such an intellectual heavyweight writer to expound on a subject like fashion perfectly illustrates the genuinely disconcerting sense of flux being experienced within society. The juxtaposition of words and pictures was, however, somewhat incongruous. 'Romantic maxis like these continue to be a controversial subject in fashion circles. While the debate rages, the clothes themselves look lovelier than ever', read the caption. While Steinem railed against the longer hemlines as being 'fascist-inspired', the photograph showed two models draped dreamily on a rock and wearing long silk jersey dresses and chiffon coats coloured lemon, pale green and mauve, patterned with flowers and checks. Both were by Gibb for Baccarat, to order from Fortnum & Mason, the upmarket department store in London's Piccadilly.

Fortnum & Mason, once a halcyon haven for ladies-who-lunched, was promoting selected young fashion designers in its Odyssey Room. 'Bill was the other designer with me and Jean Muir', says fashion designer Zandra Rhodes, who had also been a student at the RCA and was busy making her own mark – usually vividly coloured and equally experimental. 'It was definitely a time of discovery', she remembers fondly. 'Everything was caught up in a whirlwind of press. Everyone was going forward and everything was new.' And Gibb was unquestionably ahead of the pack, capturing the very essence of this remarkable period of revolution with utter conviction. Gibb's designs not only welcomed a new era, they also provided a template for the distant future that would continue to resonate for decades to come. It was a complex package made from numerous pattern-pieces and fabrics and as many disparate concepts and imagery, all sewn neatly together into the seams. Or, as Fassett puts it: 'It was like a little theatrical event, all in one dress. He would just be a smash hit now!'

Fortnum & Mason advertisement, 1970
British *Vogue*, December 1970
Gibb was one of three designers showcased in the Odyssey Room at London's Fortnum & Mason store

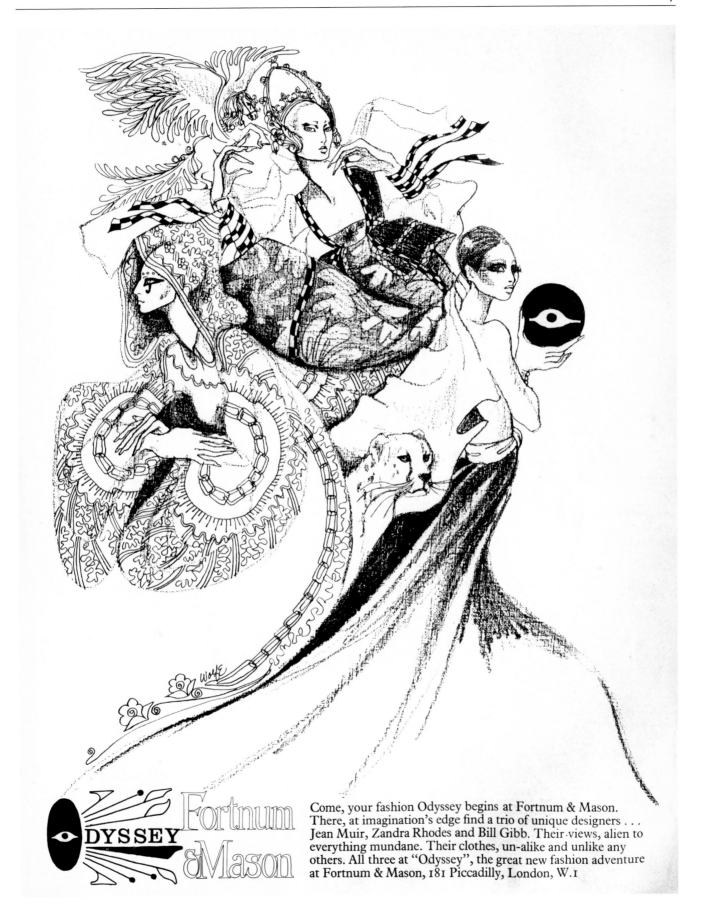

ODYSSEY Fortnum &Mason

Come, your fashion Odyssey begins at Fortnum & Mason. There, at imagination's edge find a trio of unique designers . . . Jean Muir, Zandra Rhodes and Bill Gibb. Their·views, alien to everything mundane. Their clothes, un-alike and unlike any others. All three at "Odyssey", the great new fashion adventure at Fortnum & Mason, 181 Piccadilly, London, W.1

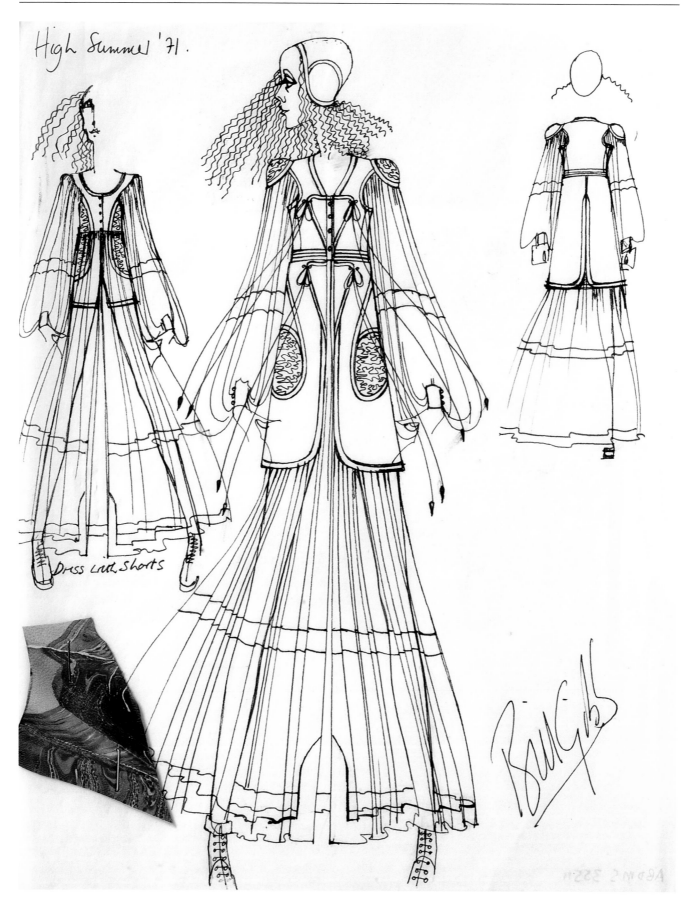

High Summer '71.

Dress with Shorts

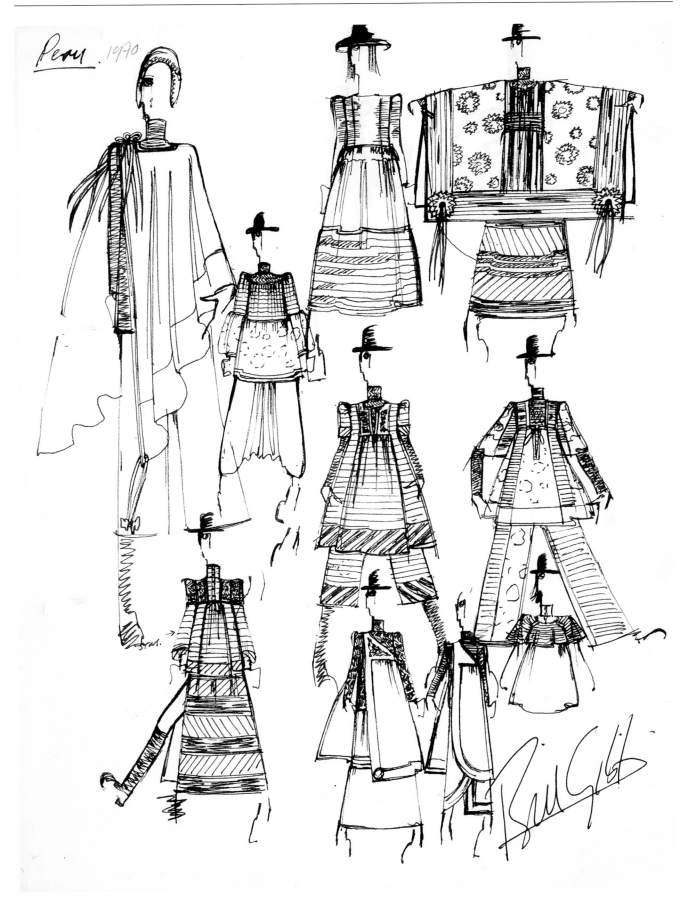

Peru 1970

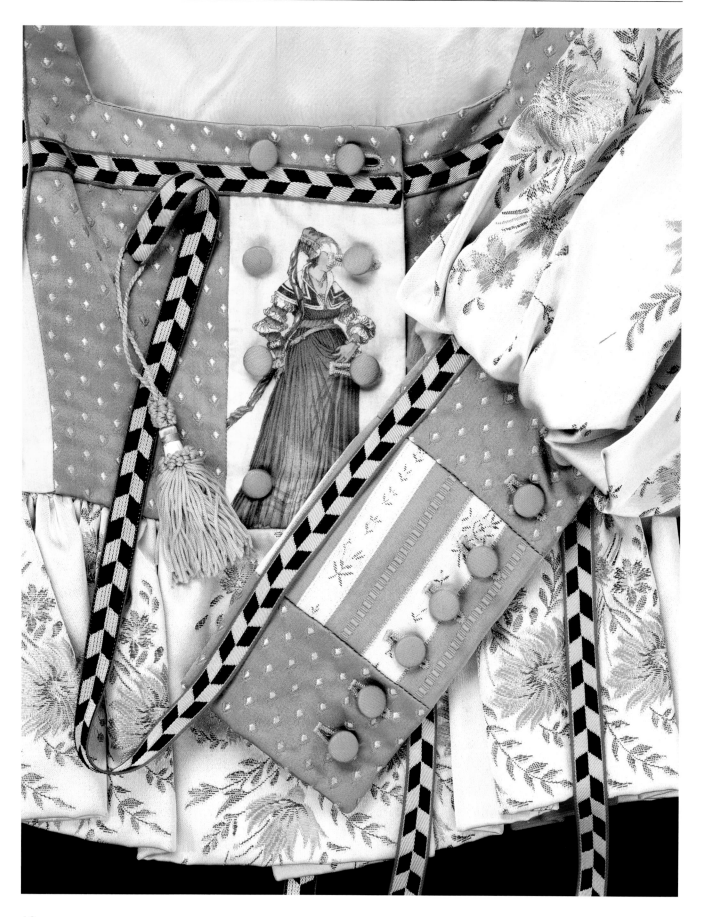

The history boy

'History fascinated me', Gibb once said.[1] 'When I was a boy, I wanted to be a history professor, an archaeologist, or a designer, so it is marvellous to … do work like this combining all my interests.'[2] As a child Gibb had invented for himself a world of imagined riches and luxury, of Renaissance nobility and medieval courtiers. Teenage sketchbooks reveal paintings of women in high-waisted gowns edged in gold with billowing sleeves – almost a template for what were to become his fashion designs.

William Elphinstone Gibb was born near New Pitsligo, a farming village in Aberdeenshire on 23 January 1943. The oldest of seven children – 'Billy, George, Patsy, Alan, Janet, Marlyn and Robert', says his mother Jessie proudly – his beginnings were far from the bright lights of London where he would eventually find fame. His father George worked the family dairy farm at Netherton and the expected route for the young Gibb, growing up in the midst of this rather austere rural community, surrounded by fields, would have been to follow in the family footsteps, but even at an early age those close to him recognized that this was not to be his destiny.

His father remembers him as, 'an ordinary boy and quite an extraordinary boy'.[3] 'He would do odd jobs like feeding the poultry', says his mother, 'but he wasn't really interested. He always preferred drawing.' As Gibb later explained

The Gibb family, early 1960s
Standing (left to right): Janet, Alan, Robert, Patsy, George, Marlyn;
seated (left to right): George Gibb, Jessie Gibb, Bill

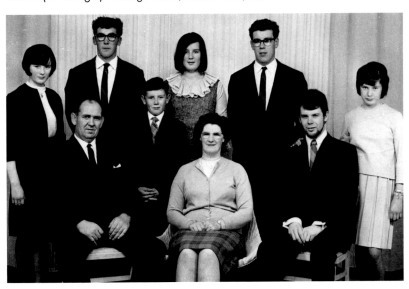

Bill Gibb dress for Baccarat (detail), c.1970
Gibb's designs for Baccarat often included historical imagery

Gibb with his grandmother and Judy Brittain on a trip home to Scotland, c.1970

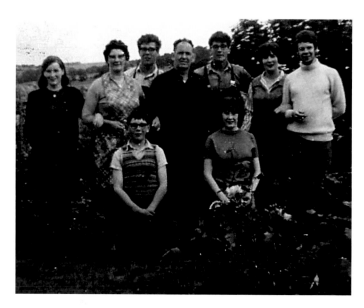

The Gibb clan, c.1968. Back row (left to right): Janet, Jessie Gibb, George, George Gibb, Alan, Patsy, Bill; front row (kneeling, left to right): Robert, Marlyn

in an interview with *Ritz* magazine: 'I was brought up by my grandparents', in particular his maternal grandmother Evelyn, who lived nearby at Lochpots Farm with husband William Reid (Gibb was named after both his grandparents, Elphinstone being Evelyn's maiden name). There is a tradition in the north-east of Scotland, according to Christine Rew, Art Gallery and Museum Manager at the Aberdeen Art Gallery and herself something of an expert on Gibb, that in large families some of the children are brought up by their grandparents. 'And there is that intermingling in farming communities, where they are in and out of each other's houses.' As Gibb said later in the same interview, 'My grandmother encouraged me, which was nice. You know, there was never any question at all as to what I was going to be.'[4]

This was a background that Gibb shared with another international fashion star, Jean Paul Gaultier. The Parisian designer readily acknowledges how he has always been drawn to powerful women – be they Joan of Arc or Madonna – because of this same pivotal influence. 'I have been educated by women', he says. 'At school, of course, and by my grandmother, who was a very strong character, so all the gratitude I have I give back to them. They were strong women, maybe even stronger than men.'

This quixotic vision of the female sex no doubt proved a principal source of inspiration for both designers. Gibb's recollections of his own grandmother were equally idealized. 'My grandmother was a landscape painter. Being the

product of a Victorian society [that] didn't believe in young ladies going to earn their living as teachers, which she probably would have been – an art teacher … she married my grandfather, who was this marvellous First World War veteran kind of character, [and] settled down to become a farmer's wife.'[5]

Kaffe Fassett confirms that the pair shared a uniquely devoted relationship: 'He adored his grandmother. She was definitely magical. That was part of the reason why he was so magical. He would dress her up in fantastic outfits and she would just sit back like a big lioness and let him. I think that had a lot to do with his development.' He adds, 'I always thought his grandmother looked rather like Colette. In her quiet Scottish way she had a definite twinkle.'

Another influential female character in Gibb's early life was his aunt Evie, his mother's sister, who also lived at Lochpots Farm. 'They were more like brother and sister', says his mother Jessie. Some years later it was Evie who would take Gibb on his first trip to London. 'It was a very close family', says fashion consultant Brian Godbold, a great friend of the designer. 'Not just his brothers and sisters but his cousins and aunts, too. He was very close to all of them and even when he was in London they were still a very important part of his life.'

While the Gibb clan may have lived in separate locations scattered across the Buchan district, the siblings continued to play together. In an article in *Woman* magazine, headlined, 'We Couldn't Have Wished For A Better Son', the writer noted that, 'While other boys climbed trees Bill Gibb's favourite game was dressing

One of Gibb's early Hollywood-inspired fashion drawings, c.1958

A page from one of Gibb's schoolbooks, which reveals his fascination for medieval history

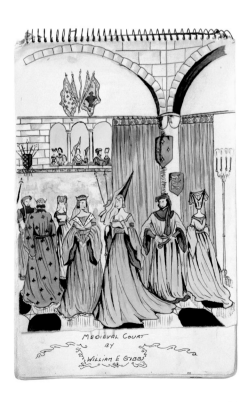

Hollywood Knits, c.1987
Gibb collaborated with John
Kobal to produce this
publication

up the other kids in the family and posing them in tableaux.'[6] His sister Janet remembers these antics fondly; how Gibb would take bedspreads and curtains from the house so as to dress his sisters as noble looking damsels and would then get them to pose for photographs at a nearby castle ruin. 'For us it was a bit of a joke but he was very serious', she recalls. 'One of us would be leaning out of the window, like a scene from *Romeo and Juliet,* and he'd be like, "Stop flapping. Be serious." The drawback was that he really wanted real actors.'

These theatrical diversions were perhaps the first hint of a fashion designer in-the-making and belied his real passions. Even though these interests were not perhaps the norm for a boy from Buchan, his mother encouraged him in his pursuits. As a member of the local Women's Rural Institute she saw a chance for her son to shine when a competition to design a collection of dresses presented itself. 'I says to Billy, "Why don't you have a go at that?" and he says, "Well, I'm not in the Rural Institute", and I says, "But it's open to everybody."' Aged just 15 he won first prize and received £25.00.

Gibb's designs were undeniably nostalgic for the glamour of Hollywood's heyday: ruched hourglass silhouettes, fishtail hems and ruffles. His fascination with yesteryear movie stars would reappear towards the end of his career when he created a knitting book called *Hollywood Knits*, inspired by photographs of silver-screen sirens including Joan Crawford, Greta Garbo and Lana Turner that were part of the archive of friend and one-time 'landlord', John Kobal. 'Janet knitted herself one', remembers his mother, 'and she put it on to go down and see him when he was dying. She said, "Look Billy, this is one of yours I made", and he said, "You've [put] on the wrong buttons."'

Gibb's unique visual flair did not go unnoticed by his teachers at Fraserburgh Academy, the main state secondary school. It was attended by children from local farming and fishing families until the advent of oil production in the 1970s dramatically changed the area. 'Mr Duthie [his art teacher] advised him to go to London', says Jessie Gibb. 'It was a shock to us all but then he never was interested in farming. It was always his drawings. A lot of them were of medieval history, and he did murals on his bedroom wall, Egyptian things. He would sit and draw for hours.'

Fassett remembers when Gibb first took him home to Scotland. 'We went to stay with his grandmother and he showed me his little bedroom, which she kept specially for him. It was painted like an Egyptian tomb with all these Egyptian figures. It was so bizarre', he says, 'on a Scottish farm. There was Bill, just a dreamy kid, studying these ancient costumes, loving the line and thinking how to play with it. And I was the weird foreign friend, who sat knitting in the corner', says Fassett, who hails originally from Big Sur, California. 'I'm sure he did live in his own kind of world, a world he created for himself away from the farmyard', says Godbold. 'He was very educated, especially historically; he knew a lot.'

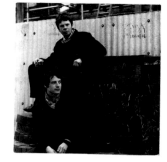

Bill Gibb and Kaffe
Fassett, *c.*1967
Steve Lovi

Bill Gibb, *c.*1967
Steve Lovi

And it was these escapist fantasies that would shape the visual language that Gibb would return to time and time again. In 1985 he noted: 'Reality is so horrific these days that only escapism makes it bearable at times. So the more glamour the world can provide, the better people like it. However fashion changes, glamour will never go out of vogue.'[7]

Encouraged by his teachers at Fraserburgh and with the help of his aunt Evie, who had to speak for him at his interview he was so nervous ('she said that I hadn't much to say, but that I did have talent', remembered Gibb),[8] Gibb gained a place at the prestigious St Martin's School of Art [now Central Saint Martins] in 1962. 'He was a tremendously talented and sensitive student, of gentle disposition, with a fine appreciation of texture – of delicate, gossamer fabrics as well as weighty, thick ones – and a great feel for mixtures', said Muriel Pemberton, the legendary Head of Fashion.[9]

At first the transition from village life to the big city overwhelmed Gibb and threatened to curtail his promising career before it had started. 'The first week I arrived I got on the phone home, a pay phone, and said, "I'm coming home, mum! I hate it! Nobody understands me"', he recalled, remembering how, in Aberdeen, people spoke in dialect. 'I didn't know a bloody soul … down I came, and sat at St Martin's … and there was a naked body you have to draw. I was as green as anything when I came, but I learned quickly. Aquarians are very quick and very broadminded.'[10]

Jessie and George Gibb had immediately travelled down to London. 'It was when he had to start doing the actual sewing himself that he decided he

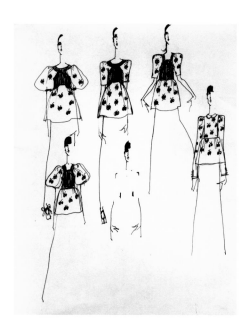
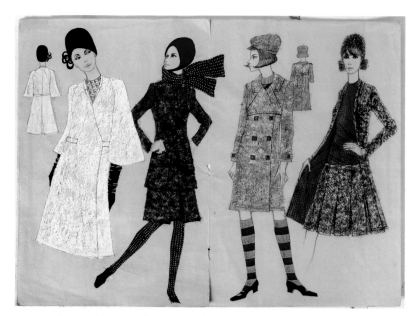

Designs from Gibb's Royal College of Art ideas book, c.1967 (left) and from his sketchbook made at St Martin's School of Art, London, c.1964 (right)

was going to give it up', explains Jessie. Gibb was also uninspired by the prevailing fashions of the day. 'Remember the Sack dress? It was too plain for him', continues Jessie. 'So we met with Pemberton and she called in some of his work. She said it would be stupid for him to give up and we persuaded him to stay on. Thank goodness he did.'

Gibb graduated in 1966 with top honours and won a scholarship to the Royal College of Art, which was fast earning a reputation for cultivating a new generation of fashion designers including Ossie Clark, Zandra Rhodes, Janice Wainwright, Sally Tuffin and Marion Foale. In amongst the geometric, less-is-more, A-line silhouettes of the day, Gibb's college ideas books reveal the essence of things to come in the voluminous puffed sleeves and squared neckline of an empire-line minidress patterned with cherries. Nurtured by the experimental environment and specifically Janey Ironside, then head of fashion, and Bernard Nevill, who also designed textiles for Liberty, he flourished. 'Right from the start what Gibb was doing was really innovative', says Wendy Dagworthy, head of the School of Fashion and Textiles at the Royal College of Art since 2000. 'The RCA at that time was a melting pot of art and fashion, everybody was breaking new ground. Gibb had a completely different perspective on clothing and his clothes were completely different to anything that had gone before. They were like art pieces.'

It was while Gibb was at the RCA that he first met Fassett in The Gigolo nightclub in the Kings Road, the start of a relationship that would be key to unlocking Gibb's true potential. 'We were both just cruising around the scene, I suppose, in the late 1960s', remembers Fassett. 'We hit it off immediately.

Angel-print leather and chiffon outfit by Bill Gibb for Baccarat, Autumn/Winter collection, 1970 'Renaissance of Costume Splendour', British *Vogue*, 1 October 1970 / **Barry Lategan**

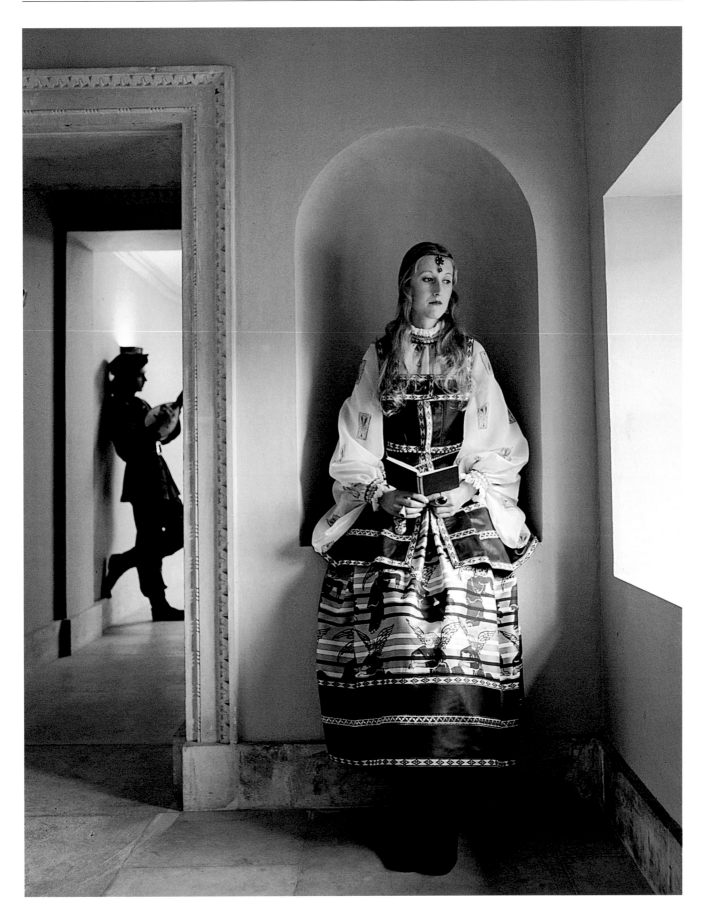

He was very funny and had that fantastic Scottish voice of his. He was dressed in an old sailor's peacoat, which he'd cut down to make it more his style. I asked him, "What's your profession?" and he said, "Well, I'm kind of interested in costumes", but he was very vague about it. Of course, I found out later he was a fashion designer and quite shy about it.'

Despite his natural reticence Gibb was gaining a growing fan club. 'His years at the RCA were on the crowded side', wrote Ernestine Carter, 'for he was asked by Wallis shops to do a collection with Gina Fratini'.[11] In 1967 he was chosen as one of six designers, including Clark and Wainwright, to contribute to the London Look Award in New York, sponsored by Yardley. Although the British team did not win, Gibb did get noticed by the buyers at Henri Bendel, the swanky Manhattan department store, who snapped up his entire collection. 'It was almost better than winning the prize', Gibb later told the *Evening Express* in Aberdeen.[12] Fashion designer John Bates, who was a judge on the competition panel having won the award the previous year, was especially excited by the sophistication of Gibb's designs. 'I had terrible arguments with the other judges', he remembers. 'I kept saying, "This guy should have won the award. He has designed the most beautiful yellow coat."'

When he returned to London from New York Gibb made the decision to leave the RCA and go into business with sisters Annie and Alice Russell. This was the era of the designer entrepreneur with Mary Quant's Bazaar providing the prototype for a slew of little boutiques selling avant-garde designs that were run up in the back of the shop. Fashion had a party atmosphere; the clothes on the racks were young, fun and (for the most part) throwaway. The boutique that showcased Gibb's designs, Alice Paul, was located in Abingdon Road, Kensington, just across the road from Barbara Hulanicki's Biba emporium. 'I remember watching it all happen', Gibb said. 'I always used to look in through the windows to see what they were up to. Fantastic, so cheap, I wondered how she [Hulanicki] did it.'[13] It was at this time that Gibb found pattern-cutter Nives Losani, who would work alongside him for the next 17 years.

Sadly, it was not long before the business faltered, so with just £100 between them Gibb and Fassett decided to take a Greyhound bus trip across America for three months. 'Everyone went off to the States to have a good time', remembers Annie Russell. Naturally, Gibb was inspired by the journey. 'He saw that the earth was this wonderful rusty red and loved that. Then he saw a couple of barns, painted a sort of grey-green, and he latched onto those two colours – rust and grey-green', says Fassett. 'We began to realize this amazing thing about fashion colours, that they were in the air, something that you could just sense. Travelling was fabulous for that. We could both go to the most dire places that nobody else would find interesting in the slightest and something would catch our eye, perhaps an old black woman going down the street wearing a great

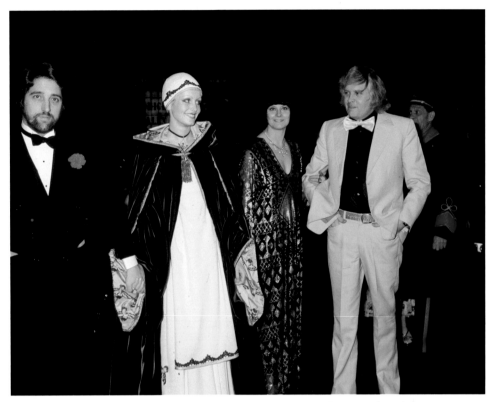

Twiggy wearing a Bill Gibb design at the New York première of *The Boyfriend*, 1971.
Left to right: Justin de Villeneuve, Twiggy, Shirley Russell and director Ken Russell

turban. There was always something to see and use. It was like the music industry; it was wide open. Every little idea that you had was precious because somebody, somewhere would respond to it – and turn it into money.' However, for the moment, back in London, the pair were penniless.

It was Bates who came to the rescue, urging Gibb to go and see Monty Black who had a job vacancy for a designer at Baccarat. 'They gave me a year's contract', said Gibb. 'They liked what I had done, so I did it for a further two or three years.'[14] At Baccarat Gibb skilfully melded the newly emerging eclectic 'fashion tourist' style, popular with the young, with his fondness for bygone eras. 'I've always been influenced by medieval clothes', Gibb told *Flair* magazine, 'that beautiful high back, the body swathed in yards of fabric. I hate skinny silhouettes.'[15] Fassett recalls that Gibb had 'an absolute fascination from the word go for those kinds of shapes and structures.'

In 1971 the model Twiggy starred in her first film, the musical *The Boyfriend*. She asked Gibb, whom she had briefly met when he helped her to dig her car out of the snow, to design outfits for her to wear to the premières in London, New York and Los Angeles. Gibb's designs showcased his forte for a little costume drama and featured a floor-sweeping embroidered ivory wool tabard dress with a full circular skirt decorated with velvet ribbons, metallic braids and

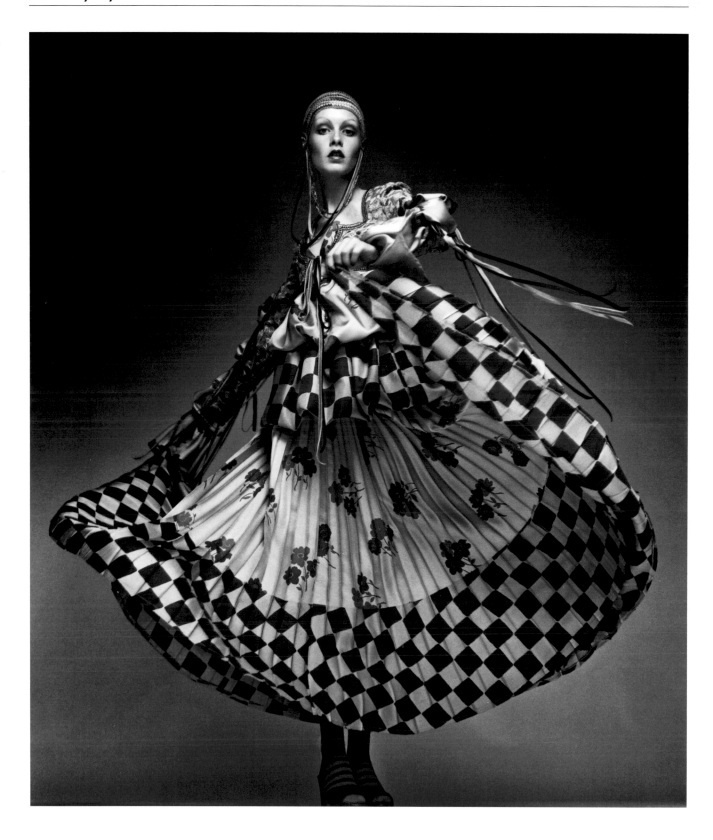

Bill Gibb design commissioned by Twiggy for the Los Angeles première of *The Boyfriend*, 1971 / **Justin de Villeneuve**

appliquéd handprinted swallows. As it was winter Gibb added a peacock-blue velvet hooded cape, lined with the same swallow print, created exclusively for Gibb by Sally MacLachlan. The designs for her Stateside appearances were equally extravagant and were accessorized with an embroidered skullcap. 'I felt like a princess', Twiggy said later.[16]

Gibb's designs chimed with the times. As the 1960s became the 1970s there was widespread disillusionment with the social system and a mood of cynicism prevailed. Gibb sought diversion in the realms of make-believe and the ancient past. 'I surround myself with books', commented Gibb, who was very much the culture aficionado. 'Bellini to Bosch to Erté to a history of the plant kingdom.'[17] But he was not alone. Others in the creative arts – filmmakers, musicians, artists and designers – looked to flee the grim realities of the day and replace them with something more romantic and, indeed, fantastical. The work of illustrator Roger Dean, another graduate of the RCA, was part science fiction, part Arthurian legend. In the early 1970s Dean created mythical landscapes on album covers and posters, most notably for the progressive rock band Yes. His paintings explored strange, otherworldly panoramas, from twisted tree roots to teardrop mountains, inhabited by serpents, black cats, wolves and dragonflies.

'It's funny how that feeling seems to come around every 100 years', says Giles Deacon. 'In the late 1800s William Morris was obsessed with going back to all things medieval. They [Arts and Crafts designers] were heavily inspired by all that, as were the occult societies of late Victorian times.' The influence of Morris, both his use of the medieval and the natural world, can be seen in Gibb's work along with another Victorian art movement, that of the Pre-Raphaelites who eroticized medievalism, painting their muses in the same garb that Gibb had copied from his history books in his bedroom. The same sumptuous looks, designed by Danilo Donati, had featured in Franco Zeffirelli's 1968 film version of *Romeo and Juliet*, which had premièred just a year before Gibb began designing his long romantic dresses at Baccarat. The models in Gibb's sketches from this period, with their crimped tresses, resemble modern-day Ophelias. Of course, nostalgia has always been a profound inspiration throughout fashion history.

Historic themes would surface throughout Gibb's career, from Pre-Raphaelite and Elizabethan influences in the 'lingerie looks for evening' in his Autumn/Winter 1974 collection to his use of lining braid from the 1930s and 1940s – 'one of the greatest little tricks of the game', Gibb told television presenter Joan Bakewell, when asked how he managed to get so much richness into clothes that looked so light and modern.[18] 'He loved gold and glitter, jewels, embroidery, Florentine colour. It was his costume research which always inspired another idea for a collection', Muriel Pemberton told British *Vogue* in 1988.[19]

Gibb's affection for bygone eras also revealed itself in the exquisite wedding dresses he designed for celebrity clients, friends and family. The inspiration could

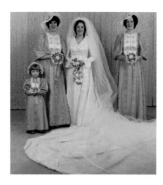

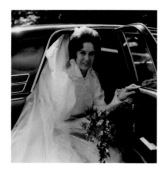

Fulfilling a long-standing promise, Gibb designed the wedding dresses for all three of his sisters
Top: Patsy, 7 June 1969
Centre: Janet, 21 April 1973
Below: Marlyn, 11 August 1973

be found close to home. 'My mother is a great floral art lady. She gets all the flowers together for the [family] weddings: sisters, cousins …', he explained.[20] Given his bent for dramatic silhouettes and his love of decoration it was not surprising that Gibb should create such romantic fairytale concoctions. In 1973 he was featured in the Spring issue of *Brides* magazine, which had been a great supporter of the designer's work. Accompanying a photograph of one of his woodland-inspired dresses, taken by Tony Snowdon, Gibb described his personal love affair with bridal wear. 'As a designer I can see in the wedding dress an opportunity to create a design both extravagant and stunning for someone who wants to look as magnificent as possible on the day', he told writer Jacqueline Taylor.

In the same year he created wedding gowns for two of his sisters, Marlyn and Janet. Marlyn, the youngest daughter, wore a dress that was medieval in style. 'A wedding is really the only occasion now when a train can be shown to its full advantage', confirmed Gibb. 'It gives me a chance to employ features of medieval dress, which I appreciate, not only for the costume element, but also because of the way I imagine it was worn – with a grace rare today.'[21] Even though Gibb professed that above all a bride must wear a dress that projects her personality, his mother remembers that there were times when he could be stubbornly intransigent. 'He wanted a long train and the girls said, "Well, the church doesn't have too long an aisle", and he said, "Well, no train, no dress!"'

Janet's dress, made from Swiss organza and duchesse satin, with a train measuring almost 20 metres, 'took the Buchan village of New Pitsligo by storm'. 'Brother Bill Makes Janet's Big Dream Come True', read the headline in the Aberdeen *Press and Journal*, the reporter adding that 'a large crowd turned out'. Gibb told the newspaper, 'I am now fulfilling what has been a long-standing promise.'[22]

Sister Patsy also wore a Gibb original on her big day. 'You had a fat chance of having any say in anything, or of getting excited about your wedding dress. Billy was impossible', remembers Patsy. 'He was late for everything, he was always last-minute, and they were still stitching the night before the wedding. Then Nives, of course, being Italian, said, "You must have horse's hair for good luck"', continues Patsy. 'So Dad went out to the horses, cut off a bit of the mane and she stitched it into the hem of the dress. Well, 30 years later I'm still married to the same man! Nives is a lovely lady, a very genuine thing.'

Woodland-inspired printed dress by Bill Gibb, Autumn/Winter collection, 1972
Brides, September 1972 / **Snowdon**
Gibb had a personal love affair with bridal wear that continued throughout his fashion career; his romantic bent and love of decoration made for dream-like concoctions

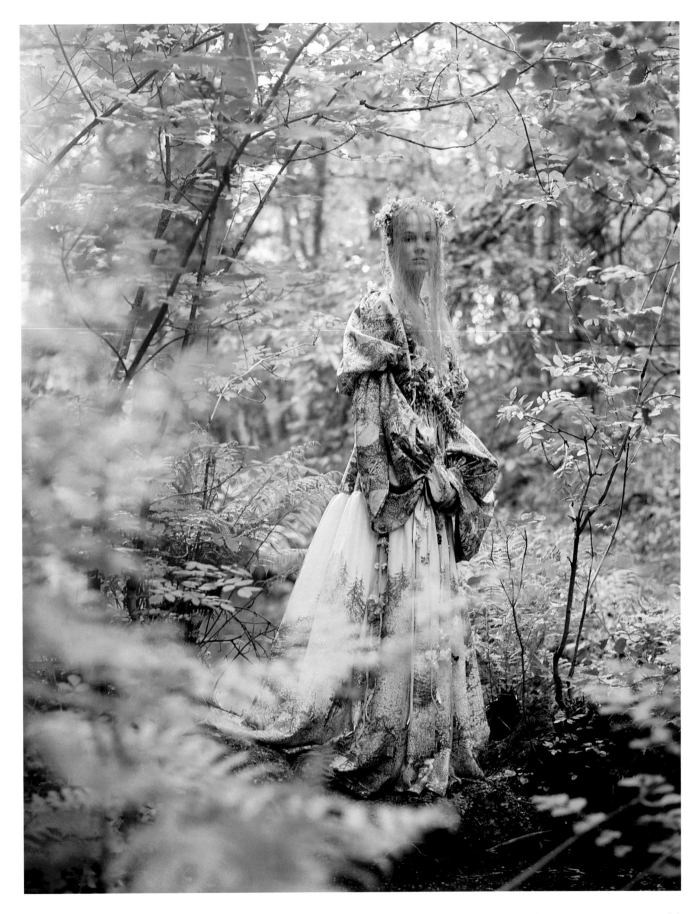

Throughout his career Gibb had a constant clientele for his particular brand of romantic spectacle: both Lucy and Tessa Dahl wore his designs on their wedding days as did numerous private clients. In 1976 the pop singer Lulu asked Gibb to design her dress for her marriage to celebrity hairdresser John Frieda. The dress he created was a stunning draped jersey kaftan, embroidered with glittering Art Deco shells. It was worn with a matching turban that echoed those seen in the illustrations of Erté, another of Gibb's favourite artists. 'If I had to choose one beautiful fabric this would be Qiana jersey, which is fine and fluid, like pouring milk out of a jug. I think cream is a fabulous colour, as it is, or with something fantastic added to it, like an embroidered motif, or painted images of contrasting colour', said Gibb.[23]

Ever the dreamer, Gibb told *Brides*: 'I rather like the idea of Miss Haversham sitting in her house in her wedding clothes gathering dust and cobwebs … I like the idea of a dream being hoarded for future generations.'[24]

Bridal gown designed by the teenage Bill Gibb, c.1958

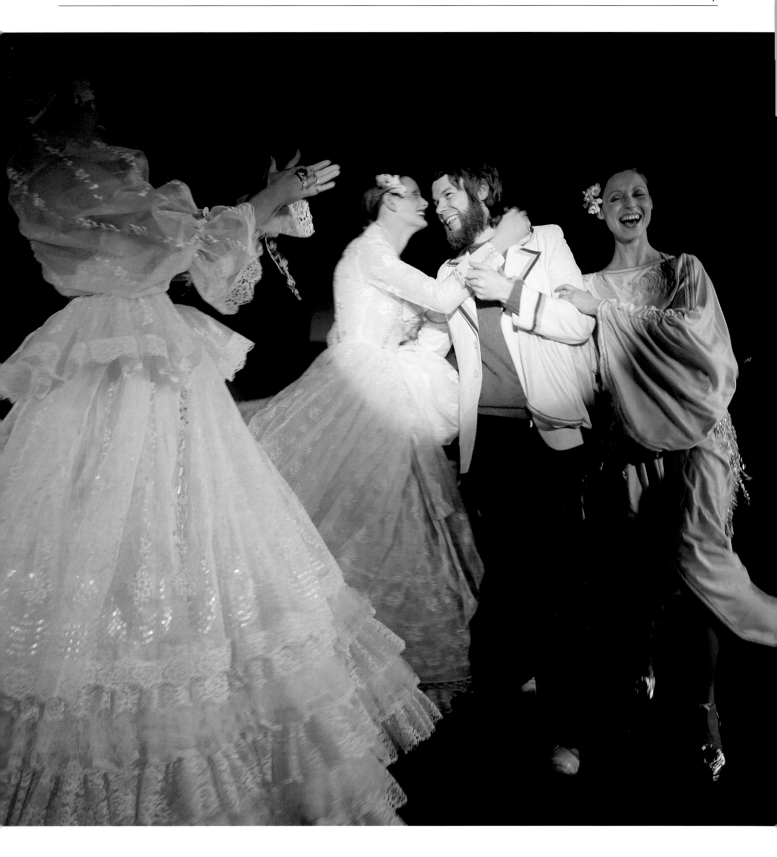

Bill Gibb dresses from his Autumn/Winter collection, 1973
Gone with the Wind-style frothy crinolines were Gibb's nod to yesteryear glamour / **Clive Boursnell**

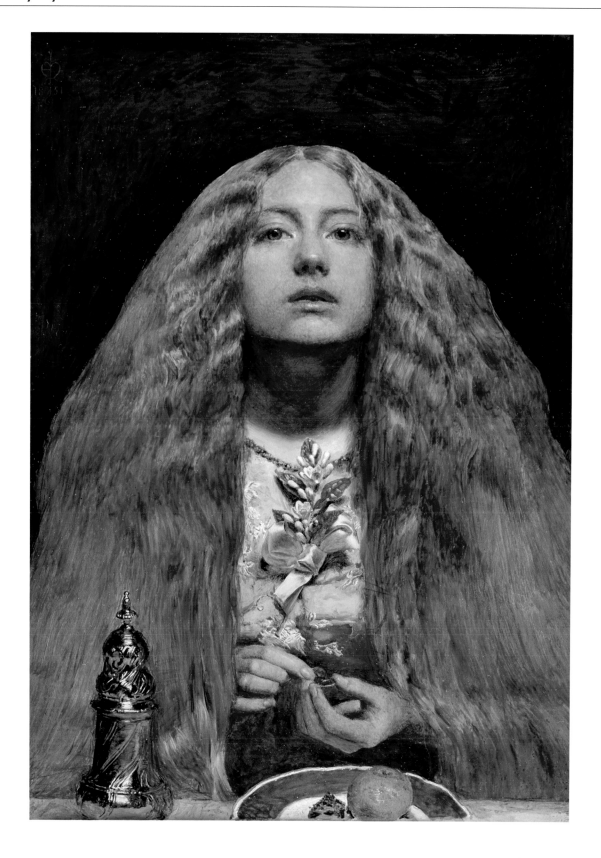

Sir John Everett Millais
The Bridesmaid, 1851

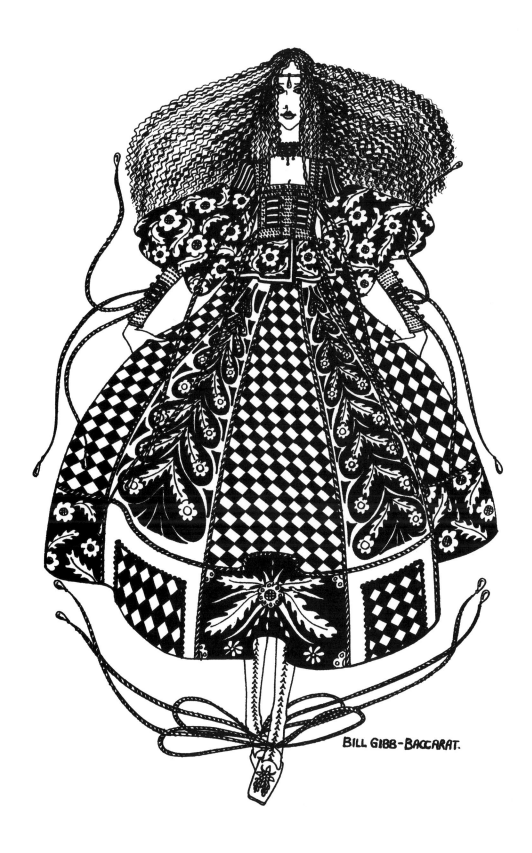

Working drawing by Bill Gibb, c.1969
The influence of the Pre-Raphaelite painters was resonant in Gibb's early work

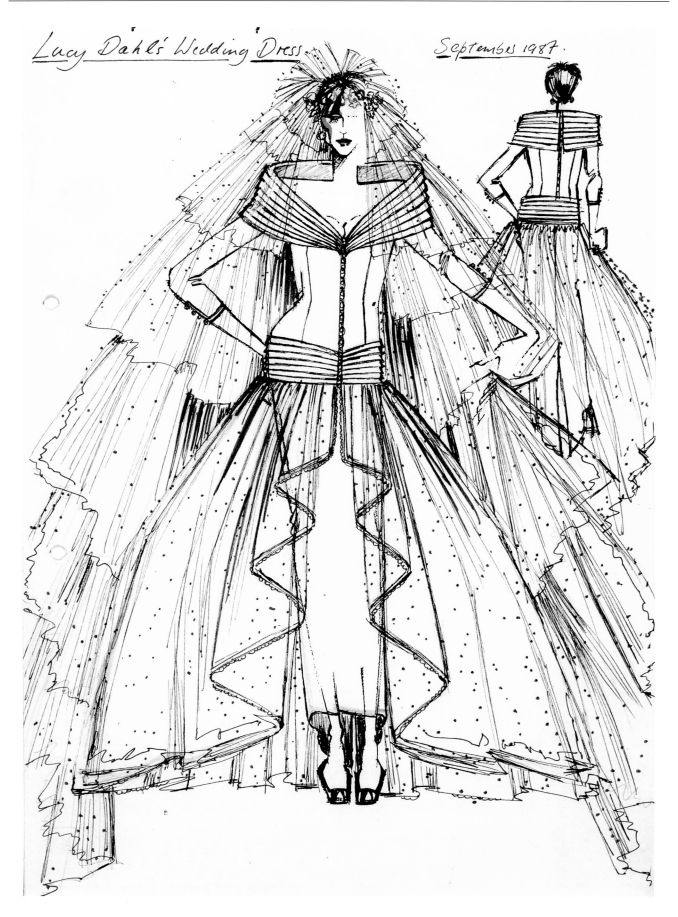

Lucy Dahl's Wedding Dress. September 1987.

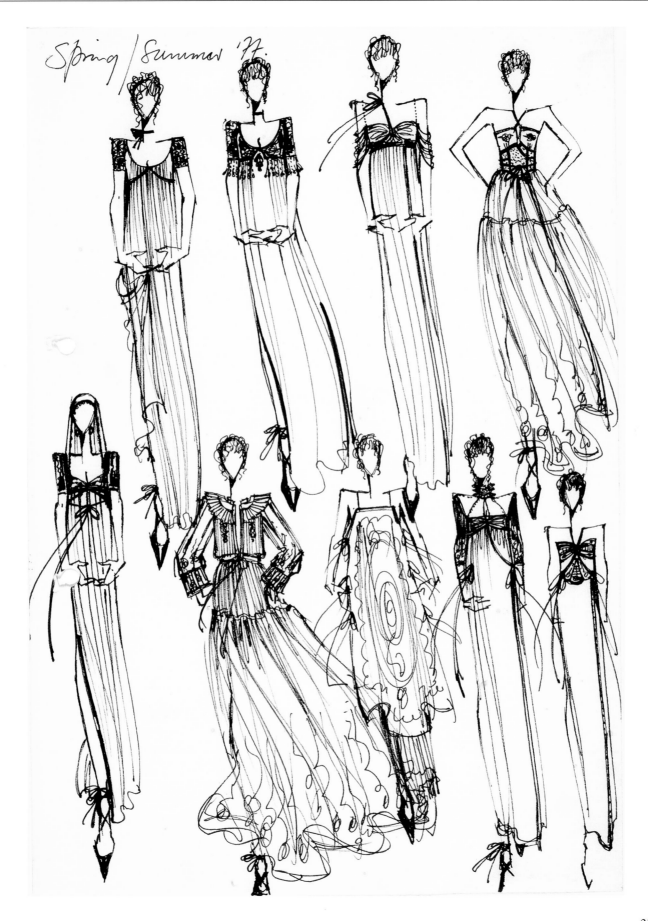

Spring / Summer '77

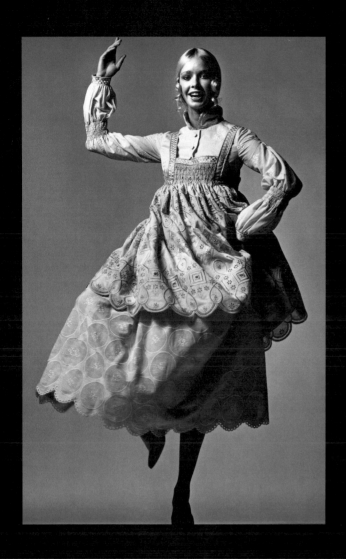
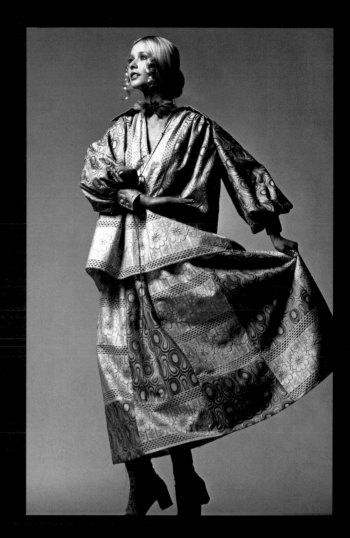

The showman

'His fashion shows had such exuberance', recalls Anna Piaggi, fashion editor of Italian *Vogue*, who featured Gibb's designs on the pages of the magazine. 'They were the hot ticket in London. Bill created a magical atmosphere on the catwalk. He had such style and was so inspirational.'

In 1971 the Federation of the Embroidery Industry of Vorarlberg, Austria were looking for a little inspiration themselves. Their plan was to commission a mini collection that would promote their product abroad, so they approached the public relations agent Kathleen (Kate) Franklin. 'I had to find a designer for their project', says Franklin, who was to become one of the key players in both Gibb's career and his life. 'At the time my daughter Susan was working with Judy Brittain, who immediately suggested that I meet Bill and Kaffe.' Franklin asked them to take on the commission: 'They selected hundreds of pieces of embroidery. I'd no idea what they were going to do with them', she continues. 'Then Billy went into a little trance in his flat and came up with about 30 designs.'

Franklin and her client were astounded by what they were shown. The outfits proffered by Gibb not only pursued his unique vision, they also revealed his awareness of the value of a show-stopping design. Gibb had constructed a 'new' fabric by stitching together row upon row of trimming samples. This he shaped into voluminous skirts, puff-sleeved smocks and blouses. 'The designs were beautiful, I mean breathtakingly beautiful', says Franklin. 'The Austrians took it all to Japan and had an absolute sell-out.'

Shortly afterwards another of Franklin's PR clients, the lingerie company Lovable, was looking for a designer to create a line of leisurewear. Having enjoyed the company of the 'shy, quiet' designer, she once again turned to Gibb, who surprised client and fashion press alike with an exquisitely pared down sportswear collection which, although against type, was equally inspiring in its simplicity and assured hand. The relaxed collection, which included a black jersey karate-style jacket and lounger pants trimmed by a striped ribbon, was featured in British *Vogue*, photographed in the glamorous Seychelles by Norman Parkinson.

Things were moving fast for Gibb in 1971. One of his designs was featured as part of the centrepiece in the *British Design* exhibition at the Louvre in Paris, and in the same year Cecil Beaton chose a Gibb dress for his portentous *Fashion: An Anthology* exhibition, designed by Michael Haynes, at the Victoria and Albert Museum in London. By this time Gibb was becoming frustrated with the set-up at Baccarat. 'It was tough. The first time I was involved in a big company', he later told fashion editor Caroline Baker. 'I was absolutely desperate to get out of what I was doing, being under the thumb of somebody, and start getting into doing my own things.'[1] Perhaps emboldened by his achievements, Gibb

Gibb's designs for the Federation of the Embroidery Industry of Vorarlberg, Austria, 1971.
Patrick Hunt

approached his new friend Franklin with a proposition of his own. Franklin remembers Gibb saying, 'Why don't you come and manage me?' She said, 'I don't know anything about the dress trade', to which Gibb replied, 'You don't have to know anything about it, it's pretty much what you do anyway.' Franklin recollects, 'What I didn't realize at the time was that the dress trade was much fiercer.'

Despite her initial reticence Franklin and Gibb joined forces to set up Bill Gibb Limited, with financial backing from the Lovable organization. 'It was all very cosy and we had this dear little showroom in Knightsbridge', says Franklin. 'I immediately got to work finding places to show the first collection.' Having decided to stage Gibb's debut show at the Oriental Club in the heart of London's West End, Franklin had a 'wonderful piece of luck' when she was contacted by a young filmmaker, Keith Sheather, who was looking to direct a documentary for BBC Television that would focus on an upcoming fashion designer.

The half-hour programme that he produced, as part of the All in a Day series, was entitled 'The Collection'. It makes remarkable viewing. For anyone with a passing interest in fashion it is, possibly with the exception of 'Unzipped', Douglas Keeve's film that followed the American fashion designer Isaac Mizrahi as he prepared his Autumn/Winter 1994 collection, one of the most astute and telling portrayals of the magic and madness that goes on behind the scenes of a glamorous fashion show.

Franklin recalls: 'Amidst the chaos that surrounded us – carpenters putting up shelves, decorators applying suede to the walls, the pattern-cutter trying to keep expensive fabrics clean and Bill trying to design, Keith bravely said he wanted to go ahead with it, in spite of the fact that we had only completed one dress. It was a colossal act of faith.' Nevertheless, the combination proved a perfect fit. 'They [the film crew] stuck with us through the whole day, recording and televising everything', Gibb told Baker excitedly. 'It was amazing. An extraordinary feat of marvellous PR on Kate's part, that she managed to pull that one together.' [2]

For any would-be designer starting out today perhaps the most surprising thing to note is that Gibb presented this all-important show, his Autumn/Winter 1972 collection, with just five models: Ike, J.J., Kellie, Priscilla and Kay.

Gibb's line-up not only showcased the theme of his collection – the natural world – but also the gifted team of cutters, knitters, colourists, printers, painters, embroiderers and weavers that now surrounded him. Included in this talented group was Albert Purton, the faithful tailor and pattern-cutter whom Gibb had purloined from Baccarat. The first outfit, worn by J.J., was a scalloped chestnut

Gibb's pared-down leisurewear designs for the lingerie company, Lovable
British *Vogue*, December 1971 / **Norman Parkinson**

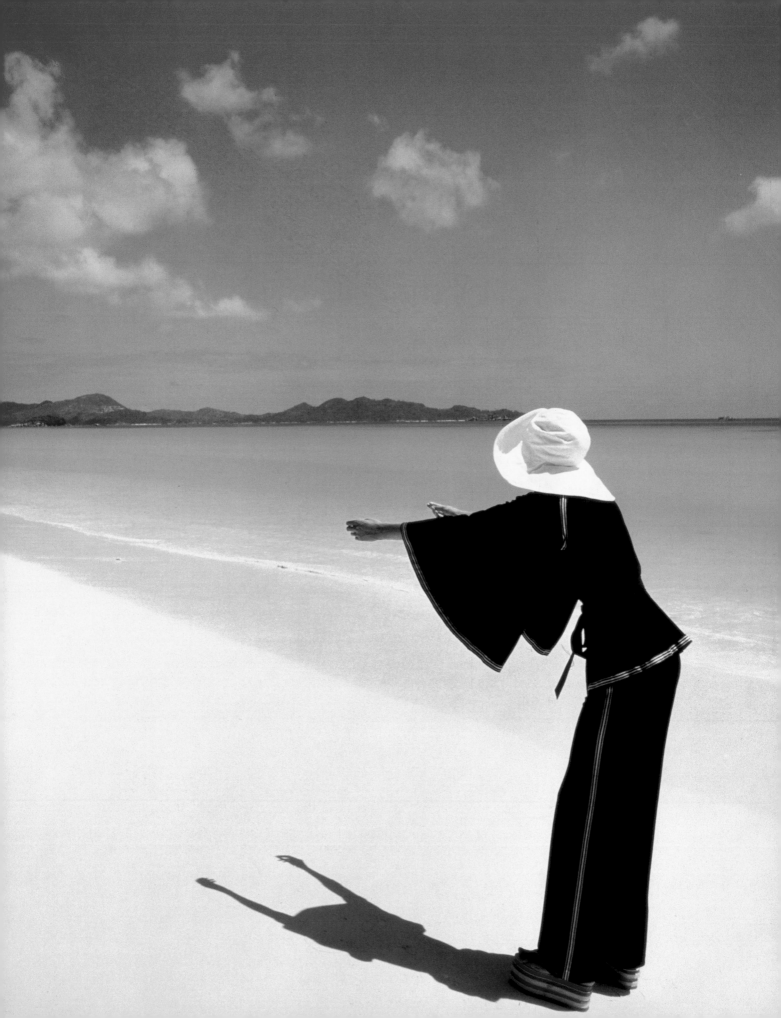

leather two-piece outfit, featuring a silvered chrysanthemum and bee design by Sally MacLachlan. The second outfit, modelled by Kellie, featured a long, panelled black leather skirt with the same flower print, matching waistcoat and silvered-sequin hooded top. Gibb also offered dresses patterned with Sue Kemp's Wind in the Willows print, another with Valerie Yorston's handpainted embroideries and yet others with Alison Combe's beads, feathers and 'raccoon' tails. Central to several outfits were wonderfully tactile handknits by Kaffe Fassett and Mildred Boulton. There were also lizard-trimmed cream wool suits, velvets that looked like fur and marbled silks by Ellen and Robert Ashley.

In the opening moments of the film, fashion doyenne Suzy Menkes, then fashion editor of the London *Evening Standard*, succinctly highlights the gravitas of the event: 'This is Bill Gibb's great day, for the first time showing a collection all his own. It marks the beginning of his career as a designer of the jet set.' Mayhem ensues, with protective plastic bags being torn from racks of clothes, stacks of gilt chairs littering the plush venue and last-minute alterations being made. The girls, as if in some kind of detached haze, make-up their own faces for the show. 'It wasn't just the dresses', remembers his sister Patsy. 'It was the hair, the shoes, the jewellery. Everything had to be right and Billy was a stickler for detail.' A team of stylish looking hairdressers, led by Christopher of Vidal Sassoon, secures coils of tiny plaits or combs sleek finger-waved bobs. The look is 1930s movie queen meets African princess, accessorized with stripy tights and chunky platform clogs from Chelsea Cobbler. Everyone smokes.

Gibb glides calmly between the models. 'You know what I'd do, honey, I'd get into your first outfit', he casually advises Ike. A moment of panic threatens as a particularly complex dress ensnares model J.J., despite help from Gibb and Veronica, another of Franklin's daughters who had been enlisted backstage. This was not to be an isolated incident. Franklin recalls: 'I had just delivered our first order to Harrods after the show when I had a call to say would we come along at once because a woman was trapped in a changing room and couldn't get her arms up or down. In the end, Bill had to cut her out. It was then that we realized all the dresses would have to have zip fasteners, which Bill hadn't wanted to do. We were terribly inexperienced.'

The director moves on to film front-of-house as the invited guests arrive. The familiar faces of the fashion press fill the seats – Janet Street-Porter, Michael Roberts, Grace Coddington, Meredith Etherington-Smith and Jackie Modlinger

Knits by Mildred Boulton and Kaffe Fassett from Bill Gibb's debut fashion show at the Oriental Club, London, 1972
Julian Allason

Orange jersey two-piece from Bill Gibb's debut fashion show at the Oriental Club, London, 1972
Clive Boursnell

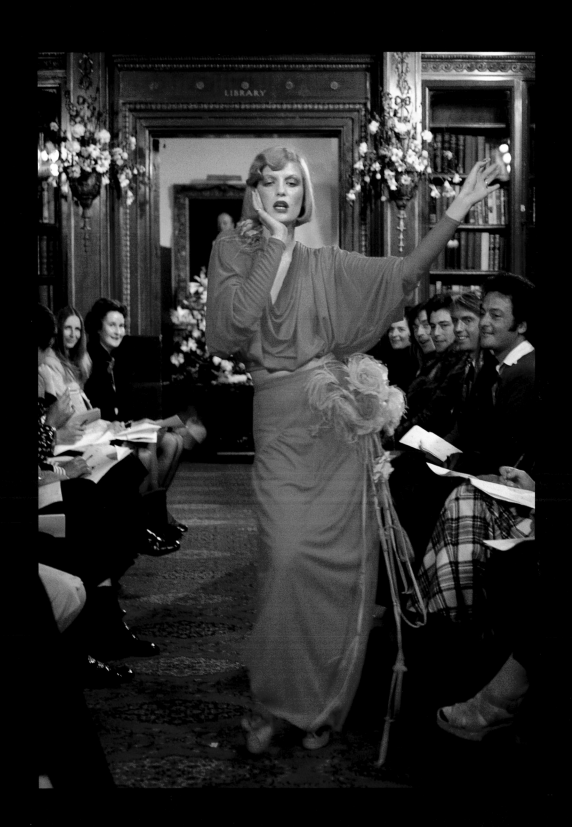

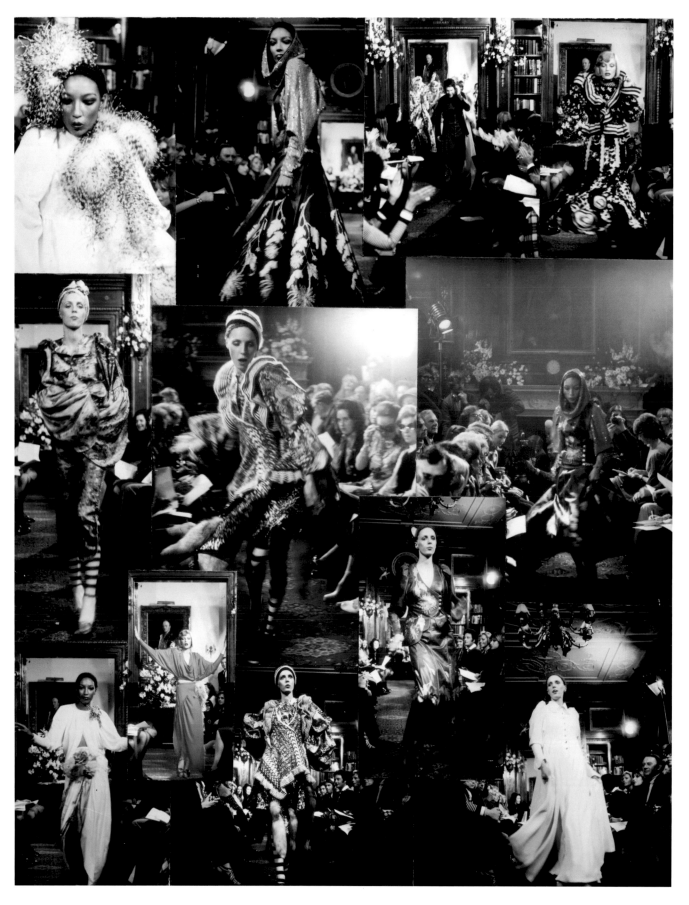

all strain to get a better view. 'Everybody, I mean everybody, was there', remembers Franklin. 'Tony Snowdon, Cecil Beaton, Beatrix Miller, Twiggy'. Twiggy's arrival caused another headache. 'I'm desperately saving you seats', says Franklin, looking the epitome of bohemian chic in a full-length oatmeal-coloured Gibb tweed dress, decorated with trailing ribbons and shells. 'There are five of us', explains Twiggy, who is with her then-boyfriend and manager Justin de Villeneuve, her leading man in *The Boyfriend* Tommy Tune and has two friends in tow. 'I'm saving you five seats', replies Franklin, quick as a flash. Backstage Gibb's family arrives and is welcomed by the designer with hugs and kisses. 'We often went down to his shows', says Jessie Gibb. 'They were amazing, such an eye opener. Bill's family was always given pride of place', says Judy Brittain.

Bark-print silk dress from Bill Gibb's debut fashion show at the Oriental Club, London, 1972
Flamboyant silhouettes decorated with textural nature prints played a key role in Bill Gibb's debut show
Julian Allason

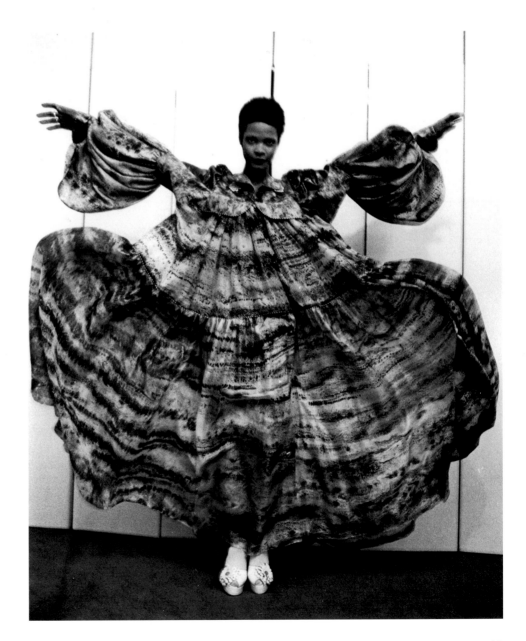

Montage of photographs taken at Bill Gibb's debut fashion show at the Oriental Club, London, 1972
Clive Boursnell

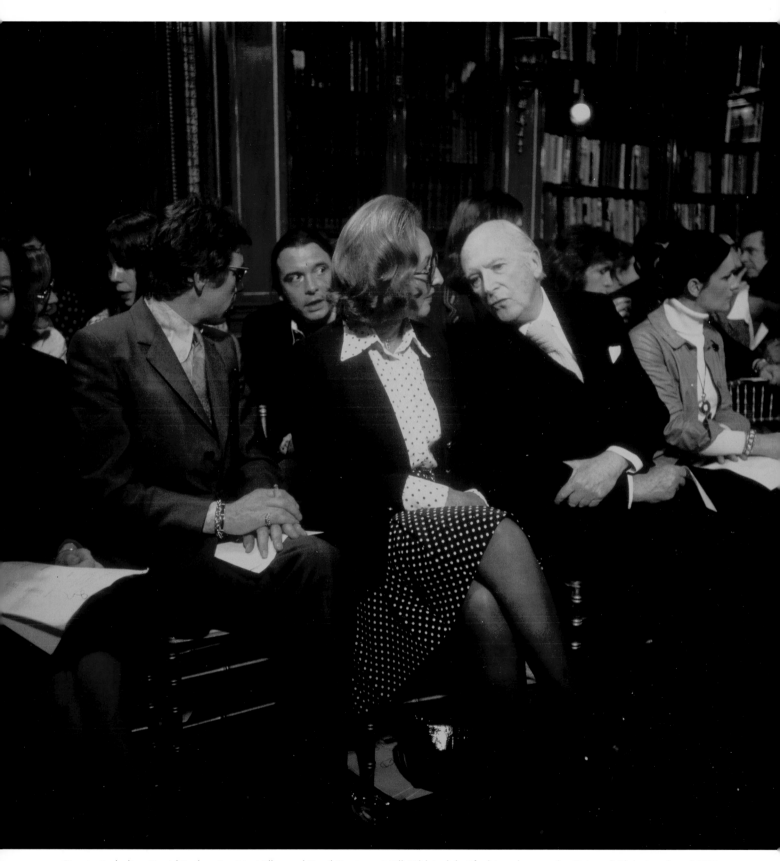

Guests, including David Bailey, Beatrix Miller and Cecil Beaton, at Bill Gibb's debut fashion show at the Oriental Club, London, 1972
Clive Boursnell

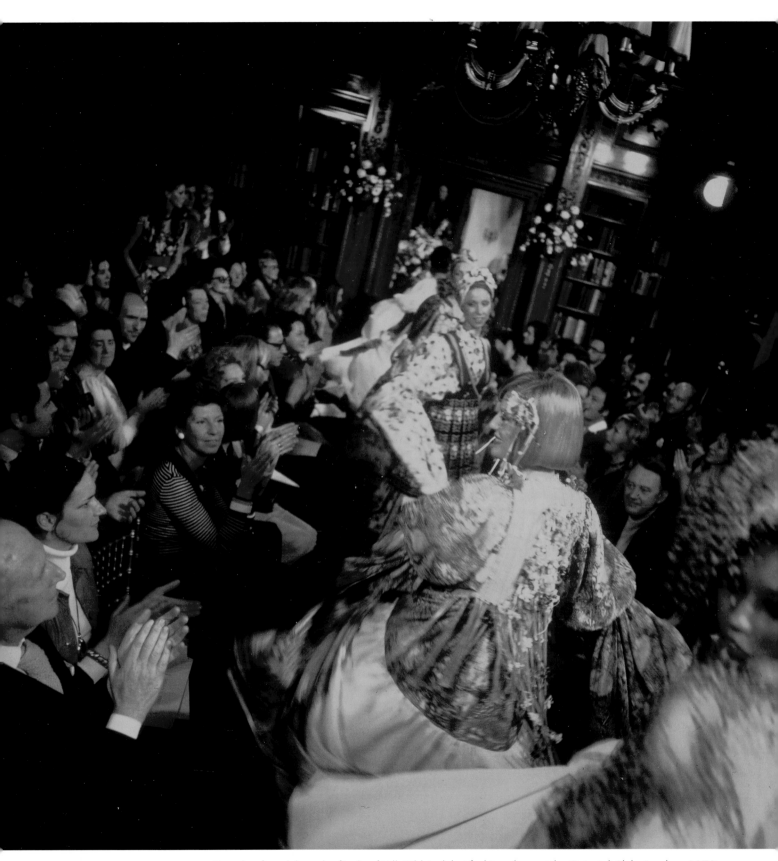

Parade of models at the finale of Bill Gibb's debut fashion show at the Oriental Club, London, 1972
Clive Boursnell

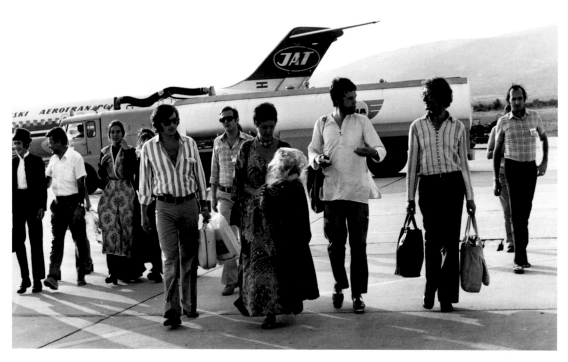

The 'Bill Gibb team' travelled the world including a trip to Trogir, Yugoslavia, for Modefest, *c.*1975
Clive Boursnell

Suddenly it's showtime, with songs from the musical *Godspell* and popular hits of the day like Gilbert O'Sullivan's 'Alone Again, Naturally' and 'Floy Joy' by the Supremes, all handpicked by Gibb. Both Franklin and Bates recall how Gibb would choose the soundtrack for his shows. 'We would buy the records and Bill would come over and we'd play various tracks', remembers Bates. 'He'd say, "Who's this?" as he walked up and down an imaginary catwalk. He was better than the models. He was a very funny guy. He was a great mimic', confirms Franklin. 'Billy would take them off to an absolute tee. His observation was amazing.'

The models themselves can barely squeeze through the crowded room. As they dance across the carpeted floor their twirling dresses caress the front row. 'Each [model] has a distinctive personality which it is essential to record', reads the director's shooting script. Backstage, agent Tony Askew gives them directions. Modelling an orange jersey batwing evening ensemble, sprouting ice-pink feathers and flowers, Ike camps it up, vamping through the room to more applause. The mood is joyful. Applause greets every outfit.

As the last model exits and cheers fill the room, Gibb emits a nervous giggle. He is reluctant to take his bows but is pushed proudly forward by Purton. Gibb is wearing a pair of orange and red suede patchwork trousers and an old cardigan. 'He could produce these theatrical shows with such splendour and yet not be of them', says long-time friend Sally Pasmore. 'He was much happier

wearing secondhand clothes, or making clothes look secondhand', adds Franklin. 'He used to trot up to business meetings wearing bizarre outfits. He even had a policewoman's coat that he'd button up the wrong way and a pair of straw shoes that he wore continually. But he always looked right, that was Bill.' Fassett also remembers that Gibb 'liked a certain flamboyance but it was very controlled and stylishly put together. He would just take a T-shirt and make a hat out of it, or he would wear it around his neck like a scarf. He would do odd things, always with a kind of discord – funny striped socks with trousers that weren't quite long enough, big clunky shoes. He loved it if he walked into a room and people gasped. It would be just like him to stir things up.'

In the after-show backstage mêlée Gibb is congratulated over and over again on his designs. Twiggy rushes forward: 'They're incredible, I loved every one, I want them all', she says. 'Is it possible to have one to wear tonight?' an anxious guest pleads with Franklin. 'Baby, you've made it', says actress and great chum Meg Wynn Owen. Even arch-rival Ossie Clark throws an arm around Gibb and can be heard praising the designer's efforts.

The film ends as it began with Menkes, who is telephoning her news story through to the paper: 'With animal skin dresses swirling up around the thighs, cuddly rainbow knits and clinging vamp dresses, Bill Gibb, son of a Scottish farmer, rocked the London fashion world this morning.'

'The show was an absolute rave', says Franklin. And so it went on. For the next five years, season after season, Gibb would be part of the twice-yearly catwalk circus. 'It's the most nerve-wracking thing to do a show', says Bates. 'I used to shake, and Bill was the same. It's a six-month business. If somebody writes a damning review, you don't know how it will be received from a commercial point of view. When you are dealing with the big stores, you need them all to order and you don't know if they are going to. There is no guarantee', he adds. 'They can come up to you at the end of a show and say, with the biggest smile in the world, "Nothing really there for me."'

Despite the financial crises that were to come later, for the moment everyone wanted a piece of Gibb. Franklin, with her adept grasp of the publicity machine and die-hard conviction in Gibb's talent, was his greatest ally. 'Kate is a very important part of the creative process', Gibb confided, in conversation with Mick Rock. [3] Her main role was to keep the Gibb catwalk extravaganzas rolling. She flourished, sourcing ever more exciting venues and, together with show producer Roger Hutchins, visualizing the staging. While the Spring/Summer shows were always held at the Hyde Park Hotel, the location schedule for Gibb's Autumn/Winter shows reads like an A–Z of London nightspots and architectural attractions from Les Ambassadeurs Club in Park Lane to Lincoln's Inn law courts, from the Floral Hall in Covent Garden to a converted brewery in St Katharine Docks.

A rare holiday, Ibiza, c.1973
Left to right: Bill Gibb,
Veronica Franklin
and Brian Godbold

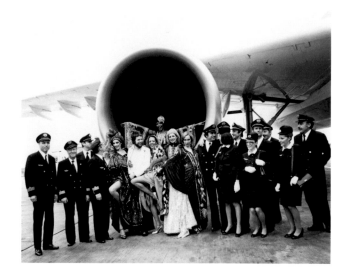

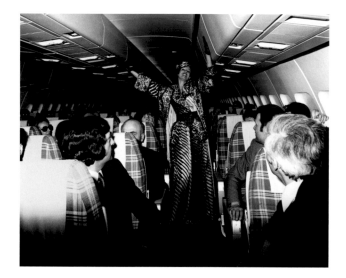

European Airbus fashion show, May 1974
Clockwise from top left: Bill Gibb with models and air staff,
Bill Gibb with Kate Franklin, the in-flight European Airbus
fashion show / **Clive Boursnell**

As staging a catwalk show could run into tens of thousands of pounds Franklin was also canny about who was to fund Gibb's exposure. For his Spring/Summer collection, presented in November 1972 (a season's collection is always shown six months beforehand), a group show was organized with Jean Muir, John Bates and Zandra Rhodes. Its purpose was to raise the British profile with overseas buyers. The ploy worked well for all concerned. 'Why Top Talents Can Afford To Show Together', read the headline in the *Evening Standard*. The accompanying story explained how the designers' efforts had been so spectacularly successful they could have staged it 20 times over, 'and still had standing room only'. 'Such collaboration between rival designers is rare in this country – and unimaginable in Paris', the story continued. 'But then, this particular quartet have such formidable, such individual talent that they can afford to be friendly.'[4] A feature in *Over 21* magazine agreed: 'It showed that four young designers could get along together without bitching.'[5]

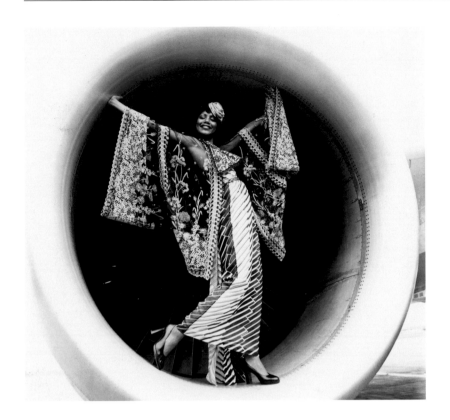

A model poses in a
jet engine to publicise the
European Airbus fashion
show, May 1974
Clive Boursnell

The event, with its atmosphere nostalgic of old Hollywood musicals, was attended by the fashion pack. Ernestine Carter was there, along with colourful characters such as restaurateur Michael Chow and Anna Piaggi. 'Bill's designs had a rich construction but were also a little mysterious', says Piaggi. 'It was a fantastic time: London, that moment', she remembers. 'Years later I found one of his embroidered over-skirts in [the now defunct vintage shop] Steinberg & Tolkien in London's Kings Road. I wear it now and think of Bill.'

The year 1972 also saw a homecoming. The headline in the Aberdeen *Press and Journal* read simply: 'He's Coming…'.[6] For two nights in November, at the Royal Darroch Hotel, Gibb presented a two-hour show billed as 'the Fashion Event of the Year' to an audience of over 500 people. A photograph reveals row upon row of Mary Whitehouse-style matrons wearing winged spectacles and even a hat or two. A caption read, 'The fashion that stunned the North.' As ever, Gibb's family sat proudly in the front row. 'With hindsight I think it was too ahead of its time for Aberdeen', says Jessie Gibb. 'I don't think they really understood or appreciated it. It took Aberdeen a while.'

Not so the rest of the world. Gibb's fame had gone international – both in terms of the press attention he was receiving and the threat he was now posing to other big name designers. Hebe Dorsey, the grand dame of the *International Herald Tribune*, warned in April 1973: 'Paris had better watch out.' Her review of another collective show, Design in Fashion, promoted by the British Overseas Trade Board and held at the Royal College of Art in 1973, praised the line-up of designers that

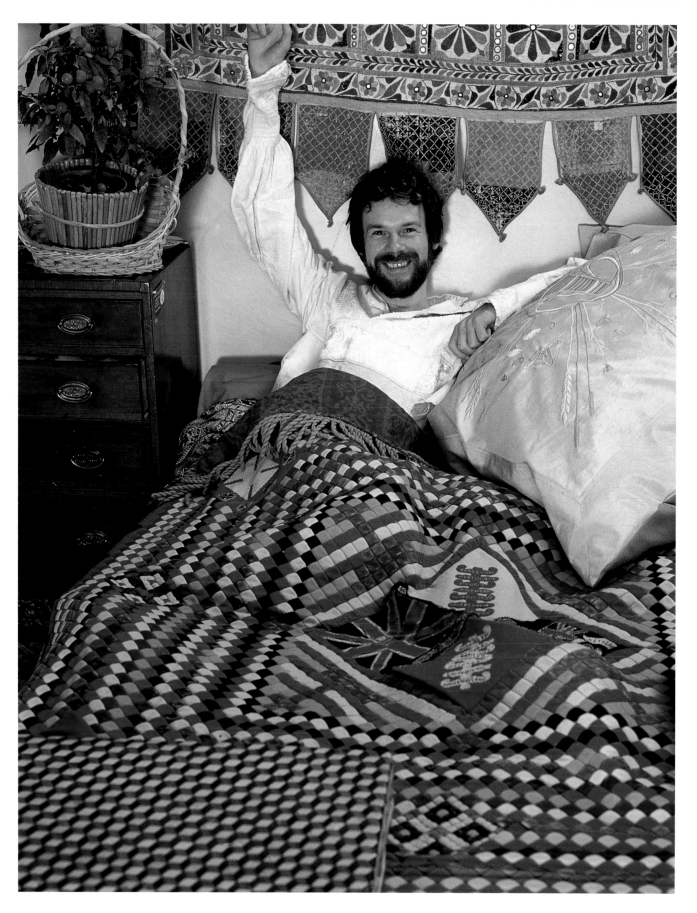

included Gibb, Mary Quant, Ossie Clark, Jean Muir, Zandra Rhodes, John Bates, Gina Fratini and Thea Porter. 'London designers [are] reviving the near defunct spirit of couture', she wrote. 'The British designers have one essential quality that seems to be lacking in other fashion circles these days: courage.' She later pronounced that Gibb and his cohort showed 'uninhibited talent'.[7]

The following years were a non-stop merry-go-round of fashion presentations. There were more high-profile shows in New York, Bonn, Singapore, Nairobi and Trogir in Yugoslavia as well as lavish charity events for the National Playing Fields Association and the Variety Club of Great Britain. Gibb also featured in a Best of British Fashion show, presented at the British Embassy in Paris by Prudence Glynn, then fashion editor of *The Times* and a keen supporter. Perhaps the most bizarre staging was the in-flight fashion show to celebrate the launch of Air France's European Airbus. This was another of Franklin's adroit promotional tactics intended to garner the designer as many column inches as possible for the least outlay on their part.

In 1974, following the collapse of the Lovable organization in America, Gibb and Franklin had to find themselves a new backer. Rock promoter Bryan Morrison later told the *Daily Express* that he considered Gibb to be, 'one of the best three or four designers in the world. He could have become one of the biggest fashion names ever.'[8] Gibb told Baker in an interview for *Ritz* magazine, 'It was fortunate, when I started with Bryan, because I had already been kind of established, so it was just a case of continuing what I was doing.'[9] The first show under the new management was presented at Morrison's OMK Gallery, not far from the new Bill Gibb store situated at 138 New Bond Street. Franklin remembers Morrison as, 'a very good entrepreneur because he would leave you alone to be creative as you liked. Billy soared.'

In October 1975 the newspapers reported that Gibb had been forced to cancel his forthcoming show having caught hepatitis. 'Bill Gibb is … lying in bed while the rest of the fashion world shifts into top gear at the start of the Spring shows', wrote Suzy Menkes.[10] This didn't stop the designer getting front page coverage, however, when a month later Elizabeth Taylor was photographed wearing one of his designs – a flowing white ostrich-feather cape over a gold-winged Grecian dress of white silk jersey – at the *Evening News* British Film Awards at the New London Theatre. 'Billy was never affected by celebrity', says his sister Janet. Gibb recalled of his sessions with the film star, 'I go trailing up there [the Dorchester] with a handful of clothes. Usually go for a fitting at eleven, and come home at five o'clock. We just have a great time and maybe she buys one dress.'[11] On this occasion, Jessie Gibb remembers, 'Billy says to her, "You've worn the dress back to front, Liz", and she says, "Have I? Oh well, I'm a damn good actress."'

Gibb's understanding of the value of celebrity endorsement was prescient, pre-empting the important role that it would later develop in the fashion

Bill Gibb in bed, with
the bumblebee cushion
embroidered by
Nives Losani
British *Vogue*, November
1977 / **Norman Parkinson**

industry. 'He was ahead of his time', notes Christopher Bailey. 'Very early on he was dressing celebrities such as Rod Stewart and Twiggy. He realized the significance of that.' With a roster of glamorous clients that also included Marisa Berenson, Bianca Jagger, Meg Wynn Owen, Susannah York, Claire Bloom and Anouk Aimée, Gibb cleverly elevated these associations onto his catwalk.

It was his 10th anniversary collection on 18 November 1977 that was to make fashion history. So coveted was a ticket for a Bill Gibb show at this point in the designer's career that he was often forced to present his collections twice over, with morning and afternoon showings, to accommodate his ever-growing audience. 'I was sitting in the Royal Albert Hall one day', recalls Franklin, 'and I thought, "This is the location. We could get everybody in here for one big show."' Despite advice to the contrary Franklin pursued the idea with fervour.

'The Albert Hall will be buzzing…' promised the advertising literature, referencing the black and yellow bumblebee motif that had become Gibb's signature ever since Ernestine Carter had proclaimed, 'Bee for Bill Gibb!' On the night all 5,000 seats were filled for a fashion show that was to be like no other. It was eight years before Fashion Aid (the fashion industry's answer to Live Aid), which was held at the same venue and featured the work of 18 international designers. Staging the show in aid of the World Wildlife Fund and the Royal National Lifeboat Institution, Franklin went about recruiting the help of Gibb's celebrity clients and friends. Actors Anthony Valentine and Gerald Harper hosted the evening. The show opened with the orchestra of the Royal Marines School of Music and included songs by Linda Lewis and Pearly Gates. Then there were dance performances by Wayne Sleep, dressed as Olympic gymnast Olga Korbut, and Arlene Phillips' raunchy troupe Hot Gossip. They shared the catwalk with several half-naked men, draped in Gibb's new bedlinen range, and models who unveiled the designer's latest collection.

To celebrate Gibb's decade in fashion, the show was staged as a retrospective and featured newsreel footage of the past 10 years, compèred by Lord Birkett. 'I called in clothes from their owners and many even agreed to model them', says Franklin. The impressive roll-call included Eileen Atkins, Lesley-Anne Down, Polly James, Una Stubbs, Zoë Wanamaker, Judy Geeson, Millicent Martin, Hannah Gordon and Angharad Rees. 'It was amazing', remembers Jessie Gibb. 'You could not believe all the people who were there. Most of the family came down, long frocks and all the rest, and we sat in a box.' The show was followed by dinner at San Lorenzo, owners Mara and Lorenzo Berni closing the restaurant so the party could continue there into the early hours.

Bill Gibb with HRH Princess Margaret at the launch of the London Collections at the Intercontinental Hotel, *c.*1975 / **Clive Boursnell**

'But Billy was right', recollects Franklin. 'It was too big. I don't think the Brits like anybody being too successful, do they? Looking back, I think it was a great thing to have done but it was also a big burden to carry.' Later, at any mention of the event, Gibb would shudder at what he described as 'the audacity of it all'. He confided to fashion journalist Brenda Polan, 'I didn't enjoy the day at all. It was too much to handle. Four and a half hours. You should never do a retrospective until you are well into your career. Otherwise, it's tempting the gods.'[12]

Less than six months later, in April 1978, with debts reported to be in the region of £200,000, the business floundered again. 'The crunch came over a perfume deal and financial agreements', Gibb told Ann Chubb, a fashion journalist who had been a die-hard fan since she had seen his sketches at the RCA.[13] As Morrison and Gibb split, new backers – property investors Alfred

The Albert Hall will be buzzing...

Publicity material for Bill Gibb's 10th anniversary fashion show at the Royal Albert Hall, London, 1977

and Philip Fox – moved in. Despite a 15-year contract the business relationship was short-lived, lasting little over a year. Ian Jack later traced Gibb's unfortunate financial track record in *The Sunday Times*: 'Over the last 10 years Gibb has had two backers, men who had made money in pop music, art galleries and property. Both were experimenting with the fashion industry and both experiments failed. The fashion industry is notoriously undercapitalized. Its glamour has often attracted backers who see quick returns in the old combination of publicity plus novelty … even serious investors are not immune. The potential designer would do well to study the Bill Gibb story', he warns.[14]

Again it was Franklin who helped Gibb pick up the pieces. 'After that we did business but no shows. We were selling a tiny collection to a very small number of people but we were making a profit', explains Franklin. 'We sold to Harrods, Chic of Hampstead, Lucienne Phillips and Papillon and we had private customers. It worked very well. I continued to promote Billy with the Silk Council, for example, getting his clothes onto catwalks without actually having a catwalk show, which used to cost a crippling amount of money', she continues. 'But that wasn't enough for Bill. He needed his own show. He loved his clothes and he wanted them to be seen', reflects Franklin.

Although Gibb would have to wait until the mid-1980s for a return to the catwalk, the craving appeared hotwired into the designer's make-up. Gibb himself summed it up: 'It's a marvellous thing to feel that they [the audience] are there, digging what you're doing.'[15]

Bill Gibb and Kate Franklin being presented to HRH Prince Philip at the National Playing Fields Association Golden Jubilee Ball, 1975
Clive Boursnell
This occasion was chosen by Franklin to publicize Gibb's Spring/Summer 1976 fashion show

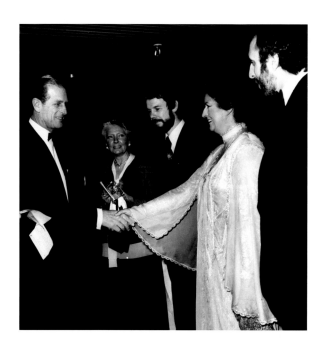

Onstage and backstage at Gibb's groundbreaking 10th anniversary fashion show at the Royal Albert Hall, London, 1977
Niall McInerney
Top left: fashion editor Lesley Ebbetts; centre left: Wayne Sleep (in red leotard); below right: singer Linda Lewis

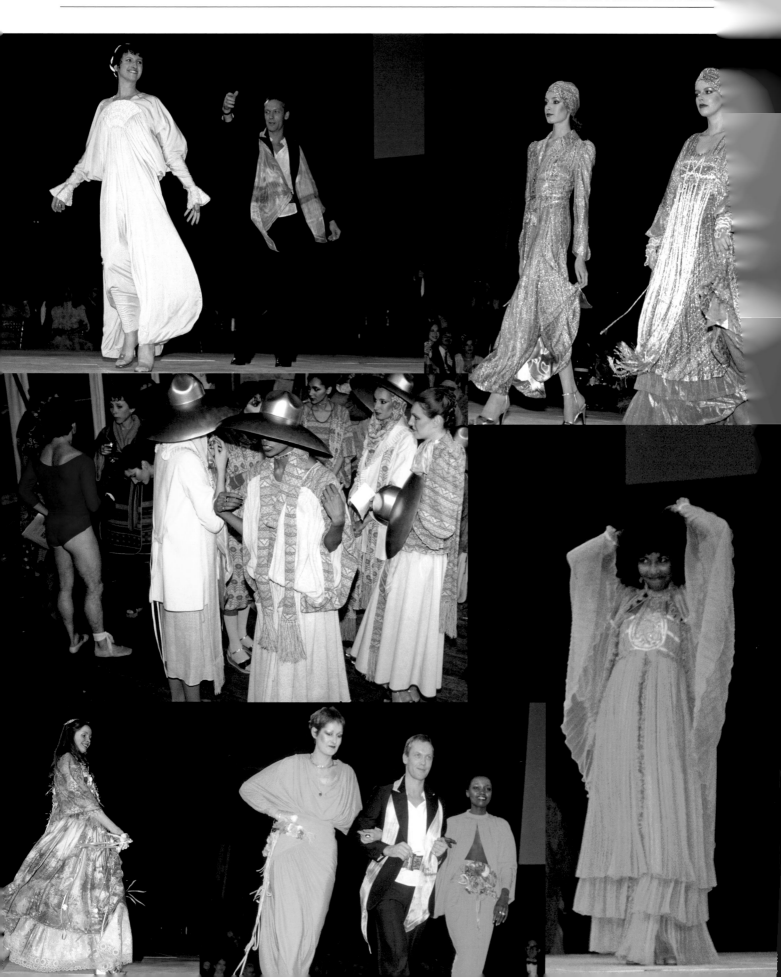

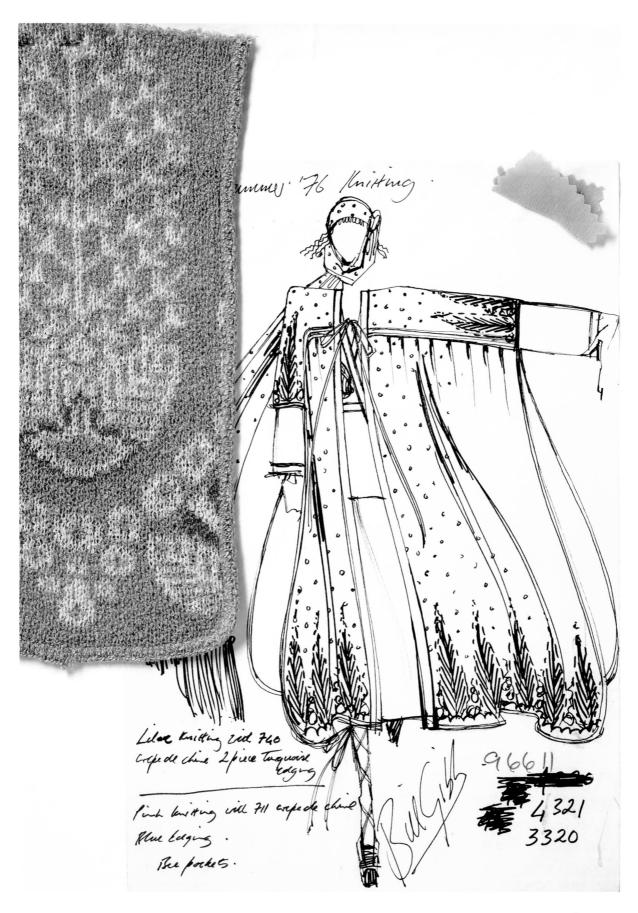

Summer '76 Knitting.

Lilac knitting with 740
crepe de chine 2 piece Turquoise
Edging

Pink knitting with 711 crepe de chine
Blue Edging.
Bee pockets.

Bill Gibb

96611
4321
3320

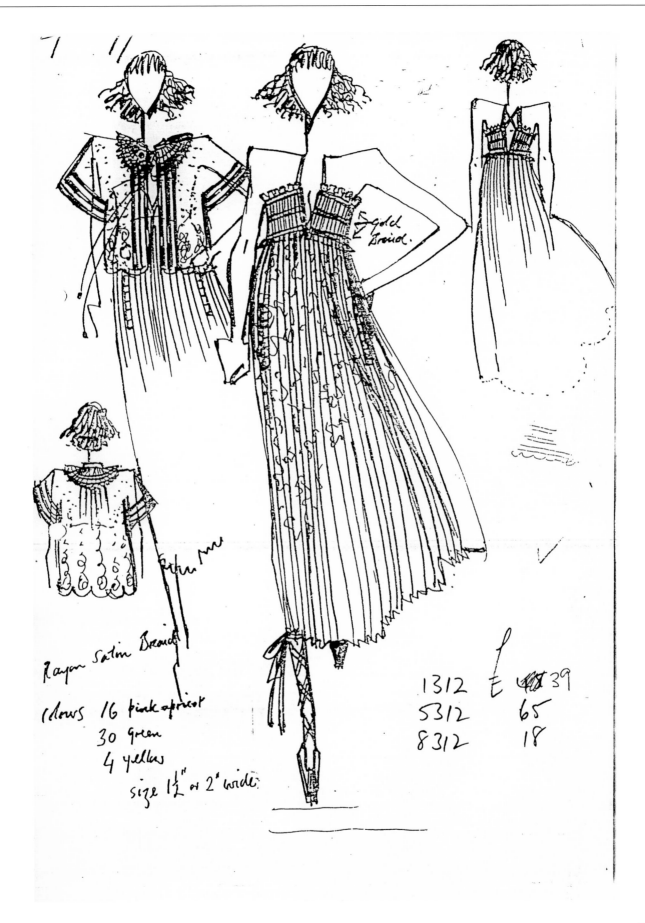

Rayon satin Braid

colours 16 pink apricot
30 green
4 yellow

size 1½" or 2" wide.

E gold
Braid.

1312 E 39
5312 65
8312 18

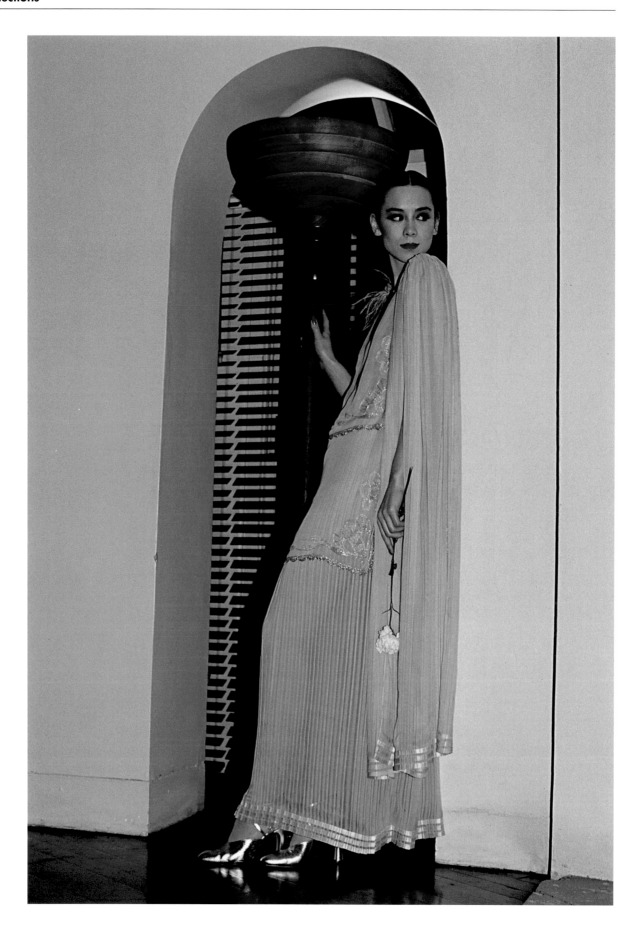

The collections

'Bill wanted his collections to be very different to everybody else's. Every time he started a new collection he would go away and study. I would ask, "Where are you off to, Bill?" and he would say, "I'm just skipping down to the British Museum. I want to look at one or two things"', remembers fashion designer John Bates. 'And "one or two things" would become the theme of the collection.' 'He would spend a lot of time in the V&A library', adds fashion consultant Brian Godbold. 'He wouldn't look at other designers' work, or the latest collections, to see what was going on. That didn't interest him. He'd only look at *Vogue* to see if another designer was getting more coverage than he was.'

Gibb didn't need to worry about getting his designs onto the pages of British *Vogue* and *Harpers & Queen*, however. After the furore surrounding his 40-piece debut show with its nature trail theme, the press now eagerly awaited the unveiling of his next collection. What would the story be this season? What trip would he take his audience on?

From the very start his designs for the fashion label Baccarat were meticulously researched and featured a variety of inspirational sources that included the tartans of his homeland, a scrap of antique furnishing fabric and maps of the world. His studies took him from the mountains of Peru to the courts of the Renaissance. 'I always work on a theme because I know there must be discipline', Gibb told British *Vogue*.[1] 'Picking the fabrics, making 200 rough sketches and boiling them down to 50 or 60. Sitting down in front of a blank sheet of paper is one of the most frightening things I know.'[2] He admitted that an integral part of Kate Franklin's role was to keep him focused. 'She knows that I need to be pushed', said Gibb, 'because I'll do anything rather than start a collection. Once I'm into it, I know that's it … I'll start getting that three-o'clock-in-the-morning urge, waking up with ideas and sketching them down, in case I forget them.'[3] He added: 'I go into a sort of coma for about three months. It's the only way I can get it all together.'[4] 'Billy was a very serious designer', explains Judy Brittain. 'Kaffe and I would see him sitting at the window by the shade of the light, in his Mickey Mouse specs, drawing and drawing and drawing. He knew exactly what he was doing, what he wanted to produce.'

As Gibb began to put together larger-scale collections, under the Bill Gibb Limited label, the process intensified. This suited him, however, as he was something of a self-confessed workaholic. 'Spare time frightens me', he said. 'I'm much happier when I'm doing things, creating. That's where I get my highs. Otherwise, I tend to fall into all kinds of fantasies and anxieties about people and life … it's a constant questioning that I go through.'[5] Kaffe Fassett remembers that he was also strangely secretive about his work. 'If you walked in while he

Column of peach pleats by Bill Gibb, modelled by Tina Chow, Spring/Summer collection, 1976
British *Vogue*, 1 April 1976
David Bailey

Previous pages:
Ethnic printed alpaca wool design by Bill Gibb for Baccarat, Autumn/Winter collection, 1971.
'Peru, in the steps of Cecil Beaton's Bolivian aunt...', British *Vogue*, August 1971 / **David Bailey**

was working, he would throw a cloth over the table so you didn't see what he was doing', he says. 'That used to amaze me, that sense of secrecy. But he was always working. Even if he was out at a nightclub he would be looking at people's shoes, or the strange way those stockings went with that skirt.' 'Billy would go into himself and out would flow all these designs. For every collection I reckon he'd have about five brilliant ideas', says Franklin. 'He'd always find a hook to hang it on. Whether it was a piece of porcelain or an Aztec pattern, there was always a hook.'

For his second collection, Spring/Summer 1973, the hook was water. Gibb crafted dramatic liquid drapery from creamy Qiana jersey, a fabric he worked with continually throughout his career. The collection was awash with long gowns featuring flamboyant batwing sleeves, flowing cape coats, oil-on-water marbled leather (by Ellen and Robert Ashley), shell motifs, scalloped hems and seed pearl embroideries. Tightly fitted jackets that flared into full, tiered, pleated skirts were cut from multi-coloured Lurex that sparkled like the sun glinting across a Scottish loch. Again Gibb's dresses made for striking photographs. 'My favourite picture is of Charlotte Rampling, modelling a Bill Gibb, with a leopard', says fellow Scotsman Steven Philip, owner of Rellik, the fashionable west London vintage store that still trades in Gibb originals. 'I love the layers, the fact that there are more skirts to go underneath. It's the ultimate in glamour, exotic and exclusive. It makes me think of a party in a private villa in Marrakech.'

Gibb's notion of glamour was not always as predictable. When the designer travelled through Morocco by train with Fassett he was charmed by the way the locals dressed, 'how they would put on what looked like the most amazing shimmering evening clothes to go out and work in the fields', says Fassett. 'Silver brocades with fuchsia and peach, gossamer finery with funny plastic shoes. That kind of combination absolutely fascinated Billy.' 'I always worry about repeating myself too much', said Gibb. 'I still love doing weird things. I love surprises. I love having a model come down the catwalk, very demure, and suddenly a great flash of leg or something.'[6] He later told *Flair* magazine: 'Details are very important. I like to design clothes with a lot to them, clothes one's continually discovering new things about ... "Gosh, I didn't know that was there!"'[7]

Bill Gibb in his flat, c.1974

Something that has often been overlooked in the hullabaloo of pattern, print and texture was Gibb's exceptional forte for line and form. His precisely executed black-and-white pen and ink sketches underline the total clarity of the designer's vision. 'Although his clothes were very decorative they still had innate good taste', says Franklin. 'If you look at his clothes from the back or the front, every detail is always thought right through.' It has been suggested that Gibb could have presented a show that solely featured his work-in-progress toiles, the samples made in cheap cream calico before the design is actually cut from the expensive fabrics and any extraneous embellishment added. Certainly this would have illustrated the designer's confident command of shape and structure along with his mastery of what he described as, 'the arithmetic of design'.

The odd juxtaposition of voluminous and skinny silhouettes was to become another Gibb trademark. 'He loved tight things that were pulled over something bigger underneath', says Sally Pasmore. 'I used to get stopped by people in the street who would ask me what I was wearing and where could they get it. His clothes had an extraordinary effect. They were very desirable.'

From the beginning Gibb's career was all about contrasts. 'To say that Bill's two greatest gifts are his consistency and his originality might sound a contradiction', Prudence Glynn wrote during one show review, 'but it is really the only way to describe his talent. Every Bill Gibb collection is categorically his own. The touches are unique, the juxtaposition of fabrics regularly amazing, and the distribution of volume of the fabric superb. At the same time his collections are consistent in their brilliance of imagination while each is new and different from the one that went before.'[8]

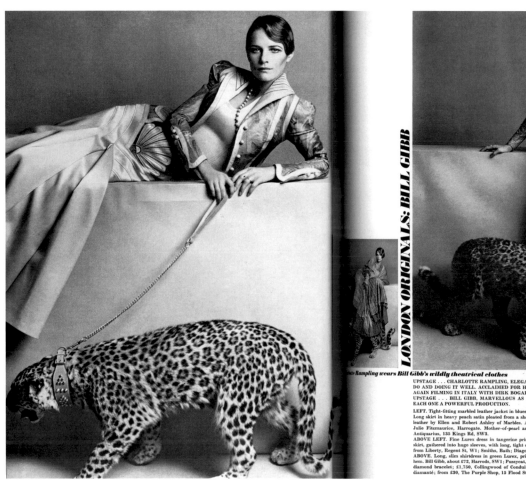

PHOTOGRAPHS BY BARRY McKINLEY

LONDON ORIGINALS: BILL GIBB

Charlotte Rampling wears Bill Gibb's wildly theatrical clothes

UPSTAGE . . . CHARLOTTE RAMPLING, ELEGANT INDEPENDENT, DOING WHAT SHE WANTS TO DO AND DOING IT WELL. ACCLAIMED FOR HER PERFORMANCE IN 'THE DAMNED' . . . SHE IS AGAIN FILMING IN ITALY WITH DIRK BOGARDE IN 'THE NIGHT PORTER'.
UPSTAGE . . . BILL GIBB, MARVELLOUS AS EVER WITH THESE GRAND-OCCASION CLOTHES, EACH ONE A POWERFUL PRODUCTION.

LEFT. Tight-fitting marbled leather jacket in blues/greens/yellows, with embroidered collar in peach satin. Long skirt in heavy peach satin pleated from a shell-shaped panel, with sleeveless matching top. Marbled leather by Ellen and Robert Ashley of Marbles. About £224, available late March from Harrods, SW1; Julie Fitzmaurice, Harrogate. Mother-of-pearl and amber beaded necklace; £11·50, Butler & Wilson, Antiquarius, 135 Kings Rd, SW3.
ABOVE LEFT. Fine Lurex dress in tangerine printed with blues/yellows/greens, pleated into a three-tier skirt, gathered into huge sleeves, with long, tight cuffs from the elbow (see cover). Bill Gibb, about £224, from Liberty, Regent St, W1; Smiths, Bath; Diagonal, Guildford; Number One, Bishop's Stortford.
ABOVE. Long, slim shirtdress in green Lurex, printed with blues/greens/yellows; flared skirt scallops at hem. Bill Gibb, about £72, Harrods, SW1; Pussycat, York; Vicki, Cobham; Gaye Williams, Chigwell. Narrow diamond bracelet; £1,750, Collingwood of Conduit St, W1. Two long necklaces with cultured pearls and diamanté; from £30, The Purple Shop, 15 Flood St, SW3. For more shops, sizes and colours see page 124. 51

Satin and fluid jersey evening dresses by Bill Gibb, modelled by Charlotte Rampling, Spring/Summer collection, 1973
'London Originals: Bill Gibb', *Harpers & Queen*, February 1973 / **Barry McKinley**

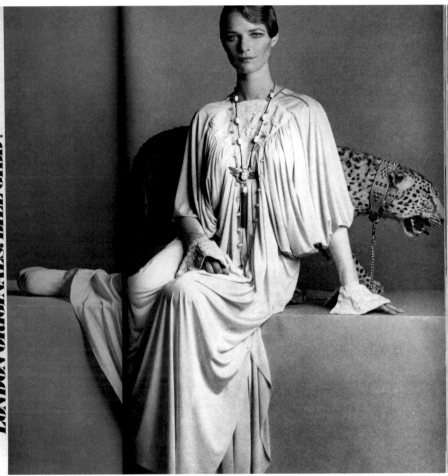

BELOW. Creamy-coloured high-priestess coat in silky Qiana jersey, with front panel and sleeves thickly embroidered with seed pearls, lace and mother-of-pearl. Underneath is a long slim slit skirt, embroidered halter top. Bill Gibb, about £310, available early March from Harrods, SW1; Helen Parker, Birmingham; Diagonal, Guildford. Shoes in gold snakeskin and cream satin; £28, Charles Jourdan, 47/49 Brompton Rd, SW3.
RIGHT. Soft Qiana jersey gathered from a shell-shaped panel into deep batwing oversleeves, slim undersleeves flare out into deep cuffs. Seed pearls and embroidery on cuffs and shell panel. Bill Gibb, about £120, available early March from Liberty, W1; Pussycat, York; Julie Fitzmaurice, Harrogate; Helen Parker, Birmingham. Long gold chain with feldspar beads, £25, and ivory bead necklace with winged scarab pendant, £17·50, The Purple Shop, 15 Flood St, SW3. Cream leather platform shoes with high vamp; to order from Chelsea Cobbler, 33 Sackville St, W1. Hair by Herta at Vidal Sassoon. Make-up by Clayton Howard of Max Factor.

Charlotte Rampling wears Bill Gibb's wildly theatrical clothes

LONDON ORIGINALS: BILL GIBB

PHOTOGRAPHS BY BARRY McKINLEY

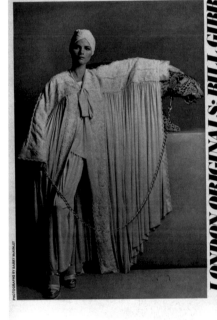

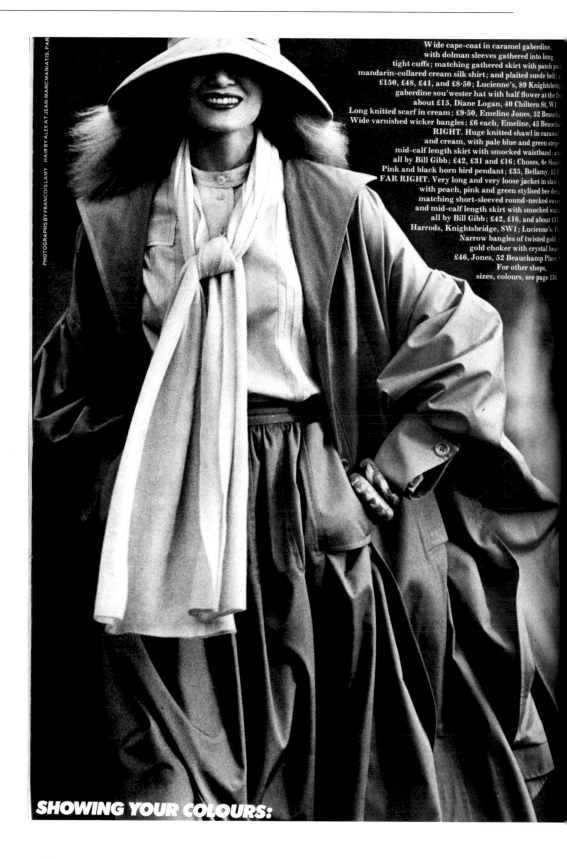

Wide cape-coat in caramel gaberdine,
with dolman sleeves gathered into long
tight cuffs; matching gathered skirt with patch po
mandarin-collared cream silk shirt; and plaited suede belt:
£150, £48, £41, and £8·50; Lucienne's, 89 Knightsbridg
gaberdine sou'wester hat with half flower at the fro
about £15, Diane Logan, 40 Chiltern St, W1.
Long knitted scarf in cream; £9·50, Emeline Jones, 52 Beaucha
Wide varnished wicker bangles; £6 each, Emeline, 45 Beaucha
RIGHT. Huge knitted shawl in caramel
and cream, with pale blue and green stripe
mid-calf length skirt with smocked waistband: an
all by Bill Gibb; £42, £31 and £16; Choses, 6c Sloan
Pink and black horn bird pendant; £35, Bellamy, 15 I
FAR RIGHT. Very long and very loose jacket in slate g
with peach, pink and green stylised bee desig
matching short-sleeved round-necked swea
and mid-calf length skirt with smocked wais
all by Bill Gibb; £42, £16, and about £3]
Harrods, Knightsbridge, SW1; Lucienne's: ()
Narrow bangles of twisted gold
gold choker with crystal hear
£46, Jones, 52 Beauchamp Place.
For other shops,
sizes, colours, see page 136

SHOWING YOUR COLOURS:

Architectural silhouettes from Bill Gibb's Spring/Summer collection, 1975
Harpers & Queen, February 1975 / **François Lamy**
Beyond the hullabaloo of pattern and texture Bill Gibb's forte was for line and form

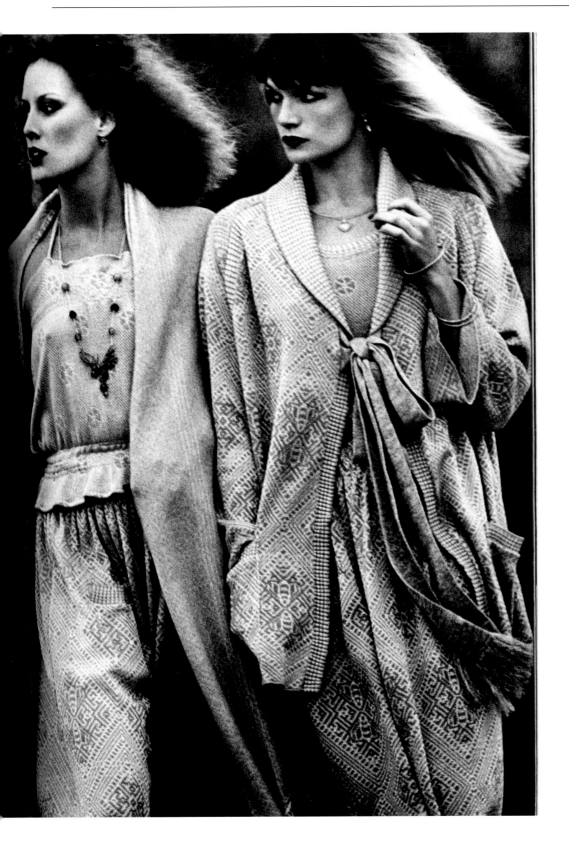

Michael Roberts (left) and
Bill Gibb (right), c.1973
Peter Phipps

In March 1973 Glynn sat next to Gibb at a grand dinner. She reported the occasion to her readers: 'We discussed whether fantasie (sic!) clothes were a dying thing. I feel that they are. So does he, and he is working on a calm, tailored (and in some cases much less expensive) new collection. Bill has a new assurance, I felt.'[9] This refined mood earned Gibb rave reviews for his Autumn/Winter collection. Michael Roberts, *The Sunday Times* fashion editor, described the collection as 'one of the season's biggest successes', adding that the line-up of cream wool suits trimmed with red fox on gauntlet cuffs, collars, capes and matching stoles was greeted with escalating enthusiasm by big store buyers. 'This brilliant collection justifies for once the use of superlatives. The look is disciplined, the cut decisive. It is fantasy redefined.'[10]

Gibb's silhouette offered neater, waisted jackets and below-the-knee skirts. These were accessorized with leather gloves and perky Schiaparelli-style hats by Diane Logan and correspondent shoes by Chelsea Cobbler. A series of slim-line knitted ensembles in muted grey, blue, purple and terracotta reinforced the feeling for 1930s elegance. Aside from a handful of *Gone With The Wind* frothy crinolines, the only ostentatious touch was Art Deco-style bumblebee embroideries and beadwork. In the *International Herald Tribune* doyenne Hebe Dorsey noted how Gibb 'has sobered up'. 'Nothing can be more powerful than a black or cream dress if the lines are right', said the designer.[11]

It wasn't long before Gibb did another volte-face. 'This season I am doing more prints and more colour', he told Ann Chubb,[12] who also reported on the launch of Gibb's new ready-to-wear range of knitwear, which he produced in 1974 in association with Fassett. 'I can't usually afford his couture-level pieces. So I'll be first in the queue', wrote Chubb excitedly.[13] Her choice: a geometric-patterned kimono cardigan for £16. This design was to become a Gibb classic. 'We used a small palm tree motif in the knitwear range. When we were travelling through Morocco I saw this little boy who was wearing a sweater with palm trees on it', says Fassett. 'I just took that idea and then there it was, on the catwalks in London.' 'They did very well with the knitwear', remembers John Bates. 'It was made up in England at a very keen price, so people could still afford a long scarf, or a hat, and say, "I have a Bill Gibb."'

1930s-inspired looks from Bill Gibb's Autumn/Winter collection, 1973
Clive Boursnell

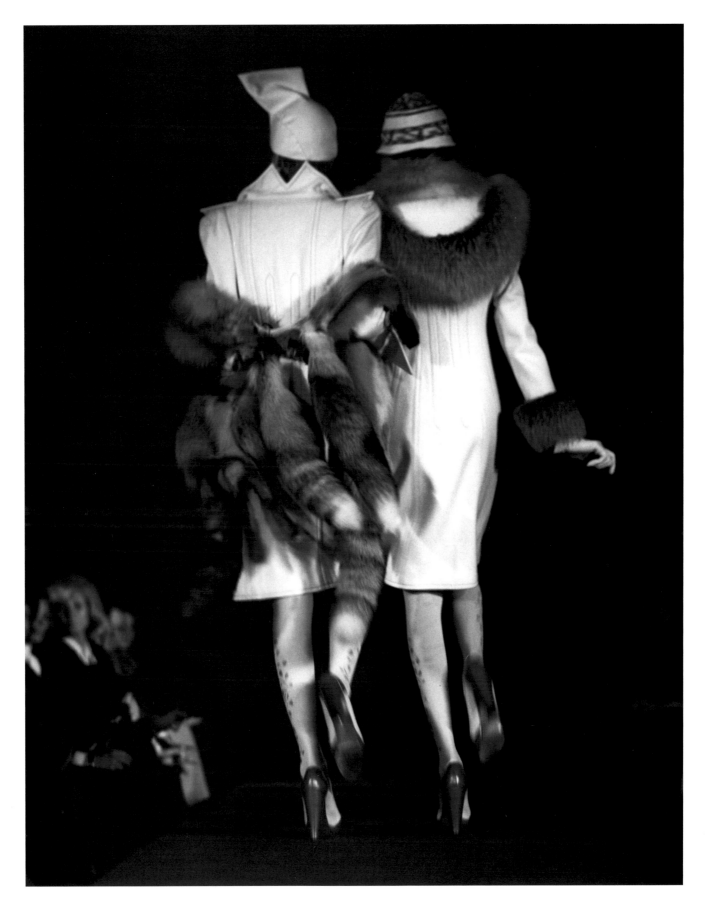

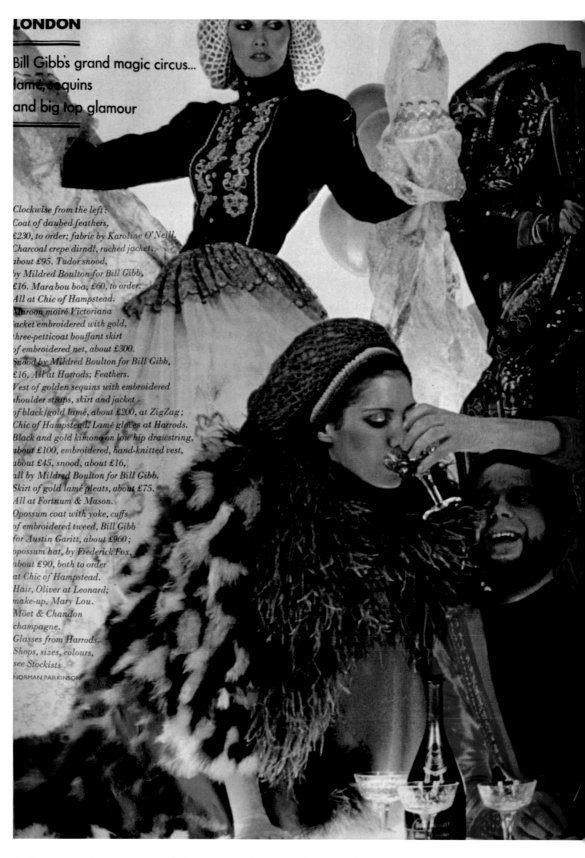

LONDON

Bill Gibb's grand magic circus...
lamé, sequins
and big top glamour

Clockwise from the left:
Coat of daubed feathers,
£230, to order; fabric by Karoline O'Neill.
Charcoal crepe dirndl, ruched jacket,
about £95. Tudor snood,
by Mildred Boulton for Bill Gibb,
£16. Marabou boa, £60, to order.
All at Chic of Hampstead.
Maroon moiré Victoriana
jacket embroidered with gold,
three-petticoat bouffant skirt
of embroidered net, about £300.
Snood by Mildred Boulton for Bill Gibb,
£16. All at Harrods; Feathers.
Vest of golden sequins with embroidered
shoulder straps, skirt and jacket
of black/gold lamé, about £200, at ZigZag;
Chic of Hampstead. Lamé gloves at Harrods.
Black and gold kimono on low hip drawstring,
about £100, embroidered, hand-knitted vest,
about £45, snood, about £16,
all by Mildred Boulton for Bill Gibb.
Skirt of gold lamé pleats, about £75.
All at Fortnum & Mason.
Opossum coat with yoke, cuffs
of embroidered tweed, Bill Gibb
for Austin Garitt, about £960;
opossum hat, by Frederick Fox,
about £90, both to order
at Chic of Hampstead.
Hair, Oliver at Leonard;
make-up, Mary Lou.
Möet & Chandon
champagne.
Glasses from Harrods.
Shops, sizes, colours,
see Stockists
NORMAN PARKINSON

Richly layered designs from Bill Gibb's Autumn/Winter collection, 1974
'Bill Gibb's grand magic circus', British *Vogue*, 1 September 1974 / **Norman Parkinson**

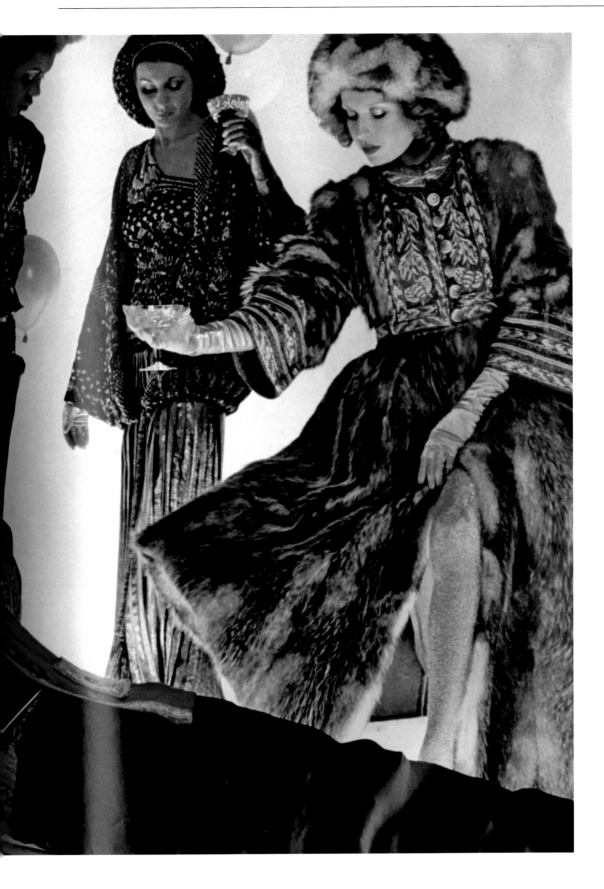

Knitwear designed by
Bill Gibb for his Autumn/
Winter 'Byzantine' collection
(detail), 1976

For Spring/Summer 1974 Gibb concentrated on daywear, with an emphasis on softness that suggested a sporty mood. The collection focused on blouson-backed jackets, skirts with extraordinary hip-encompassing pannier pockets and the absence of shoulder padding. There were variations on the shirtwaister and tea gown. Colours and prints echoed the illustrations of artist Léon Bakst and the influence of designer Paul Poiret.

Very often for his Autumn/Winter presentations Gibb would return to explore the ethnic maximalist mood. His 1974 collection was a particularly ravishing brew of rich layers. Complex patterned knits and tweeds were lavishly combined but it was the eveningwear that really provided fashion fireworks. *Vogue* called it 'Bill Gibb's grand magic circus … lamé, sequins and big top glamour'.[14] The credits listed a litany of glorious layers: a coat of daubed feathers (fabric by Karoline O'Neill) worn with a charcoal crêpe dirndl and ruched jacket; a maroon moiré Victoriana jacket embroidered with gold, worn with a three-petticoat bouffant skirt of embroidered net; a vest of gold sequins worn with a skirt and jacket of black and gold lamé; a black-and-gold kimono with a low hip drawstring and embroidered hand-knit vest (with a beaded bumblebee wing strap) by Mildred Boulton worn with a skirt of gold lamé pleats; and an opossum coat with yoke, cuffs of embroidered tweed (Bill Gibb for Austin Garritt) and a matching opossum hat by Frederick Fox.

Gibb is photographed with five models, some wearing knitted 'Tudor snoods' (also by Boulton), all supping Moet & Chandon champagne from cut-crystal glasses. The designer had every reason to celebrate, as his line-up of peasant princesses pre-dates Yves Saint Laurent's much raved about Ballets Russes-Opéra collection of Autumn/Winter 1976, which has gone down in the annals of fashion mythology. Once again Gibb failed to get the accolades he deserved. 'It was perceived as very English and eccentric', says Brenda Polan, then fashion editor of the *Guardian*. 'When you get someone like YSL doing it, then it's hot, it's international. British designers were doing it first but they were seen as eccentric. American journalists would say things like, "The trouble with London is it's all very pretty but you can't wear it."' 'Alas, none of these talented designers has behind them the half-million dollars that Saint Laurent's Russian collection is said to have cost', Ernestine Carter later acknowledged.[15]

Knitted 'Moon and Buddha' design from Bill Gibb's Autumn/Winter collection, 1975
'What An Idea: The harem suit…', British *Vogue*, 15 September 1975 / **David Bailey**

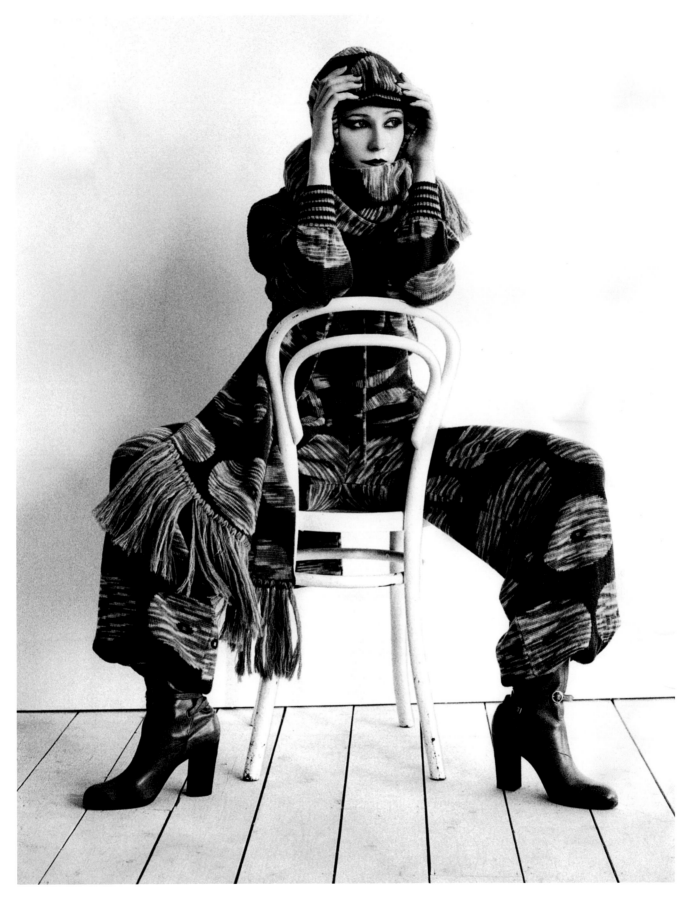

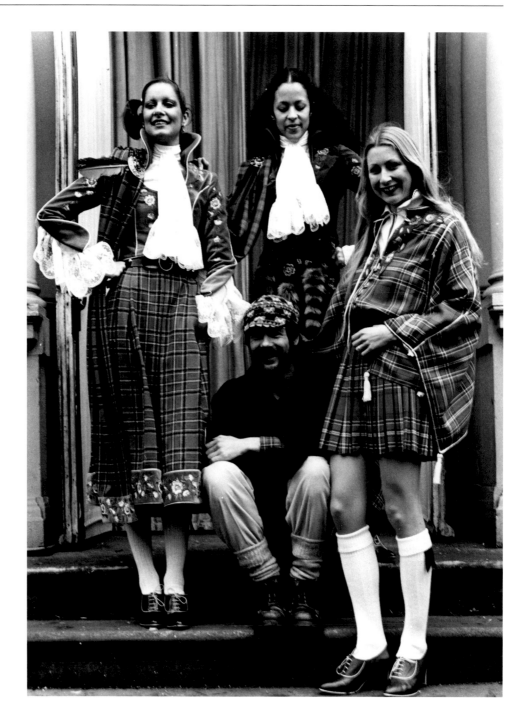

Bill Gibb with models wearing designs from his Autumn/Winter collection, 1977
Peter Phipps

Gibb's ardent supporters, such as Glynn, were always ready to defend the designer: 'Like all really strong designers Bill Gibb does some clothes that take a lot of wearing', she wrote in *The Times*, 'but it is precisely this initial strength that makes him so important. Only a shout can be heard in the current din. Any radical line will be modified for mass taste, and the problem with many designers is that they start out *sotto voce* and end up inaudible. Bill Gibb has made a fine speech, and one which many will listen to.'[16]

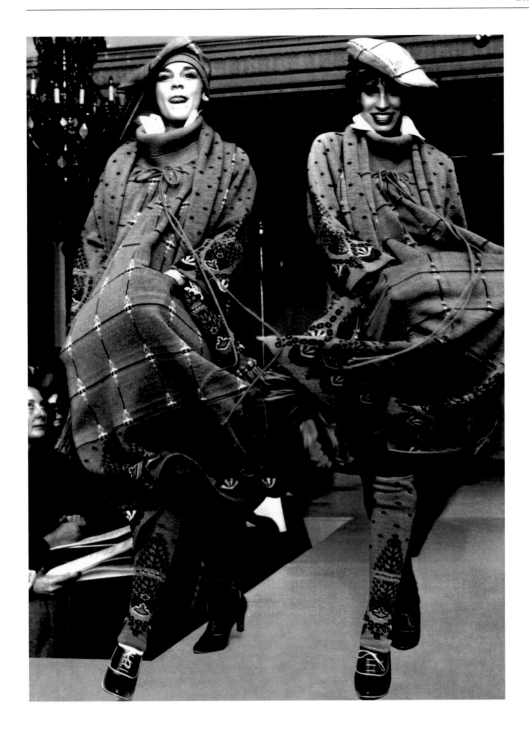

Knitted outfits from Bill
Gibb's Autumn/Winter
collection, 1977
Peter Phipps

Gibb's statement for Spring/Summer 1975 cleverly combined the bold and
the beautiful. The collection featured voluminous caramel gabardine raincoats (with
oversized sou'wester hats, again by Logan), exaggerated shirts and nightshift styles
in nursery pastels and deckchair stripes along with dainty meadowsweet chiffon
and lace designs. Another bucolic reference included embroidered ears of corn.
The show ended with a Pre-Raphaelite bride swathed in fans of pleated lace.

Poppy print, designed by Susan Collier and Sarah Campbell for Bill Gibb's Spring/Summer collection (detail), 1975

Gibb's collection for Autumn/Winter 1975 prompted British *Vogue* to ask: 'How about the knitted harem suit?'[17] This new ensemble, featuring a striking tapestry design by Fassett called Moon and Buddha, was shown in the magazine – a dark grey 'big collared, belted, buttoned sweater, trousers gathered onto cuffs, a mighty fringed muffler with pockets, hood and shoulder bag', all patterned with a distinctive orange-marmalade stripe and circle motif. It also came coloured mauve and lichen.

While Gibb's Spring/Summer 1976 collection offered light and airy Arabian stripes and sun-drenched pastels, knife-pleated columns and side-split tabards, it was his Autumn/Winter presentation for that year that prompted Helena Matheopoulos of the *Daily Express* to pronounce it, 'his best collection yet'.[18] The theme was Byzantium meets Aztec. 'It's emperors, it's mosaics, it's icons', she enthused. Gibb continued to plunder ethnic provenance, patchworking together colourful suede, embroidered leather and fun furs, djellabahs, gaucho pants and kimonos. Outfits made from silk scarves and saris added yet more opulence. 'The feel of fabric is terribly important', Gibb told *Flair* magazine. 'I love discovering new fabrics. In Germany I spotted yards of this foam-backed synthetic fur, used for old ladies coats – terrible. But I got the manufacturers to make it for me without the foam, and look, feel it now – it really flows.'[19] 'And if he liked the reverse side of the fabric he'd use it that way round', remembers Franklin, 'much to the annoyance of the manufacturer.'

By this time Gibb had created his own stylistic vocabulary but each season his melting-pot mind would throw something new into the mix. 'For next season', he said, when asked to describe his look for Spring/Summer 1977, 'I am going to do semi-sport separates, like a little boy, with shorts, something I've never done before.'[20] The invitation depicted a barefooted girl wearing a simple empire-line dress in a garden, surrounded by a garland of flowers. 'Women want to get into pretty clothes', he continued.[21] Gibb presented one of his most delicate-looking collections, combining his cute boyish styles with pastoral allusions – embroidered cheesecloth and lawn, broderie anglaise and crayon-striped white cotton – and sparkling sequins, fairytale frosted lace and organza party dresses. Even though he called this his 'Flowers and Lace' collection, Gibb's discerning eye ensured the look never became too sugary sweet by boldly punctuating the collection with splashes of black – a black satin bra-top here, seams framed in black braid there. 'I like a dress to have great richness; there are many ways to do this, like a black cat printed on the hem of a starkly white dress. Or I use black and white, possibly on a binding, next to a coloured patterned fabric', Gibb said. 'It's incredibly effective.'[22]

Gibb pursued this feminine mode for the launch of his first lingerie collection. 'I always wanted to design the sort of peignoirs that women dream about', he said. 'It's a culmination of all the luxurious lingerie I've always remembered in old

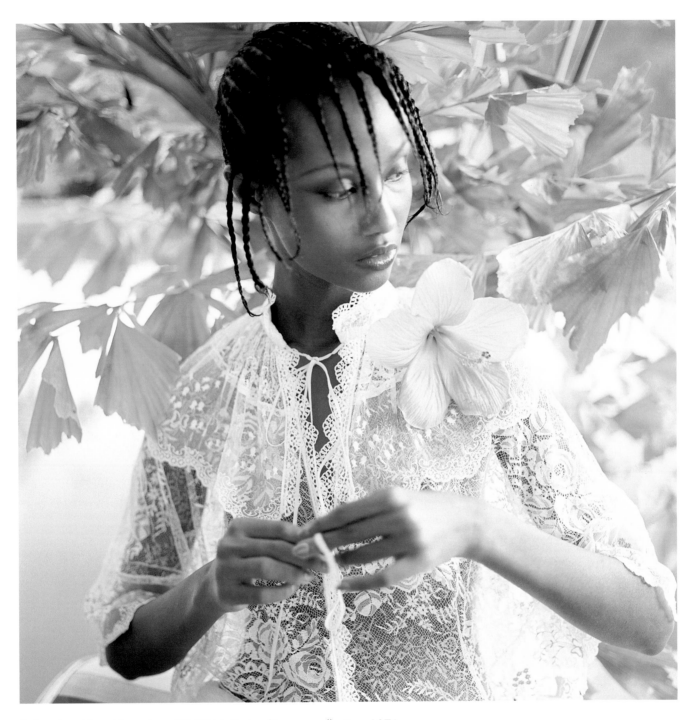

Embroidered lace blouse from Bill Gibb's Spring/Summer collection, 1976
'Go Tobago', British *Vogue*, May 1976 / **Norman Parkinson**

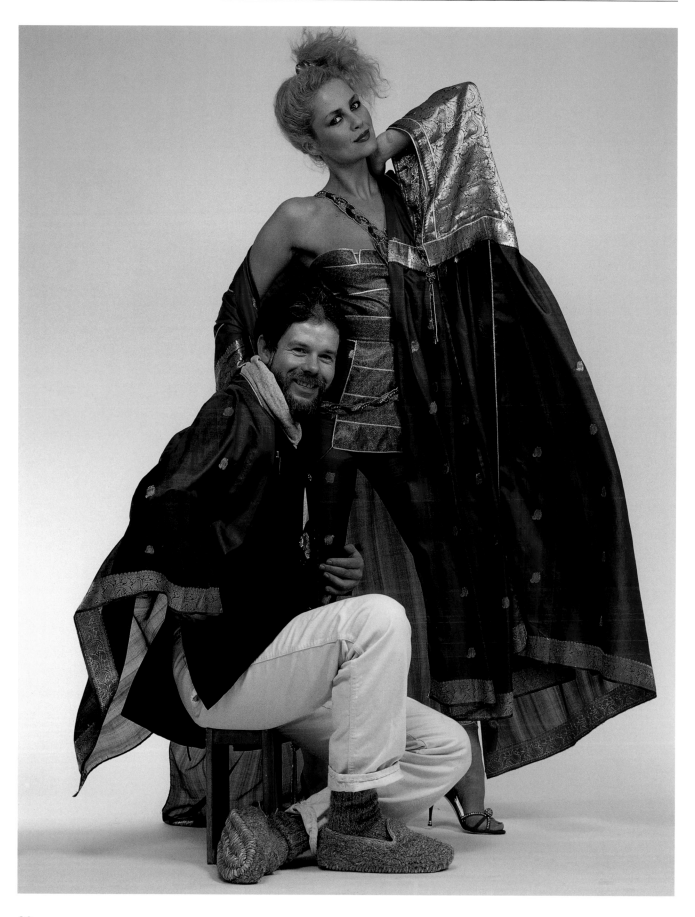

movies.'[23] The designer's intention for some of the exquisitely detailed underwear to be worn as eveningwear was again an idea ahead of its time.

For Autumn/Winter 1977 Bill Gibb presented a collection that was to divide the fashion press and demonstrate that the business of fashion is as subjective as any of the creative arts. 'SCOTLAND should be proud', bellowed Suzy Menkes from the pages of the *Evening Standard*. 'Bill took subdued tartans, made them into slim skirts, spiced them with flower embroidered velvet, wrapped them with fan pleated tartan shawls and topped them with pheasant feathers.' She went on to praise Gibb's latest look as, 'one of the strongest and most consistent he has ever done', calling it a 'return to his native roots … it is a beacon for British fashion.'[24]

Over at *The Sunday Times*, however, Michael Roberts launched a particularly acid attack on 'the Brit pack' with only Jean Muir and new name Bruce Oldfield escaping his wholehearted wrath. Referring to the season's penchant for 'the Rob Roy look', Roberts tore into Gibb's collection. 'With the fervour of a Scottish Frankenstein, he cobbled together Bonnie Prince Charlie's lace jabot and velvet doublet with Rob Roy's kilt and tartan throwover. He then topped it off with Harry Lauder's tam-o-shanter and Flora MacDonald's shawl, and (some sort of Macbeth witchery?) hung it all about with bits of dead animal. The whole thing then staggered down the catwalk to the lament of a Scottish piper. And lo, the Loch Ness monster.'[25] John Bates, who was himself a target of Roberts' pithy penmanship, remembers the effect it had on Gibb: 'He was really cut up about it. Bill was very concerned that people would like him and his work.' John Siggins, Bates' partner, felt that Ernestine Carter had the right attitude: 'If she didn't like something, she didn't write about it.' Regardless of this damning review the collection was fêted by the cognoscenti. British *Vogue* photographed two of Gibb's velvet suits – one red, one blue – on the McLean twins, the hot sister-act models that season.

The collection illustrated precisely how Gibb would often work laterally around his theme: the picture-postcard Scottish motifs – tartan, kilts and thistles – were accompanied on the catwalk by bright red and gold sari eveningwear, straight out of the British Raj. Yet the reference to Scotland was still threaded through: paisley designs may have hailed originally from Kashmir but they were adopted by the Renfrewshire town that gave the swirly-shaped motif its name and supplied the shawls that became so popular in the nineteenth century. 'He had a wonderful, romantic, Celtic quality, a rich imagination quite different from an Anglo-Saxon one', Jean Muir told British *Vogue* .[26]

And it cannot be denied that the designer's heritage played a strong influence on his work. 'I had been going to the tartan mills [for] most of my childhood and I promised myself that, if I had the opportunity, I would use tartans', Gibb proudly told a reporter from the Aberdeen *Press and Journal*.[27]

Bill Gibb with model
at a silk promotion at
Liberty's, London, 1979
John Adriaan
Indian saris provided another
source of inspiration for Gibb

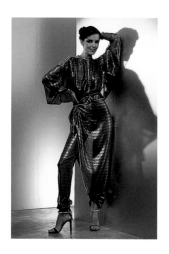

A glittering evening outfit
from Bill Gibb's Spring/
Summer collection, 1979
John Adriaan

'I think my inspiration has probably come from the western Highlands – but who knows. Something here [Fraserburgh] might have influenced me. The Broch [the local name for the area] and the North East have an earthy look. Even as far as colour is concerned, I don't like things to be too crisp. I quite like those sort of peaty, muddy colours.'[28] It was not just in the rolling countryside that Gibb found inspiration. Any visitor travelling through the city of Aberdeen cannot fail to notice that the colours of the granite buildings tinged with lilac, pink, pistachio and sky blue chime with the subtle shaded palette favoured by the designer.

Perhaps more affected by the drubbing he received in *The Sunday Times* than he cared to admit, Gibb did not present another major themed collection until his Bronze Age show 1985. Between the two the designer was to experience devastating financial upsets and the onset of illness. In the spring of 1979 fashion editor Lesley Ebbetts reported in the *Daily Mirror* that the new financial backing of Alfred and Philip Fox would finally allow Gibb to 'turn his fantasies into real life fashion'. She explained how the pair of businessmen intended to take the production and selling of the collection out of Gibb's hands so that he might concentrate on creating a brand that would reach a wider audience, beyond the faithful fashion pack and glitterati. 'ELEVEN COLLECTIONS', she wrote. 'A fur collection, suede and leather collection, four knitwear collections, his latest, less expensive rtw [ready-to-wear] collection, a menswear range, his usual sensational couture collection and two export ranges. There really is something for everyone … from £25 to £7500.'[29]

Although billed as 'one of his most commercial collections', this show lacked the drama and pizzazz that had previously caused celebrity clients to swoon in their seats and had hardened journalists reaching out to touch the hem of a skirt as a model twirled past them. This was the stuff of fashion history and for which Gibb will be remembered. 'Once in a blue moon, a collection comes down the catwalk – Galliano does it – and you are just moved by the beauty of it', explains Polan. 'And that's to do with the richness of the references … it's exciting … that was Billy at his best.'

Blouson-backed jacket and printed skirt from Bill Gibb's Spring/Summer collection, 1974
British *Vogue*, January 1974 / **David Bailey**

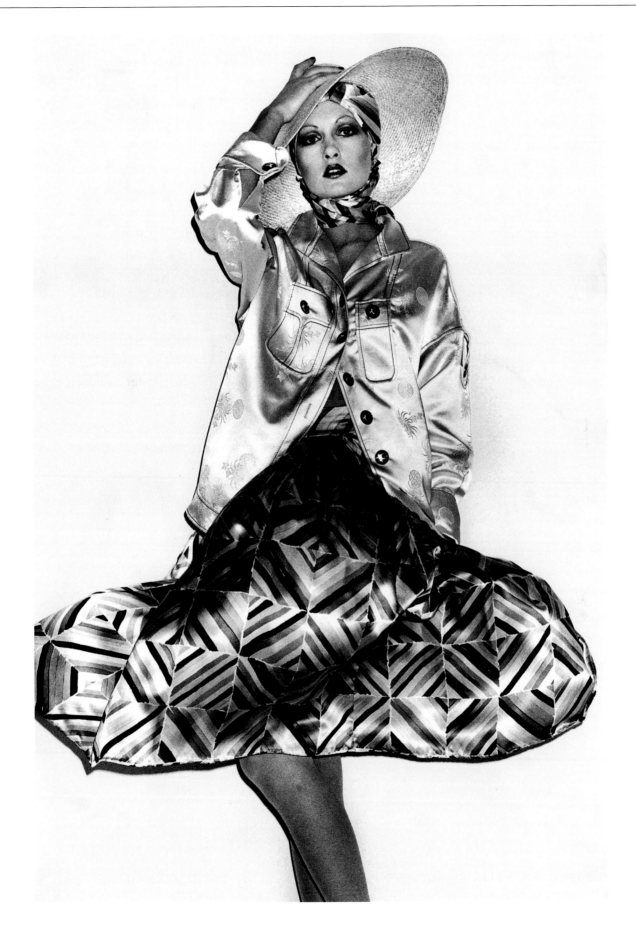

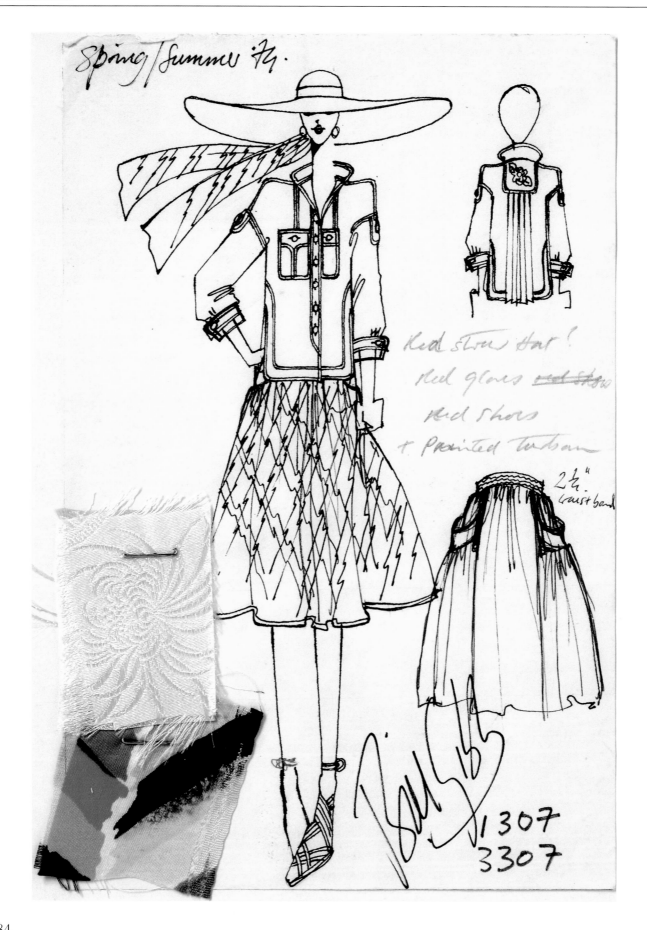

Spring/Summer '74.

Red straw Hat!
Red gloves ~~red straw~~
Red shoes
+ Painted Turban

2½"
waistband

1307
3307

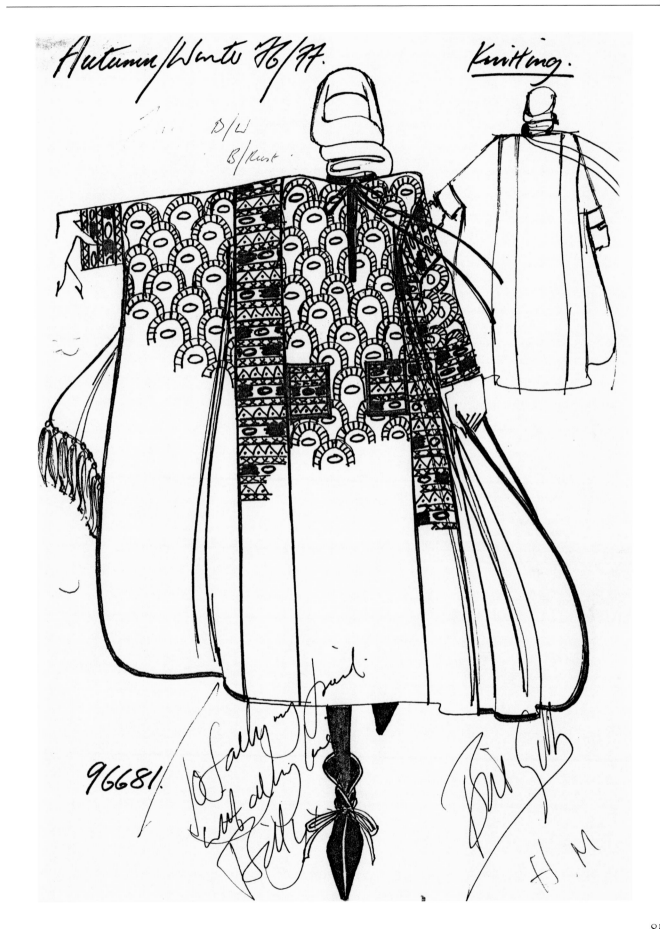

Autumn/Winter 76/77.

Knitting.

D/W
B/Rust.

96681.

To Sally my friend
with all my love
Billy

Bill Gibb

H.M

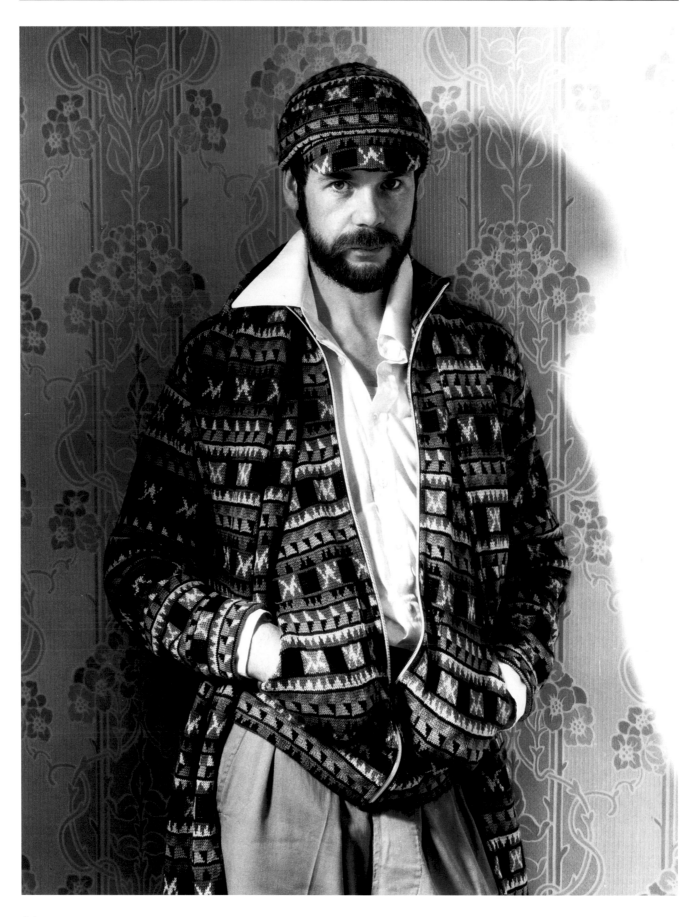

The collaborator

'An integral part of his special talent was a generosity of nature that elicited loyalty and friendship from everyone who worked with him', wrote Beatrix Miller after the designer's death in 1988.[1] It was a particularly astute observation that succinctly encapsulated Gibb's magnanimous disposition. For a man so fêted, Gibb was almost indifferent to success. He cared little for the trappings of fame or fortune and was happier singing the praises of those working with him than taking the applause himself. In a conversation with Mick Rock (who still refers to the designer as, 'one of my favourite people'), Gibb stressed the importance of his 'work-mates', crediting them with his success.[2]

One of these was Nives Losani, Gibb's pattern-cutter, who joined him after answering an advertisement for a job at the Alice Paul boutique. Losani became one the central members of Gibb's team. 'There were a lot of people working for him then', she says. 'There were times when he had no money and we didn't get paid, but it was always a pleasure to work for him, even if it was just to help him out.' Gibb once said: 'I know how I work, I know the best way I can work and it is through all that funny tension and carry-on. It's the same with my pattern cutter. She [Losani] is really an artist at heart, she's got the same temperament, everything at the last moment. The great rush is on, she's lined up with five packets of fags and two gallons of coffee, and she is staying up all night before the collection, churning it out and I am going nuts thinking, "It's never going to happen."'[3]

Losani admits that her methods were rather more calculated and pragmatic than Gibb might have imagined. 'We always worked until the very last minute', she says, 'but the main reason was because I don't like to keep clothes hanging around for too long. If you finish the clothes too quickly, designers always want to change things.'

Gibb's often challenging and intentionally dense ideas were precisely conceived and impeccably illustrated in his original working sketches, on occasion scribbled directly onto the cutting table, thereby making it easier for his team to produce the desired effect. Losani was struck by the designer's remarkable capacity to visualize exactly how he wanted an outfit to look. 'He was so particular, with the buttons, the braids. Everything had to be right', she says. 'Some dresses were quite difficult to make, but he would say, "Nives, nothing is impossible" – and it never was', she says. 'I would always find a way.'

The pair quickly developed a shorthand form of communication. Rather than make a calico sample with which to trial a design, which would then be shown to Gibb for approval and alteration, Losani would often cut directly into the preferred, invariably expensive, fabric. Their rapport was unique. 'She knows me inside out', said Gibb.[4] Indeed, of the many drawings by Gibb that Losani

Bill Gibb wearing knits
from his Autumn/Winter
'Byzantine' collection, 1976
John Adriaan

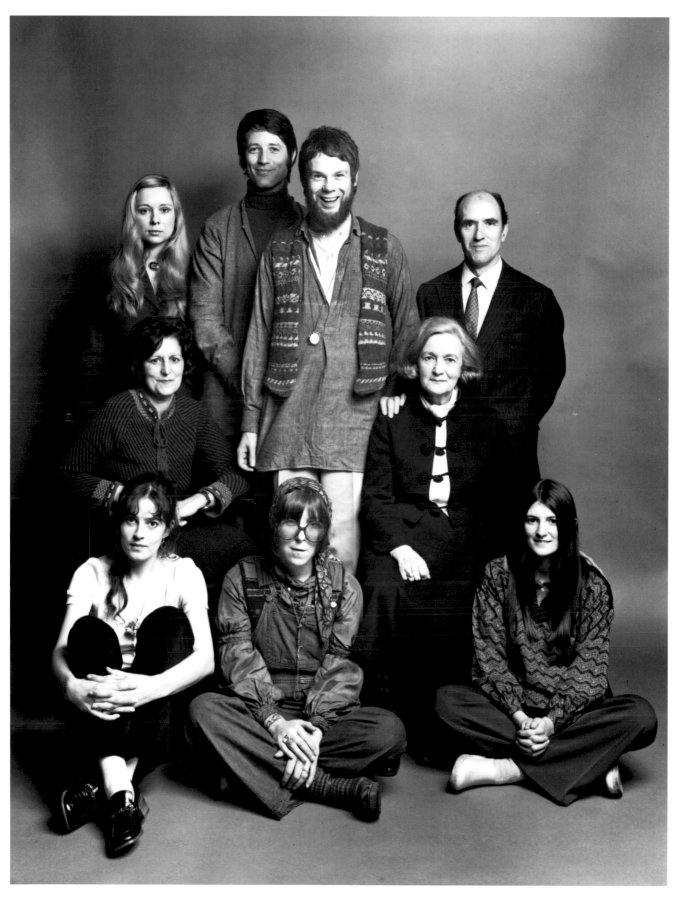

Bill Gibb with Nives Losani,
c.1972 / **Clive Boursnell**

still treasures there is one, inscribed by the designer, that perfectly sums up their relationship. It reads simply: 'To Nives, my extraordinary shadow'. Losani showed her affection with a gift for Gibb on his 33rd birthday: a cushion lovingly embroidered with as many bumblebees.

Another faithful team member was Albert Purton, who Gibb had poached from the workrooms of Baccarat. Purton, described in the *Glasgow Herald* as 'wise cracking incessantly in a quiet, dry voice',[5] provided the tailoring expertise that became the backbone of Gibb's dramatic silhouettes. His forte was the striking leather ensembles and elegant structured suits. Peter Wright was another cutter in the workroom as was Pauline Parsons, who worked on many of the ballgowns and bridalwear.

As knitwear formed such an important part of the designer's fashion statement Mildred Boulton was central to the set up. It was Boulton who would interpret on her knitting machine the groundbreaking one-off designs produced by Fassett and Gibb, designs that would use up to 20 different colours and separate threads. Once orders began to flood in, this method of working proved neither economic nor sustainable, so in 1974 the company took a huge step forward by collaborating on a more commercial level with Harry Green of Gould's in Leicester. Green is said to have laughed when he first saw the complicated and often raggle-taggle samples presented by the pair but eventually embraced the challenge and, determined to create just the right effect desired by Fassett and Gibb, worked hard to translate and produce their designs, tirelessly dyeing wools until they were a perfect match for Gibb's imagination. Boulton continued to work with Gibb, however, producing hand-knitted couture designs and many of the knitted hats that accessorized the looks.

Perhaps befitting a man who used a bumblebee motif as a trademark, Gibb was once described as a 'honeypot' around whom swarmed loyal admirers and talented individuals. Whatever his financial situation Gibb was staunchly supported by high society patrons including Sir Nicholas and Lady Henderson and Viscountess 'Bubbles' Rothermere, Lady Pamela Harlech, Jan de Villeneuve and Tessa Dahl. His workrooms were always a hectic hub of imagination and originality. 'Young creative people were inspired by Bill', says Franklin. 'They would come to his door with a multitude of ideas which he would incorporate into the collections.' Some were former art students, many of them ex-graduates

Gibb with his extraordinarily talented team, 1972
Terence Donovan
Clockwise from centre back: Bill Gibb, Albert Purton, Mildred Boulton, Sue Kemp, Sally MacLachlan, Alison Combe, Kate Franklin, Valerie Yorston, Kaffe Fassett

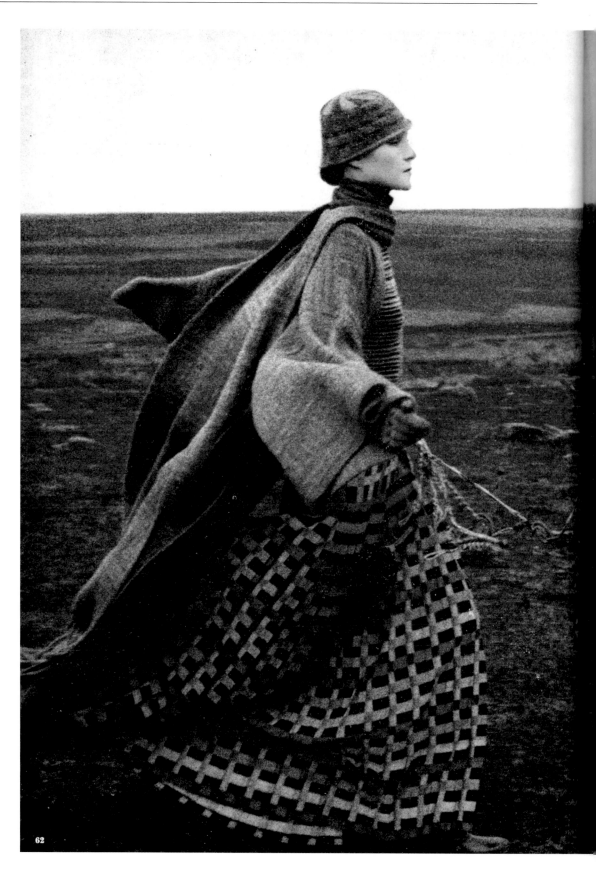

Knitted outfits from Bill Gibb's Autumn/Winter collection, 1973

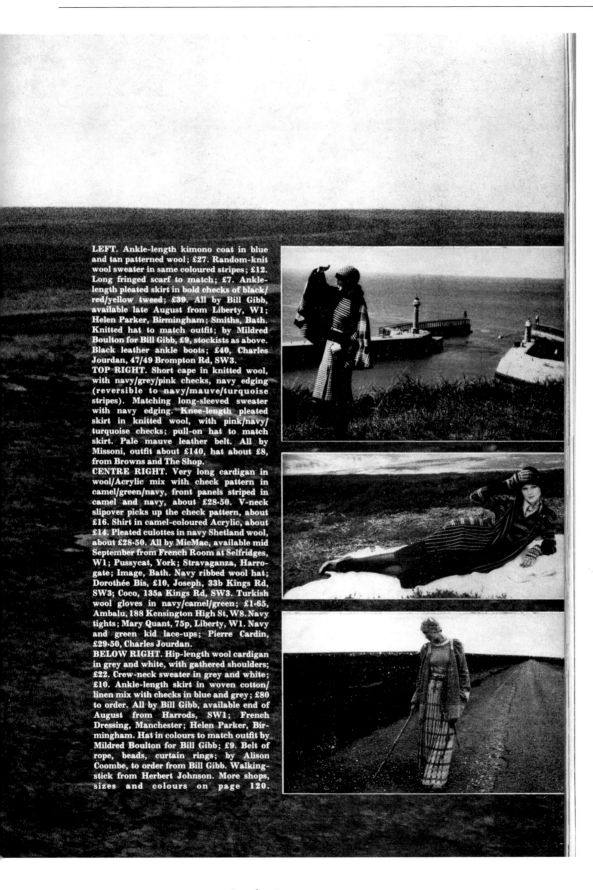

LEFT. Ankle-length kimono coat in blue and tan patterned wool; £27. Random-knit wool sweater in same coloured stripes; £12. Long fringed scarf to match; £7. Ankle-length pleated skirt in bold checks of black/red/yellow tweed; £39. All by Bill Gibb, available late August from Liberty, W1; Helen Parker, Birmingham; Smiths, Bath. Knitted hat to match outfit; by Mildred Boulton for Bill Gibb, £9, stockists as above. Black leather ankle boots; £40, Charles Jourdan, 47/49 Brompton Rd, SW3.

TOP RIGHT. Short cape in knitted wool, with navy/grey/pink checks, navy edging (reversible to navy/mauve/turquoise stripes). Matching long-sleeved sweater with navy edging. Knee-length pleated skirt in knitted wool, with pink/navy/turquoise checks; pull-on hat to match skirt. Pale mauve leather belt. All by Missoni, outfit about £140, hat about £8, from Browns and The Shop.

CENTRE RIGHT. Very long cardigan in wool/Acrylic mix with check pattern in camel/green/navy, front panels striped in camel and navy, about £28·50. V-neck slipover picks up the check pattern, about £16. Shirt in camel-coloured Acrylic, about £14. Pleated culottes in navy Shetland wool, about £28·50. All by MicMac, available mid September from French Room at Selfridges, W1; Pussycat, York; Stravaganza, Harrogate; Image, Bath. Navy ribbed wool hat; Dorothée Bis, £10, Joseph, 33b Kings Rd, SW3; Coco, 135a Kings Rd, SW3. Turkish wool gloves in navy/camel/green; £1·65, Ambalu, 188 Kensington High St, W8. Navy tights; Mary Quant, 75p, Liberty, W1. Navy and green kid lace-ups; Pierre Cardin, £29·50, Charles Jourdan.

BELOW RIGHT. Hip-length wool cardigan in grey and white, with gathered shoulders; £22. Crew-neck sweater in grey and white; £10. Ankle-length skirt in woven cotton/linen mix with checks in blue and grey; £80 to order. All by Bill Gibb, available end of August from Harrods, SW1; French Dressing, Manchester; Helen Parker, Birmingham. Hat in colours to match outfit by Mildred Boulton for Bill Gibb; £9. Belt of rope, beads, curtain rings; by Alison Coombe, to order from Bill Gibb. Walking-stick from Herbert Johnson. More shops, sizes and colours on page 120.

Harpers & Queen, August 1973 / **Andre Carrara**

Detail of silvered bee
embroidery by Sally
MacLachlan, Autumn/
Winter collection, 1972

of the Royal College of Art, who specialized in textile printing, weaving, embroidery and other crafts. From the outset many of Gibb's designs might feature the work of up to four or five different collaborators in one outfit alone, which was one of the reasons why the designer's clothes carried such hefty price tags and were often viewed as demi-couture. The handcrafted work of this group of talented artisans often prohibited mass production. Nevertheless, time and time again throughout his career Gibb would enlist their creative expertise. 'I never tell them what I want', Gibb told *Flair* magazine. 'I suggest things.'[6]

When the designer's clothes were featured in magazines each collaborator would be correctly credited. For instance, Sally MacLachlan, who screen-printed gloriously silvered patterns onto the leather pieces in the designer's debut collection and created the stylized birds-in-flight motif alongside more naturalistic ornithological designs on chintz; Sue Kemp, who handpainted silk with delicate landscape designs and a hedgerow full of furry animals; Ellen and Robert Ashley of Marbles, who created swirling silks and leathers; and in a later collection Robin Renwick, who handpainted silk scarves.

Gibb also favoured fabrics from Liberty, often designed by Susan Collier and Sarah Campbell. 'He was a great working companion', remembers Collier, 'because he embraced every development and was very responsive during the whole process. I remember him even taking one print and turning it upside down. We were rich in ideas and imagery and Bill loved that', she continues. 'It was the ideal partnership.' Gibb also used prints designed by Bernard Nevill, who had lectured the designer at the RCA.

Another RCA graduate, who worked with Gibb from the mid-1970s, was Janet Taylor. 'People were drawn to him', she says. 'It was chaotic but we enjoyed ourselves, it was fun. I loved working with Billy. He would have a specific idea or theme', says Taylor. 'Sometimes he'd show me a fabric and say, "Well, if I cut it like this" We'd then decide together how a print might work in that particular instance. We'd inter-relate things.' Gibb's seasonal colour palette was sometimes taken from the knitting samples of Boulton and Fassett. Taylor continues: 'With colour, he would say, "It's going to be orange and yellow, stronger than yellow ochre, and a funny greeny brown." Whether it was pattern, or colour, he had very definite ideas when designing.'

Taylor's prints echoed Gibb's love of the abstract and the natural world – the bee motif, frogs on a lily pad, or poppies in a cornfield that became a stylized stripe. She created a special print to commemorate the Queen's Silver Jubilee in 1977 that included roses, thistles, birds and butterflies. Bianca Jagger later wore a kimono patterned with the same print – 'it was held together with a safety-pin', laughs Taylor. The textile designer also handprinted and produced the wallpaper, bedlinen, drapes, throws and cushions in the flat that Gibb shared with John Kobal, all of which featured a woodblock design of bunches of grapes, vine

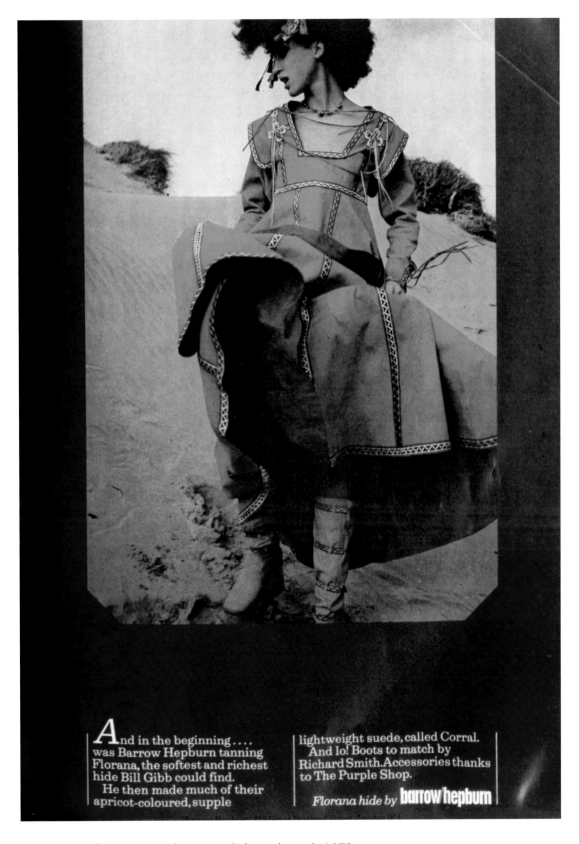

And in the beginning.... was Barrow Hepburn tanning Florana, the softest and richest hide Bill Gibb could find.

He then made much of their apricot-coloured, supple lightweight suede, called Corral.

And lo! Boots to match by Richard Smith. Accessories thanks to The Purple Shop.

Florana hide by **barrow/hepburn**

Advertisement for Barrow Hepburn's new lightweight suede 1972
British *Vogue*, March 1972
Bill Gibb designs appeared in several advertisements of which this is one example

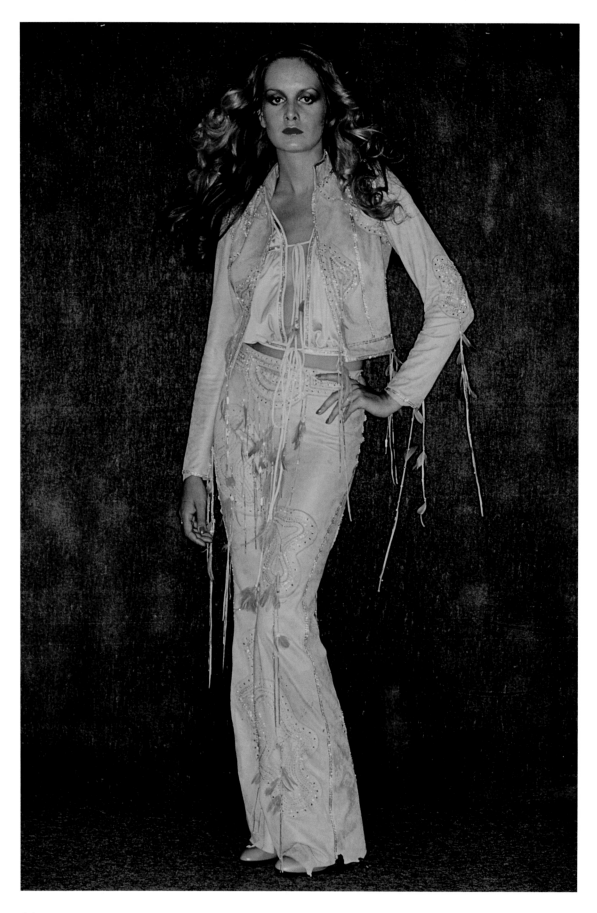

leaves and, of course, bees. Often handpainted and even over-embroidered, the naïve black outlines echoed Gibb's love of the Arts and Crafts movement. Taylor says: 'Billy and I were a good fit because we both enjoyed messing around with the same idea on different surfaces.'

Other exciting collaborations included Valerie Yorston's embroideries; appliqués by Lillian Delevoryas; Alison Combe's fantastical accessories and trimmings that featured weaves, beads, feathers, leather, trailing ribbons and 'raccoon' tails; and Diane Logan's quirky hats that often topped Gibb's ensembles. Lesley Hogger and her company Spangles created Gibb's exquisite and often highly complicated beadwork designs, while his sumptuous tweeds were woven by Richard Womersley and the Otterburn Mills in Northumberland.

Of course, two of the most important relationships to Gibb's career were those with Fassett and Franklin. When asked about his rapport with Fassett, Gibb once said: 'Kaffe is in the blood, know what I mean, he'll always be around.'[7] 'They worked seamlessly, you could never see where one finished and the other began', remembers Franklin, describing the pair's working method. 'Kaffe would come up with the colours and patterns for the knitting and then Billy would design the shapes and incorporate the knitting in his magical way – there might be stripes down the back of a coat, or a strip of a totally different pattern or texture, but everything worked. Even though they were outrageous, the clothes sold and sold and sold. People couldn't get enough of them.'

There can be no denying that Fassett's influence on Gibb was crucial to the designer's development. When the pair first met Gibb was a callow youth from the Highlands; his talent was unmistakable but it was also unsophisticated. It was Fassett who widened Gibb's horizons. 'He was a little nervous about pattern on pattern. He loved structure, which had always been an anathema to me, while I love surface pattern and colour', says Fassett. 'I might drag him along to see some Persian paintings and I'd say, "Look at the way they put a flower print on top of stripes on top of checks and then stand them against a background that has the same things going on". That was my job, really. I would give him a knitting design and he would turn it into the most amazing leg-of-mutton sleeve, things that no one did in knitting. Bizarre, wonderful stuff', says Fassett. 'Sometimes he would say, "Do you have any ideas for this season?" and I might say, "Yeah, I've been looking at some cave paintings in Turkey", and I would go home and knit a little swatch and bring it back to show him. But once you had fed him those ideas, then that incredible architectural mind of his would take over.'

In conversation with Kate Franklin, the adoration that Gibb's long-standing business partner had, and still has, for the designer is barefaced. 'I could never imagine my life without having met Bill', she says. 'I came from a very provincial background and so somebody like Bill was an absolute gift. I loved him more than my marriage but not as much as my children. He was that

Stage outfit commissioned by Twiggy for her debut Royal Festival Hall concert, 1976 British *Vogue*, 15 October 1976 **Barry Lategan**

Jubilee-print kimono
by Bill Gibb, worn by
Bianca Jagger, c.1977

Opposite:
Jubilee print, designed
by Janet Taylor for
Bill Gibb (detail), 1977
This print was designed
to commemorate
the Silver Jubilee of
HRH Queen Elizabeth II

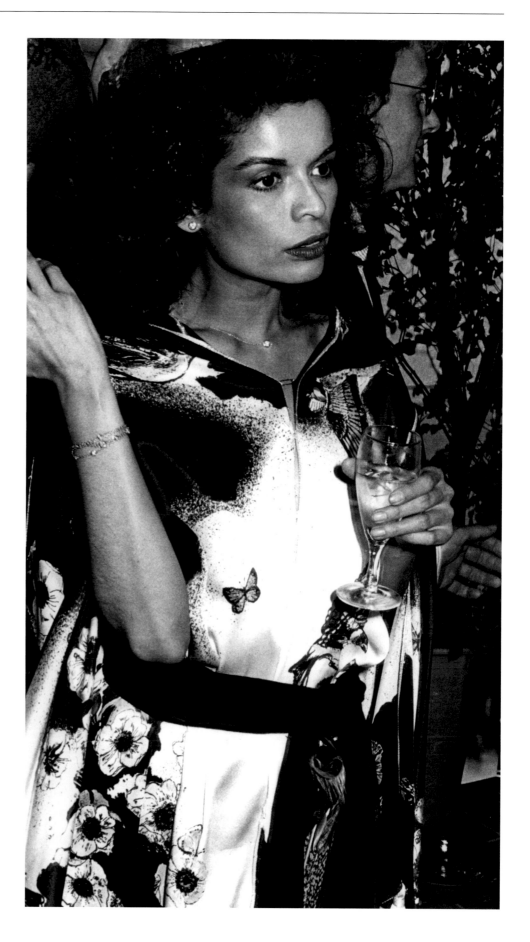

attractive, he was like a magnet. He never knew what was going to happen in the next minute, let alone the next hour.' The feeling was mutual. In 1974 Gibb told Mick Rock, 'She's a very positive influence.'[9] In the same year journalist Antony King-Deacon noted, in a profile of the designer, how Franklin's warm presence seemed to encourage him, how they touched each other frequently – the boy and his guardian.

Franklin talks animatedly about the effect that working with Gibb had on her. 'Naturally enough, when working with Bill daily, my taste changed. My hair was coloured and restyled by Clifford at Leonard. I wore Bill's wonderful clothes and I began to gain confidence in this new style.' Franklin relished Gibb's sharp sense of humour, even when she became the butt of his teasing. She remembers one particular day when the showroom was in a frenzy, with everyone working feverishly to keep the latest collection on track. 'We were doing everything – brochures, sewing. People were rushing here and there. And at one point, I just had too many things going on. So I said to Bill, "Oh Bill, could you get me a cup of tea?" He looked absolutely amazed and about 15 minutes later, into the showroom came a cup being borne by Billy wearing an apron, yellow Marigold washing-up gloves and a turban wrapped around his head. He asked, "Is this alright, madam?" With Billy, you didn't get away with a thing.'

Gibb was not afraid to mock himself. 'I am probably the worst dressed designer I know', he told Caroline Baker, 'but I have just done my first men's collection for Reid & Taylor.'[10] At this time Gibb undertook several successful commercial collaborations with fashion retailers. Reid & Taylor's managing director John Packer, whose flair for promotion was described as 'approaching the legendary in the textile world',[11] commissioned Gibb, along with designers Tom Gilbey and Ian Thomas, to create a small collection for a spectacular show in Bad Neuenahr, a German spa town near Cologne. The theme was, appropriately, the Highland Games.

Journalist Iain Finlayson covered the event for the *Glasgow Herald*: 'We waited for his [Gibb's] appearance like kids waiting for fireworks'. The audience was treated to all the designer's trademarks, translated into a man's wardrobe: 'Appliqué, tassels, pie crust frills, multicoloured stripes, Dr Who scarves, swinging jackets, blousons, plus-four trousers tucked into boots, a sensational rust and black Regency dandy evening outfit, and for a moment the Italian contingent of buyers … applauded wildly'. Finlayson observed that if a gentleman should attempt to cross a moor dressed in Gibb, he would not exactly blend into the landscape, 'the game bird colours make one a sitting target',[12] and added that other manufacturers would no doubt tone down Gibb's innovative fashion ideas into more conservative and financially profitable collections.

Gibb did not attend the event because he had to return to Scotland for the reading of his grandmother's will. This was not the only reason, however, as

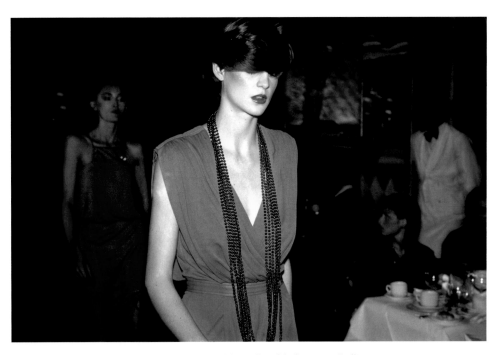

Capsule collection of silk dresses designed by Bill Gibb for Herschelle, 1980
Niall McInerney

he revealed in an interview: 'One of the reasons I haven't gone is because if I am sitting there and I see a cuff or collar wrong I'd start freaking out.'[13]

This was not the designer's only foray into menswear. In 1979 he worked with Reid & Taylor again for another event, this time at Leeds Castle in Kent. That same year Graeme Tong of Austin Reed also commissioned Gibb to create a menswear collection to be launched in the company's Cue shops. Styles included knitted waistcoats and shawl-collared jackets cut in traditional corduroy, flannel and tweed. Gibb worked his signature bee design into embroideries on pockets and onto a new range of silk ties. Gibb modelled these 'sporty, practical separates', as he described them, alongside actor Terence Stamp for the *Sunday Telegraph* magazine.[14] 'The exercise has been good, it forced me to strip things to the minimum and still keep the clothes alive', Gibb told *Menswear* magazine. 'Everybody is quite surprised that I've come up with this collection because it actually is wearable.'[15]

Gibb also accepted private commissions, image making proving a natural spin-off from his fashion output. During the mid-1970s he designed outfits for male pop performers including Rod Stewart and Steve Harley of Cockney Rebel. 'He made the clothes for my 1975 and 1976 world tours', says Harley proudly.

Stage costume designed by
Bill Gibb for Steve Harley,
c.1976 / **Mick Rock**
Harley referred to this Gibb
outfit as his 'haute couture
Cockney barrow-boy look'

'Mick Rock introduced us. Billy would come round to my flat at Marble Arch.
We got along extremely well. He was the loveliest man in the world – I still miss
Billy to this day. He was phenomenally charismatic and popular with both men
and women.' Harley was photographed by Rock wearing an exotic hooded robe
coat, outlined in Gibb's familiar chevron braid. 'That was my haute couture
Cockney barrow-boy look', laughs Harley. 'A beautiful Chinese silk coat, worn
with a waistcoat and velvet trousers.'

Gibb was equally delighted to dress women in the public eye, his take just
as flamboyant. He once again designed an outfit for Twiggy, this time for her
concert debut at the Royal Festival Hall in 1976. The designer created a Las Vegas-
style diamante-studded and embroidered jacket and trousers. In flesh-coloured
chamois leather, with a sky-blue silk blouse edged in silver braid, the outfit was
decorated even further with pink and blue feathers fluttering on beaded ribbons.

Gibb's boutique at 138 New Bond Street in London had opened in the
autumn of 1975. It was part of the master plan of business partner Bryan

From Bill Gibb's first men's collection: a woollen cardigan in distinctive blue and black knit teamed with trailing pink and black knit scarf. Featured in *The Evening Standard* November 13 1974.
Anthony Crickmay

Sketches by Bill Gibb for a Reid & Taylor menswear promotion, 1976

Morrison, whose strategy it was to expand and open stores in Athens, Paris and New York. Although nothing came of these schemes, the New Bond Street store provided the perfect showcase for Gibb's designs and also further reinforced the Gibb experience. Julie Hodgess, who had decorated the original Biba emporium, worked with Gibb to design the interior. The *1978 Fashion Guide* was euphoric in its praise: 'Bill Gibb is the master magician of fashion and his sea-change shop is pure enchantment – mother-of-pearl walls, tables made from seashells bound with ropes of pearls, mirrors frosted with delicate sea foam, iridescent shimmers everywhere … The clothes are lovely, and the atmosphere is lovelier still – easy, warm and helpful. The girls are the best-looking, friendliest staff in London – all best-dressed by Bill Gibb, of course. Beautiful clothes deserve beautiful service, and that's exactly what you get here – right down to the Bill Gibb cocktail served to special visitors, a wonderful concoction of orange juice, mandarin brandy and Beefeater's gin. You can take all the time you want – and advice, assistance and smiles are freely given. It's hard to walk out of Bill Gibb – but when you do, you'll walk out happy.'[16]

But in 1978 this store closed when Bryan Morrison and Gibb parted company. With the backing of the Fox brothers, the designer set up shop again at 17/18 Old Bond Street. This was also decorated in calm creamy shades with a touch of Middle Eastern furnishings. It opened with a cocktail party on Valentine's Day, 1979.

Numerous people and companies were involved in the tragically short-lived career of Gibb, especially in the latter years when his lack of financial acumen forced a leave of absence from the seasonal catwalk presentations that he so loved. Promotional collaborations such as a Benson & Hedges Silk Cut association with Liberty, A Salute To Silk presentation for the Silk Council at the Guildhall and a show for the Harris Tweed Federation traded on the designer's high profile as did newspaper and magazine tie-ins. Gibb designed the wedding dresses for the winner of the *Daily Mirror*'s Bride of the Year competition and his knitting and dress patterns were published in the *Daily Mail*, the *Daily Telegraph*, *Woman's Own*, *Woman's Journal* and *Homes & Gardens*. These do-it-yourself Gibb designs comprised ruffled skirts and blouses, a chunky cable knit gilet, a Fair Isle jacket with bee motif and culottes. There was even a capsule wardrobe intended to take you through any occasion. These partnerships were said to be extremely popular with readers and especially lucrative for the magazines and newspapers.

Fashion writer Avril Groom enlisted Gibb for her 'ADD-itions' series in the *Daily Telegraph*. 'I had been a big fan since I was at college – I had those original *Vogue* pictures on my wall – so it was a real joy to work with him', she says. 'I can't believe we actually published knitting patterns in the newspaper – usually linked with a company like Rowan Yarns – so that readers could knit themselves an original Bill Gibb.'

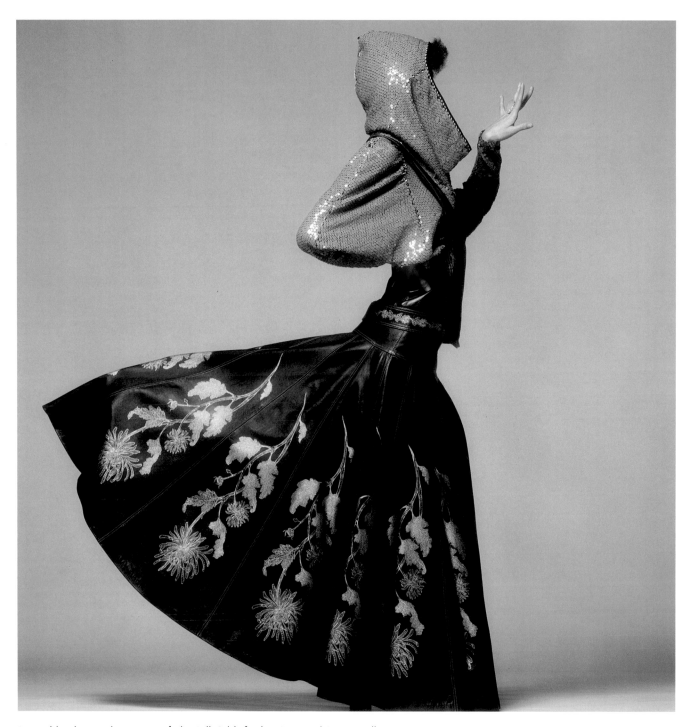

Printed leather and sequin outfit by Bill Gibb for his Autumn/Winter collection, 1972
British *Vogue*, 15 September 1972 / **Clive Arrowsmith**

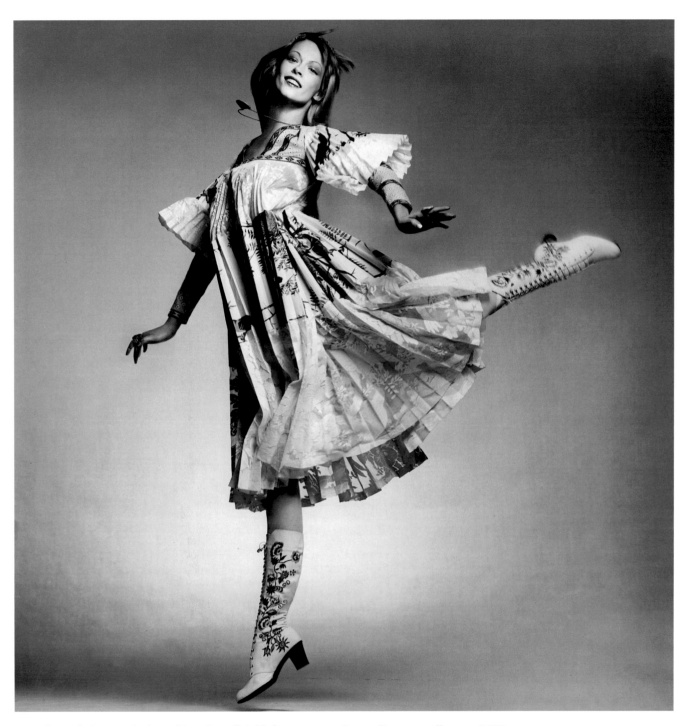

Printed smock dress with pleated lace by Bill Gibb for Baccarat, Spring/Summer collection, 1971
'A jigsaw of silks…', British *Vogue*, April 1971 / **Clive Arrowsmith**

Invitation to the opening of the Bill Gibb shop at 17/18 Old Bond Street, London on Valentine's Day, 1979

Bill Gibb and party-goer in the doorway of Gibb's first shop at 138 New Bond Street, London, c.1975
Clive Boursnell

By early 1982 Gibb had repositioned himself within the industry. As Brenda Polan wrote: '[He is] working on a lavishly beautiful couture range, which he sells from his workshop in Queensdale Road, and a range of eveningwear from Harrods and Chic of Hampstead. There is also a range of furs for Philip Hockley and the knitwear and jeans ranges, which are so far exclusive to Harrods. "It's nice", he says, "to do pocket projects that will lead to licenses."'[17]

While the furs Gibb created for Hockley were a huge success (and true to form, equally uncompromising in their design), for the most part these licensed collections – a commercial arrangement whereby the designer is paid solely to create a clothing line while the manufacturer funds the production – were not Gibb's most creatively challenging associations. With Annette Carol he produced ranges of Courtelle knitwear for Harrods (the store remained

tremendously loyal throughout his career), for Rayne he designed glamorous shoes and for John Bernstein of Herschelle he created a line of silk summer dresses.

A new market presented itself when Amanda Bishop commissioned Gibb to design extravagant evening dresses for her Craven boutique in Jeddah. 'I'm off to design ballgowns for Arab princesses', said Gibb stoically. However, while these dresses certainly fitted Gibb's fantasy ethos, they were far from fashion-forward. In another TV film, entitled 'The Fall and Rise of Bill Gibb', which documented the designer's financial struggles in the late 1970s, the commentator identifies what was to be an ongoing problem for Gibb: 'Perhaps this is the most difficult part for Bill, having to go against his natural instincts and compromise in order to make money.'[18]

A coterie of exceptional creative types continued to draw inspiration from Gibb and in turn nourished the designer's imagination, just as they had done at the beginning of his career but by now this had gone international. 'It [the early to mid-1970s] was an incredible period', remembers shoe designer Manolo Blahnik, who created 'totally mad clogs and high stack heels – like insane!' for Gibb, having made his own journey to London from the Canary Islands. 'Bill used to influence everyone in Paris. They all came over to London to see what he was doing. Those boys not only believed in themselves, they also created an amazing interest in their work. Bill belonged to a group of people who exuded creativity. There were some unique collaborations. I immediately felt part of the scene. Everybody fed off each other', he continues. 'I remember just how fabulous it all was: the excitement, going to parties just to see the dresses!'

And for Gibb it was always about the dresses. As *Over 21* magazine noted in 1973: 'Some of his friends are painters, sculptors and actors but mostly he's wrapped up in fashion exclusively'. In the same article the designer declared, 'Once Zandra [Rhodes] and I were in Rome together and we said: "Let's talk about something other than fashion for a change", and we were stomped. We didn't know what the hell else to talk about.'[19]

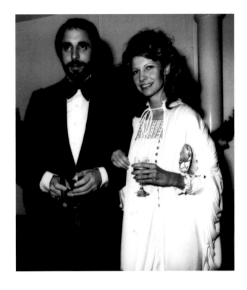

Rock promoter Bryan Morrison, one of Bill Gibb's business partners, with his wife Greta, c.1975 / **Clive Boursnell**

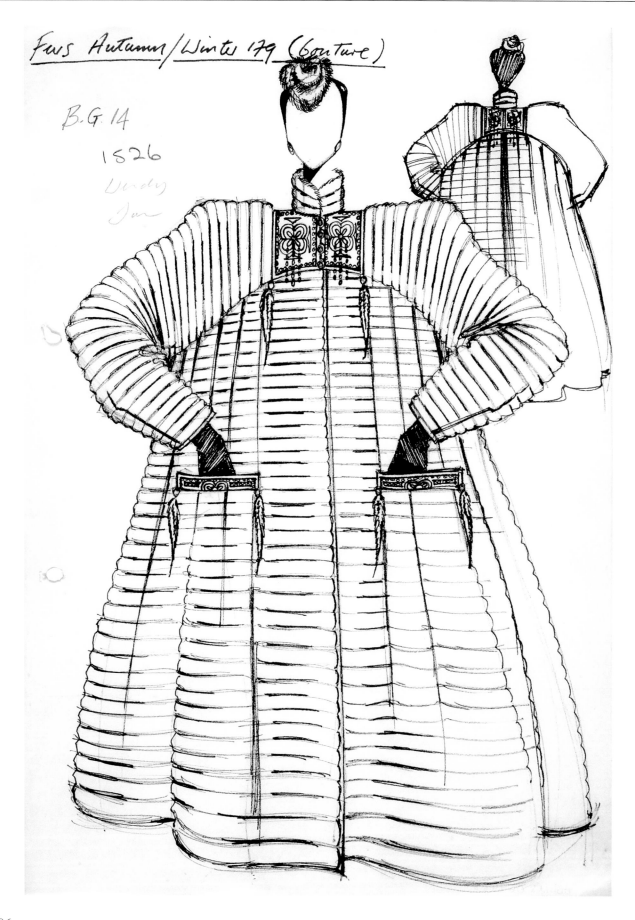

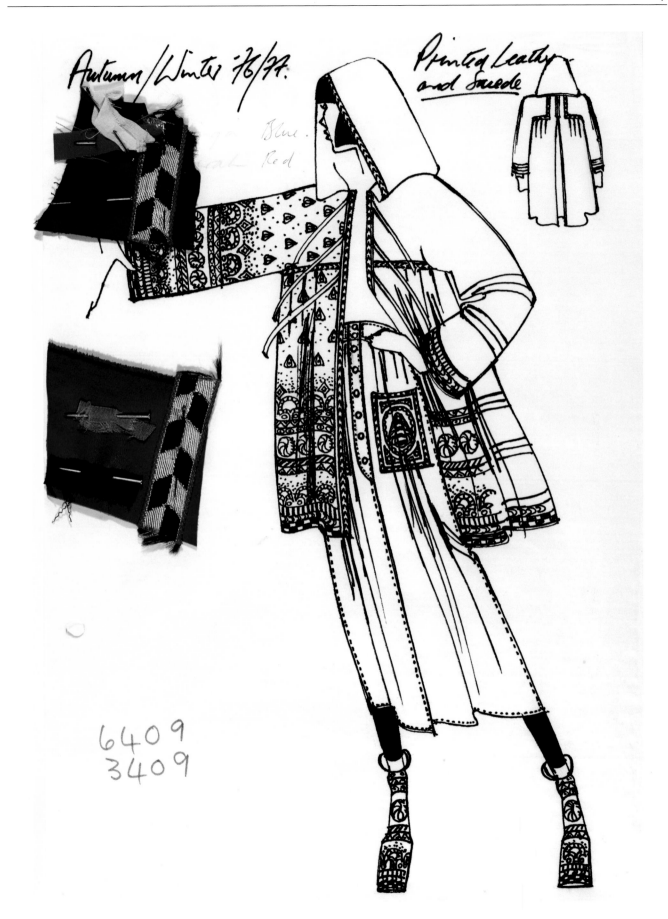

Autumn/Winter '76/77.

Printed Leather and Suede

Blue.
Red

6409
3409

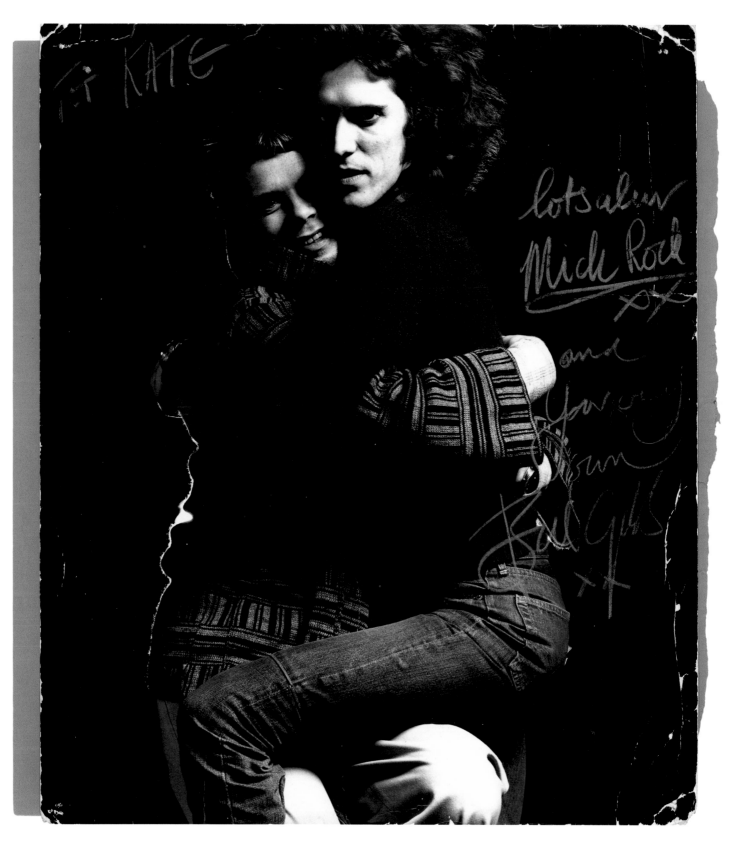

Bill Gibb with Mick Rock, c.1974
Mick Rock

The artist

'I just design to please myself. I create in a vacuum', Gibb once remarked. 'Outside this showroom I've never seen anyone in one of my dresses and I don't care if I never do. Once I've finished something I'm no longer interested.'[1] The designer's comments were especially revealing because they acknowledged a discontent that is so often apparent at the core of many a creative soul. Gibb's design philosophy was anchored in the moment and informed by it.

This was a period when a fashion designer was seen primarily as a creative force, just as a painter or sculptor. 'He definitely represented that point of view. In the 1970s, if you were a designer that was how you thought about yourself', says Christopher Bailey. 'Today it's more a combination of aesthetics and business. Back then there was a different perception of a fashion designer – he or she was an artist painting a canvas of clothes. It was an expression of creativity and draping clothes was a craft. Maybe that's why later Bill had such a tough time.' Writer Bronwyn Cosgrave is even more direct. In *Costume & fashion: a complete history* she declares: 'Designers are no longer artists … the internationally recognized names assume the combined roles of designer, serious business professional and glamorous celebrity.'[2] She also makes the rather depressing observation that the fashion industry is now 'run by a team of spin-doctors'. Everything Gibb railed against.

And it is not only the role of the designer that has changed so radically but also the concept of fashion itself. As ex-*Women's Wear Daily* fashion writer Marion McEvoy notes in the brilliantly insightful book *The Beautiful Fall* by Alicia Drake, fashion in the 1970s 'was a form of self-expression and I guess in a funny way it was more of an artistic expression then'.[3] 'Now fashion is a commodity, but then it was all about creativity', says Manolo Blahnik. 'People didn't care about being a brand, being global. We only cared about the shoe or the dress. At the time, we only worried about one thing: doing something fabulous. We weren't thinking about money. The only thing people cared about was doing something DIVINE!'

Blahnik, who would often bump into Gibb at a matinée performance at the National Film Theatre, was amazed by the designer's dogged determination and inner strength, even in later years when he became sick. 'He knew what he was doing. Like John [Galliano], he created his own visual culture of fashion', says Blahnik. 'He put an incredible stamp on the period. Bill had vision.' Brian Godbold concurs: 'He was an artist. He loved dressing people – clients, models, famous people. But what really turned him on was a full-page picture in *Vogue*. It represented what he was all about. He designed the dress, he made it and then *Vogue* took it to another dimension.'

It was this journey, this exotic flight of fantasy that defined the designer. The creative force inherent in the *Vogue* magazine photographic sittings fuelled Gibb's imagination. It proved an exciting relationship: the more photographers such as Norman Parkinson, Sarah Moon, David Bailey, Clive Arrowsmith and Barry Lategan were inspired to take Gibb's clothes to unusual, faraway locations, or pose them against dreamy make-believe backdrops, the more the designer was stirred to attempt even more dazzling endeavours. 'I really loved to model his clothes', says Marie Helvin, who was often photographed wearing Gibb's designs. 'They weren't hard work for a model because they always told a story. You just had to get into the fantasy. It was as if you became another character wearing those fabulous dresses.'

Mick Rock, who also captured this era on camera, remembers the period as a particularly inventive epoch, not only for the artefacts produced – be they a dress, a painting or a song – but also for the way in which it was possible to portray yourself in an image of your own making and become an actual walking, talking piece of post-modern art. 'You could be anyone you wanted to be because you were not under surveillance then', explains Rock. 'People are fascinated by that period because gossip columnists didn't rule the world; there was no internet, no cable television. We were a close-knit group. At the time we weren't interested in anyone who was outside the circle. It started out as quite a small thing yet its influence grew to be ridiculously huge. That includes David [Bowie] in his Ziggy days – he didn't have any money because the royalties didn't come in for a couple of years. At that time people didn't give a damn if they made any money or not. Barbara [Hulanicki] was like that at Biba, until it went down. It was a very naughty time in terms of experimentation, but also a very innocent time', he continues. 'It was certainly very innocent commercially. Maybe that's what made it so good.'

When Caroline Baker once suggested to Gibb that, 'the wonderful thing about your designs is that they don't date', it elicited an enlightening diatribe from the designer. 'One always has a style, don't you think?' he said. 'No matter what. Whether you do two or three collections, say if you did a cheap collection, something of your own would come through. If I had my way, I'd stick to one kind of look, all the time. I suppose I do in a way. It is what people come to me for, know what I mean? But then, how important is it in one's career to change. I always try and figure this out. Should I try a completely new line that's alien to what I have done. But then, what would I be proving, except that I can do something different. I suppose if you can stick to the same, I suppose like Jean Muir does, you know, she does variations and variations and it works well. I don't

Sari-inspired design, modelled by Marie Helvin, from Bill Gibb's Autumn/Winter collection, 1976
British *Vogue*, 15 September 1976 / **David Bailey**

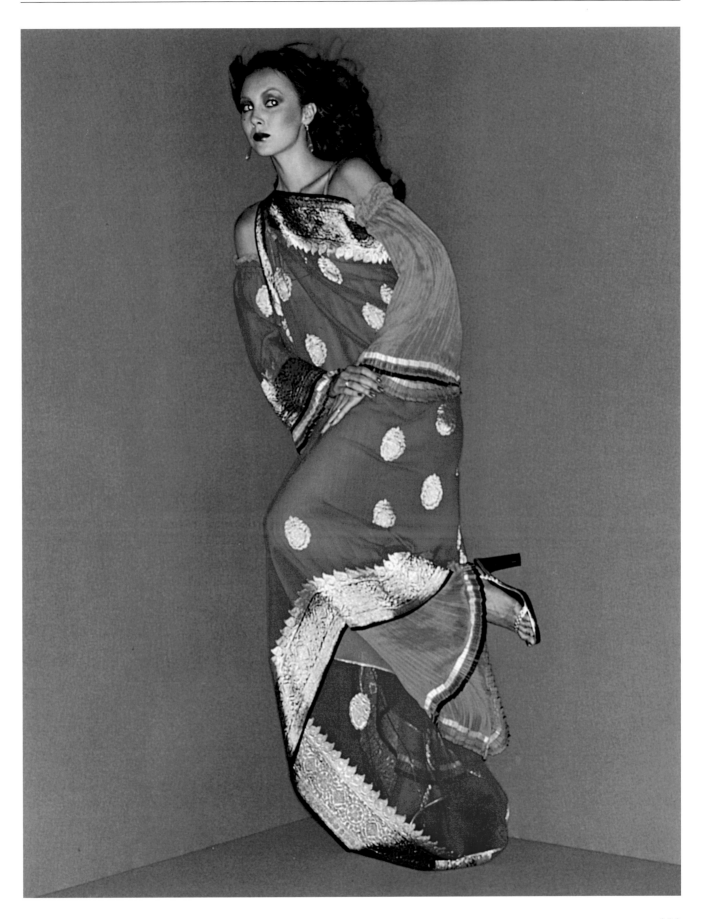

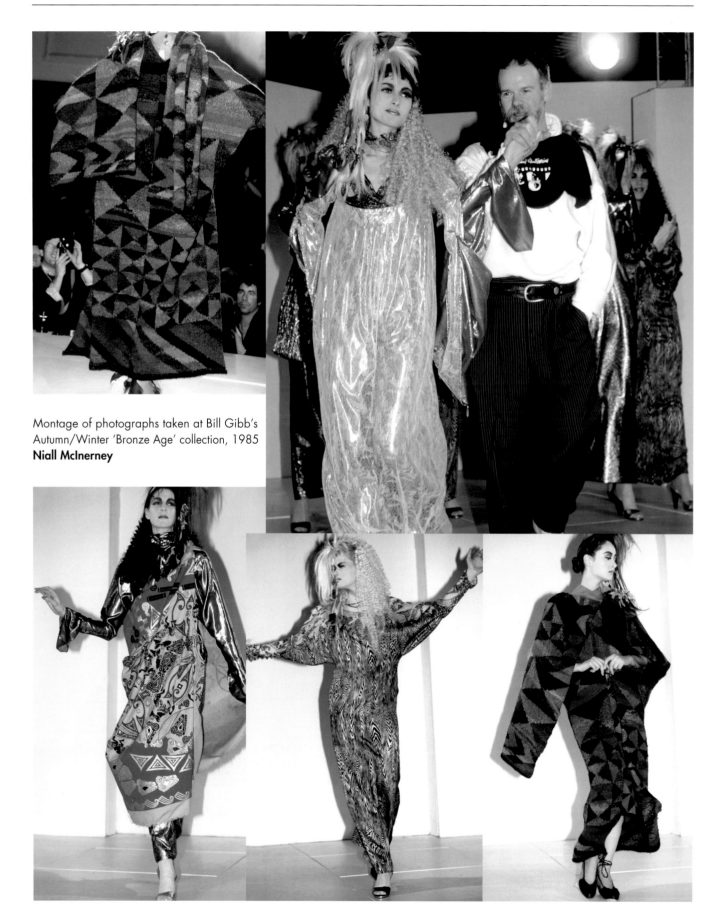

Montage of photographs taken at Bill Gibb's Autumn/Winter 'Bronze Age' collection, 1985
Niall McInerney

believe in influencing fashion … That idea is obsolete now, I would say. I just continue to do what I do, which is [to] perfect, there are so many designers that do so many different things, which in a funny way let's you get along with your own thing, and if you've got a following, which we have built up by now, everything can work out really good.'[4]

Later in the same interview Gibb gingerly confesses that he is, 'a creature of habit. I tend to go to the same restaurants. San Lorenzo and Mr Chow. I should go to the theatre more, but I don't. I rarely go to the cinema, I do watch TV.'[5] It was this incredibly focused, almost introspective view of the world that afforded his clothes their standout appeal and had fashion commentators, such as Helena Matheopoulos, falling over themselves to pay rapturous tribute. 'What you will see at his shows are far from being just clothes', she wrote in the *Daily Express* in 1976. 'They are museum pieces of the future.' If this were not enough, she continued the hyperbole: 'It's the work of an artist of genius who brings an entirely different dimension to fashion design.'[6]

Gibb was certainly never a designer who just thought about making another pair of trousers or a new occasion dress. His designs were motivated by more cerebral imaginings, their

Gilded portrait of Bill Gibb, used to publicize his 'Bronze Age' collection, 1985
Robyn Beeche
body painting by Richard Sharples

inspiration far removed from the humdrum and commonplace. In an early profile in the *Fraserburgh Herald* the interviewer was surprised by Gibb's response when asked to explain his latest collection: 'Novelly he sums up the creation of his designs as being, "like taking a load of gravel, cigarette butts, Bostik glue and matches. Sticking them all on a board and painting them cream"'.[7] In the real world this meant that for this specific collection he would continue to mix pattern and texture, for which he was known, but would colour the garment top-to-toe in one particular hue.

Gibb's designs were not just physically layered, one article of clothing upon another. They were also imbued with all kinds of ideas and imagery that were developed throughout each collection and afforded his clothes an artistic bent. When French designer Christian Lacroix visited London in the 1960s and 1970s he was inspired by Gibb's layer-cake concoctions. 'His retro but so modern mood epitomized for me the unique Brit way of designing', says Lacroix. 'It lay somewhere between nostalgia and avant-garde and made tradition the quintessence of cutting-edge.'

There are arguably discernible parallels between Gibb's work and that of the Japanese designers, in particular Kansai Yamamoto, whose avant-garde designs were also popular in the 1970s and were a favourite with rock star David Bowie. Gibb shared a talent for architectural construction, which was key to the work of both Yamamoto and Issey Miyake. But where they drew much of their inspiration from the traditional costume of their heritage, Gibb's designs derived from an imagined heritage; there was always something extra, something magical between the seams.

'I want to paint a picture', Gibb said. 'I'm catering to girls who want individuality.'[8] Gibb had a precise picture of his ideal client. He described her as having, 'a certain aestheticism, an enjoyment of beauty and quality not just in clothes but in décor, food and gardens … it is an aura that permeates everything in a woman's environment.'[9] 'Bill's clothes weren't sexy', says Godbold. 'They were timeless and ageless, very Art Nouveau. His clothes weren't for young trendy people particularly. They looked very good on older women because they weren't cut close to the body. They suited a woman who was confident and knew who she was, knew herself. So they were worn by arty, intellectual, theatrical women.'

Among them was actress Meg Wynn Owen, who wore Gibb's clothes from the very beginning. 'Bill taught me how to twirl', she says, laughing at the memory. 'We twirled a lot, Billy and I. His clothes made me happy.' 'His ideas were so ahead of their time', she continues. 'Bill taught me how to look, how to see. To me he was an artist who used fabric, all his gang were artists. I think we were such great friends because we were both story tellers. I remember I bought a sweater when I went to Fraserburgh with him on one of his trips home and Billy told me that each sailor's family had a different knitted pattern, so when a sailor drowned at sea they knew who it was.' It was exactly this kind of romantic folklore that Gibb absorbed and wove into his clothes.

When he made his catwalk comeback in 1985, having been unable to resist the offer of considerable financial backing organized by Mary Toman (an American benefactor and Harvard Business School MBA), it was still his intention to tell a tale on the catwalk. His collection for Autumn/Winter 1985, shown at the Apex Room, Olympia on 16 March, was titled 'Bronze Age'. Gibb explained how his trawl back through time was actually inspired by the clothes worn by young people on the streets, 'tainted with forms of aggression, fighting to retain individuality.'[10] However, even from the opening, which featured blaring trumpets, drums and chanting reminiscent of the soundtrack to *She*, the camp Hammer Horror movie starring Ursula Andress as a high priestess, the presentation missed the beat of the times, feeling melodramatic and sadly old-fashioned. Maybe during his research Gibb had rented the video as the models shared a look with the actress: a slash of metallic lipstick, darkened eyes emphasized by heavy eyebrows and false eyelashes and a mish-mash hairdo – part sleek bob,

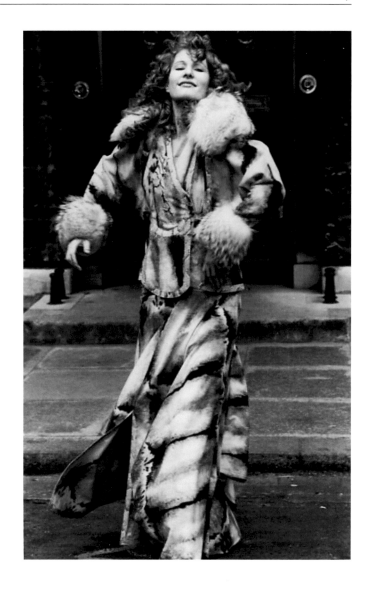

Bark-print jacket and skirt, worn by Meg Wynn Owen,
from Bill Gibb's Autumn/Winter collection, 1972
Daily Mail, 27 April 1972 / **Ronald Fortune**

part Pebbles Flintstone-style ponytail tangled with bone and feathers. The
soundtrack was a mix of pomp classical and electro disco favourites including
Donna Summer's 'State of Independence', perhaps a witty, ironic choice by Gibb.
The result was faux dramatic, verging on the histrionic. In the *New York Times*,
fashion editor Bernadine Morris noted that, 'Gibb's designs were more impressive
on the clothes racks than in an overproduced show.'[11]

Indeed, at the heart of the collection were some great clothes – blanket-
stitched hooded coats that cocooned the models, wide-shouldered wrap jackets
cut with a curve over tube skirts fastened with tough leather belts, tapestry knits
(again by Kaffe Fassett), a new scroll motif designed by Rachel Leach, a subtle
mélange of earthy tones and metallic hues and a finale of shimmering goddess
dresses – in much the same vein as the groundbreaking 'Nostalgia of Mud' designs
that Vivienne Westwood had been exploring a few seasons earlier. A review in
the *Washington Times* magazine was more glowing: 'Gibb brought back the

Bronze Age with an outstanding collection … Quality workmanship was evident at a glance in the intricate Gibb garments. He used cork fabrics for skirts, tops or dresses that were so supple they looked like soft suede. He often paired his cork creations with pewter or bronze lamés.'[12]

It is telling that Gibb received more coverage on the Arts page of *The Times* than he did in Suzy Menkes' review of the London collections. In a story headlined 'No place for demarcation', writer John Russell Taylor questioned the definition of art and fashion in a review of designer Issey Miyake's *Bodyworks* exhibition at The Boilerhouse at the Victoria and Albert Museum. 'Is it art, or is it just design, we ask, confident that such a clear distinction exists and that we know precisely what it is. But these days the distinction is much easier to invoke than to define.'[13] Russell Taylor goes on to discuss the exhibition along with the work of artist Tony Cragg, whose colourful displays of litter and rubbish from the streets he describes as 'assemblages': 'In the mid-Eighties we are hardly likely to baulk over the terminology which classifies this as art: the only question it raises is why the term should not be extended even more widely, to include Miyake, and the amazingly inventive "Bronze Age" fashions of Bill Gibb's new collection; with their command of line and colour far beyond that of many unargued practitioners of the fine arts, or into realms still traditionally, snobbishly relegated to the less eminent area of crafts.'[14]

This was not an easy moment for Gibb, finding himself as he did in the frustrating predicament of being at odds with the very industry he worked within. 'Fashion moves on unscrupulously', says Bailey. And indeed it had, as Brenda Polan explained on the pages of the *Guardian*: '… the recession had begun to affect the clothing industry. The feeling prevailed that, in hard times, there was no room for fantasy; insecurity produced a need to conform, to look worthy and employable; fashion writers coined the term "investment dressing" and illustrated it with camel coats, grey flannel suits and "hard-working" separates.'[15]

'Bill Gibb's designs are not so much clothes as lavish productions', wrote another journalist.[16] There are some critics, too, who believe that Gibb would have been advised to turn his artistic attention towards the theatre and costume design, as several designers including Gianni Versace, Jasper Conran and Zandra Rhodes have since done. Gibb did make a few theatrical collaborations during his career although these were not grand productions. In 1974 he created costumes for the London Contemporary Dance Theatre. For the eight-strong cast he designed Fair Isle-striped knitted bodysuits, lilac and turquoise chiffon

Printed and appliquéd outfit by Bill Gibb for Baccarat, Autumn/Winter collection, 1971
'Mapped champagne satin…', British *Vogue*, 1 October 1971 / **Clive Arrowsmith**

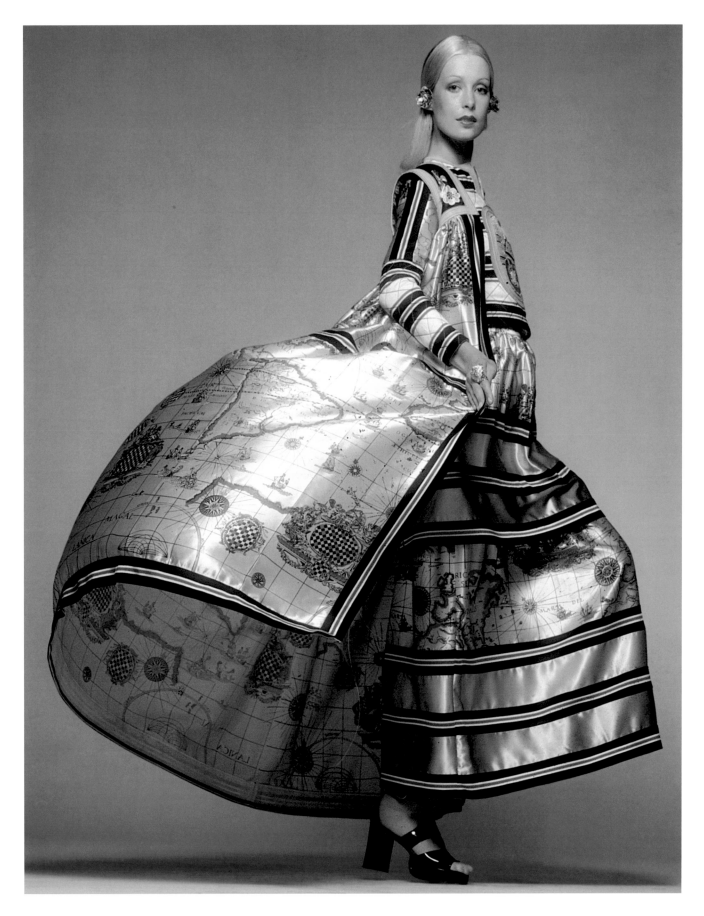

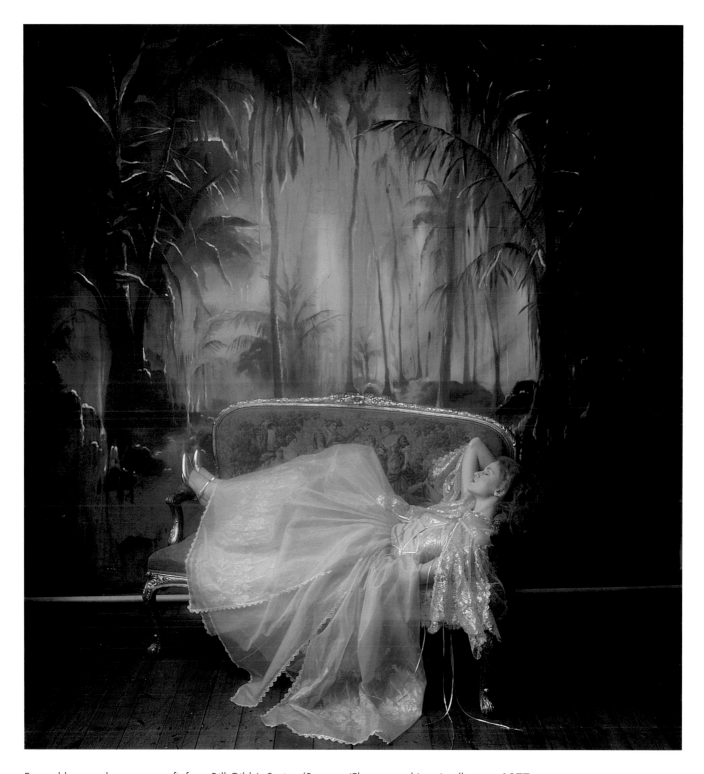

Frosted lace and organza outfit from Bill Gibb's Spring/Summer 'Flowers and Lace' collection, 1977
British *Vogue*, 15 March 1977 / **Barry Lategan**

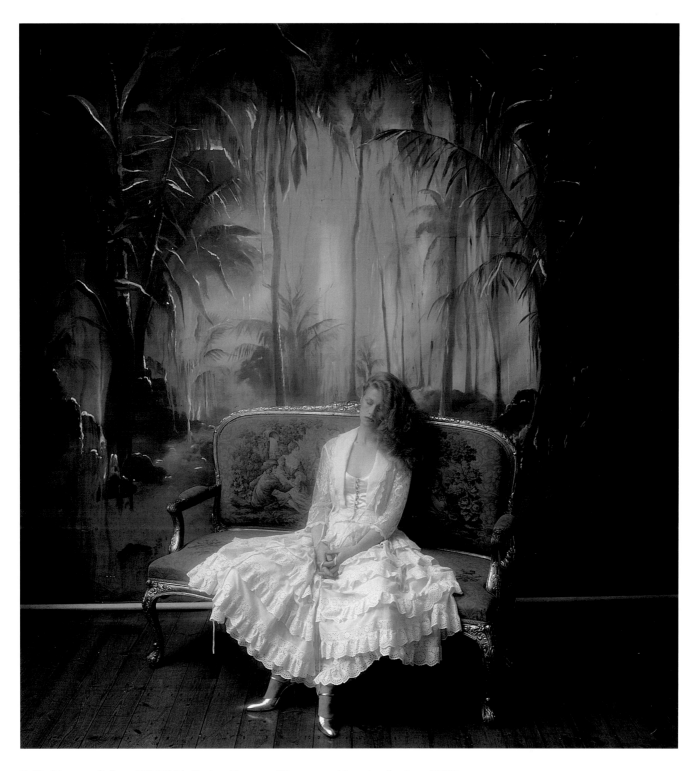

Ruffled lace outfit from Bill Gibb's Spring/Summer 'Flowers and Lace' collection, 1977
British *Vogue*, 15 March 1977 / **Barry Lategan**

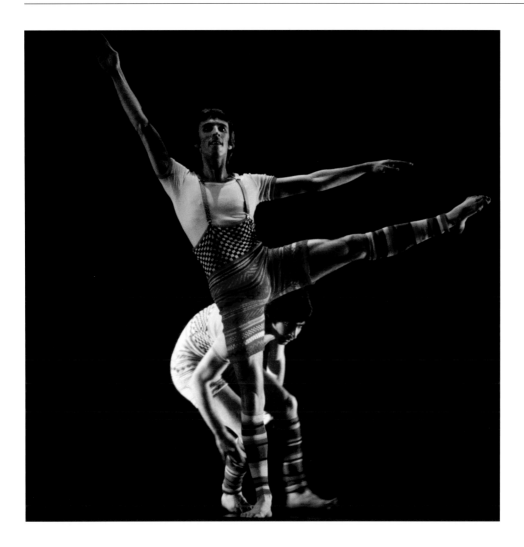

Fair Isle-striped knitted
costumes designed by
Bill Gibb for the London
Contemporary Dance
Theatre, c.1974
Mick Rock

dresses and a pair of ultra-baggy silver dungarees worn over a striped lamé leotard.
In 1981 he dressed Lynn Seymour as Salome and a year later he created a series
of outfits for a revue called *This Thing Called Love*. According to his mother Jessie,
'What he really wanted to do was design the costumes for *Tess of the d'Urbervilles*.'
The commission never came.

Examining the designer's archive and talking to those closest to him it
becomes obvious that Gibb was both a gifted artist and skilful artisan. It is also
clear that he would have preferred not to endure fashion's treadmill; he did not
enjoy the production line ethos of having to roll out endless ideas every season
just to satiate an industry demanding new, new, new. 'Producing a collection is
exactly like planning a war', he told the Edinburgh *Evening News* in 1985. 'This
is a very cut-throat business.'[17]

At its most basic Gibb simply enjoyed making things and relished the process
of seeing his ideas evolve. 'He liked to develop an idea', says Fassett. 'That's tough

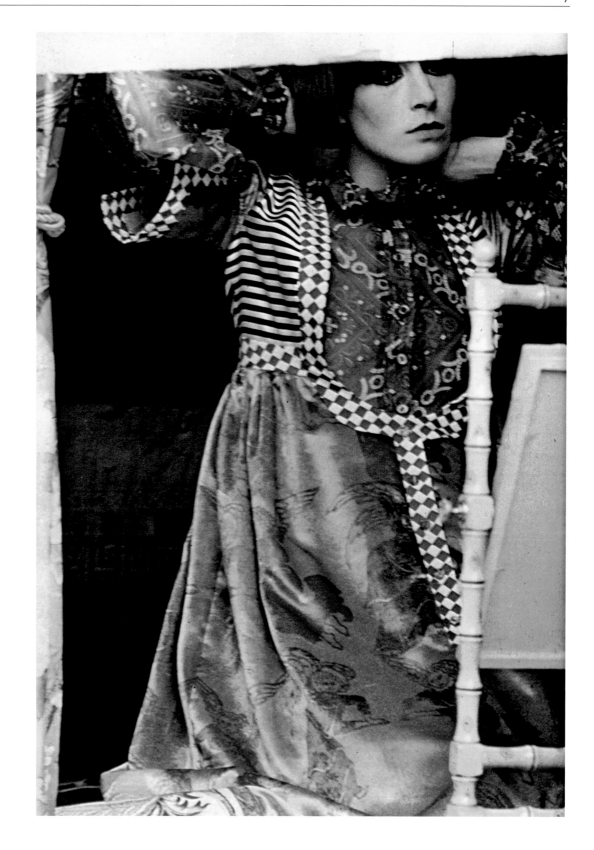

Bill Gibb dress, designed for Baccarat and modelled by a young Anjelica Houston,
Autumn/Winter collection, 1971
Harpers & Queen, November 1971 / **Bob Richardson**

in this business.' Sadly, Gibb lacked the financial acumen to develop his name, his label, into a viable commercial enterprise and there was not the machinery around him to help him to succeed. 'Given the right backing, the right investment in advertising and image making, he could have made a fortune off the back of his designs', says Polan, 'including subsidiary lines such as perfume, or cosmetics. His main clothes line could have been watered down and a made a bit cheaper to bring his designs within the reach of average follower of fashion, but that wasn't happening in London. There was nobody working with those London designers who had the imagination to make a long-term investment.'

'Really and truly we didn't really take enough care of the money or the business', admits Franklin. 'We were very vague, all of us, about money', adds Fassett. 'There was no business', said Marit Allen. 'It was much closer to art than it ever was to business and that's what dragged poor Bill down. It was just the undoing of him.' Gibb qualified these views in a rare television interview: 'It's terrifying for anybody who is creative in any sphere. One hurdle to get over the show, then another the selling.'[18]

Almost certainly the underlying problem for Gibb was that throughout his career he was never motivated by material wealth. In conversation with Baker, Gibb admitted that the bank had been advising him to buy a flat. He was, he said, between lodgings. 'I'll kip down with a friend until I get somewhere. I am not into possessions. What I've got I could pack into one suitcase, more or less, except for two favourite chemist's chests. The poor buggers are almost falling apart from moving around so much. Them and my drawing board I take with me everywhere I go.'[19]

Gibb's ultimate driving force was a desire to design beautiful clothes and to see those designs on a catwalk or magazine cover, regardless of their commercial potential. It is an attitude that is still endemic among today's young breed of British designers, who scrape and scrimp so that they might produce something fantastical to inspire delight and awe in others, or simply push the boundaries and possibilities of what fashion might be. British fashion's latest bright young thing Gareth Pugh, yet another ex-Central Saint Martins student, has to date produced major catwalk shows without selling one ready-to-wear item. For several seasons he worked out of a squat in the East End. The hardship is an accepted by-product in the pursuit of creative freedom. 'You think when you leave college that all these things are going to fall at your feet but that doesn't happen', says Pugh. 'My studio is big but we have no heating or lighting. I am always hoping, praying, that someone will give me a lot of money and say, "Go on, put on a show!"' But Pugh is happy with his lot: 'I couldn't do what I do in any other city.' Said Gibb in one of his last interviews, 'Britain still has some of the best ideas in the world, that's what we're good at. We just don't have that built-in marketing instinct that other nations have. That's all.'[20]

In November 1985 what was to be Gibb's final collection, for Spring/Summer 1986, was featured in *A.D. Art & Design*, an architectural design magazine. His good friend Robyn Beeche photographed the flower-inspired designs – painted organzas and silks (a collaboration with Janet Taylor) cut into petal shapes – as did John Adriaan. His images are particularly resonant, having a distinct melancholy about them. The collection was never produced.

Beatrix Miller, who had championed the designer from the very start, summed up his true vocation beautifully following his death on 3 January 1988. 'Bill Gibb was never a fashion designer in the conventional sense, rather a brilliant decorator, a creator of fantasies.'[21] Or, as Gibb himself said: 'My real joy in life is creating.'[22] 'I think I am really an artist painter who happens to be in the fashion world.'[23]

Bill Gibb, John Kobal and Kate Franklin, *c.*1985 / **Abe Frajndlich**

Next page: Tartan and velvet suits from Bill Gibb's Autumn/Winter collection, 1977
'Suits of tartan, velvet, silver, silk and lace', British *Vogue*, 15 September 1977 / **Terence Donovan**
Scotland was always in Gibb's heart

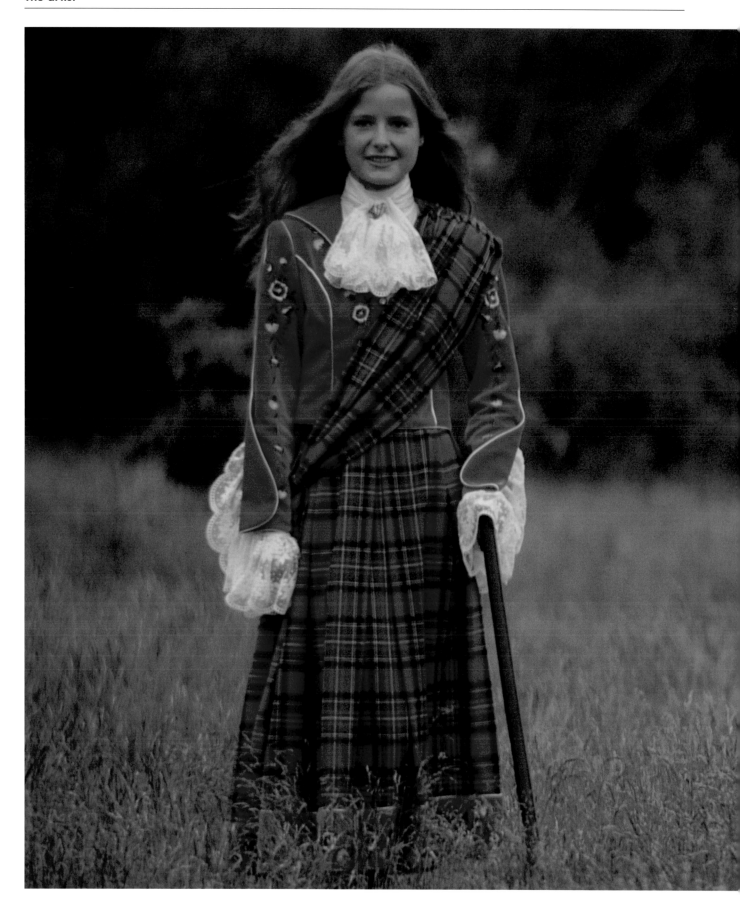

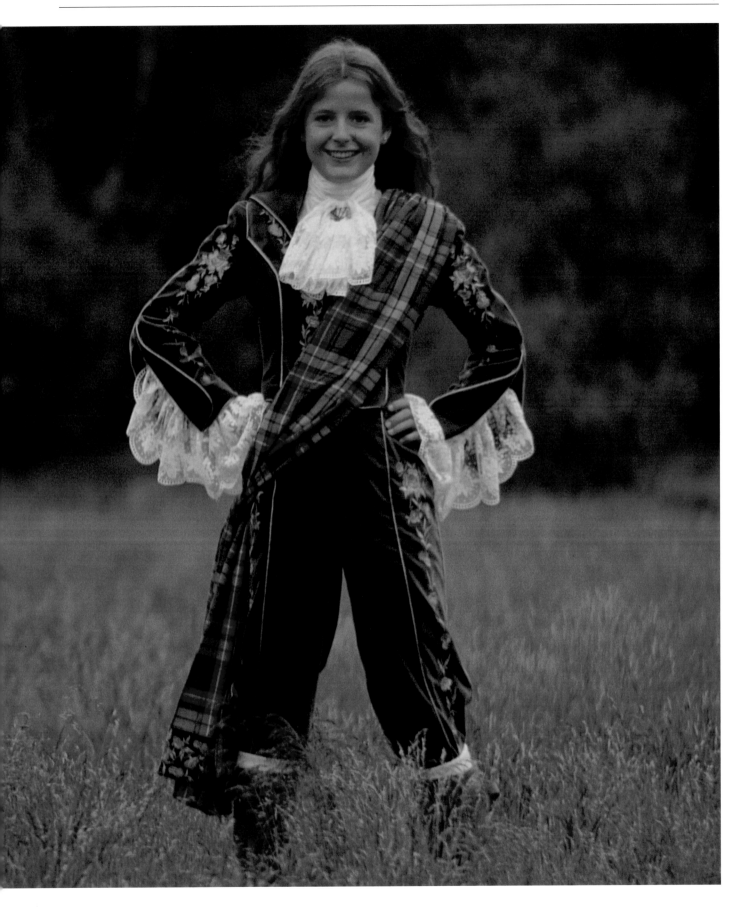

Afterword

The seeds of this book were planted in the early 1970s, when Bill Gibb was charming the world with his wonderful brand of fantastical fashion. As a teenager I was bewitched by the photographs of his designs, which were featured in *Vogue* magazine, and was inspired to follow his lead and study fashion design at St Martin's School of Art, the very same course that Gibb himself had taken years earlier. Growing up in the rural wilds of Wiltshire, surrounded by myriad siblings, I identified with the designer and dreamt that one day I might be part of his glamorous world. During the school summer holidays I even applied for a job at his New Bond Street boutique.

In 1978, as part of a college project, I interviewed designer Vivienne Westwood, who arrived wearing full tartan bondage gear, her peroxide white hair sticking up at all angles. At that time she was the poster girl of punk and yet when asked if she had any favourite designers, her answer surprised me. 'I think Bill Gibb is a very good designer', she said. 'I think he's the only one we've got. I don't know why people don't respect him in the UK. They feel he's a little too flamboyant, but he's got that ability to be critical about his own work, which is what pulls a design together. Every design he does has got guts, or it's got some sort of crunch to it.' I have always respected Westwood's exceptional standpoint and this only confirmed her visionary status in my eyes.

In 2006 I was approached by Kate Franklin, Gibb's long-term business partner and faithful fan, with the idea of writing a book about the designer. I immediately jumped at the chance and have spent two years in fashion heaven researching this project. While tracing Gibb's story, examining his archive and talking to his friends and colleagues, I have been awe-struck by the expansive vision of the designer, perplexed by the continued conundrum of fashion as art versus commerce and fascinated by the parallels between Gibb and the legion of vibrant British fashion designers that followed in his wake. Most of all, I am delighted to have had the opportunity to show the designer in all his glory and record the talent that has, for the most part, gone uncelebrated by the fashion industry. Gibb has become one of British fashion's forgotten stars.

As I began work on this book, with the full blessing of his family, Bill Gibb received a posthumous Hall of Fame award at the Scottish Fashion Awards for 2006. Long overdue, I hope that this book will put him back in the spotlight where he belongs and re-establish him as a fashion designer of great imagination and influence.

Iain R. Webb

Notes

Chapter 1: The legacy

1 Quoted from British *Vogue*, January 1970

2 Bill Gibb, in *Free Press* (Detroit, Michigan), 21 August 1972

3 See *Rolling Stone*, 24 June 2004, issue 951

4 Prudence Glynn, 'Peaceful Co-existence', *The Times*, 26 May 1970

Chapter 2: The history boy

1 Bill Gibb, in *Ritz* magazine, No.1, 1976

2 Bill Gibb, in the Edinburgh *Evening News*, 20 August 1985

3 Quoted from *Woman* magazine, 18 October 1975

4 Bill Gibb, in *Ritz* magazine, No.1, 1976

5 Bill Gibb, in *Ritz* magazine, No.1, 1976

6 Douglas Keay, 'We Couldn't Have Wished For A Better Son', *Woman* magazine, 18 October 1975

7 Bill Gibb, in the Edinburg*h* *Evening News*, 20 August 1985

8 Bill Gibb, in the Aberdeen *Evening Express*, 7 November 1984

9 Muriel Pemberton, British *Vogue*, March 1988

10 Bill Gibb, in *Ritz* magazine, No.1, 1976

11 Ernestine Carter, writing in *The Sunday Times*, 21 December 1969

12 Bill Gibb, in the Aberdeen *Evening Express*, 8 November 1984

13 Bill Gibb, in *Ritz* magazine, No.1, 1976

14 Bill Gibb, in *Ritz* magazine, No.1, 1976

15 Bill Gibb, in *Flair* magazine, September 1972

16 Twiggy, in 'The Sun King of Style', BBC Scotland, 1999

17 Bill Gibb, in *Flair* magazine, September 1972

18 Bill Gibb, in an interview with Joan Bakewell for *Radio Times*, 26 April 1973, promoting the BBC programme 'For the Sake of Appearance', aired 1 May 1973

19 Muriel Pemberton, British *Vogue*, March 1988

20 Bill Gibb, in *Ritz* magazine, No.1, 1976

21 Bill Gibb, in *Brides* magazine, Spring 1973

22 Bill Gibb, in the Aberdeen *Press and Journal*, 23 April 1973

23 Bill Gibb, in *Brides* magazine, Spring 1973

24 Bill Gibb, in *Brides* magazine, Spring 1973

Chapter 3: The showman

1 Bill Gibb, interviewed by Caroline Baker for *Ritz* magazine, No.1, 1976

2 Bill Gibb, interviewed by Caroline Baker for *Ritz* magazine, No.1, 1976

3 Bill Gibb, in *Ritz* magazine, No.1, 1976

4 Quoted from the *Evening Standard*, 6 November 1972

5 Quoted from *Over 21* magazine, February 1973

6 Quoted from the Aberdeen *Press and Journal*, 9 November 1972

7 Hebe Dorsey, *International Herald Tribune*, 10 April 1973

8 Bryan Morrison, *Daily Express*, 12 July 1978

9 Bill Gibb, interviewed by Caroline Baker for *Ritz* magazine, No.1, 1976

10 Suzy Menkes, *Evening Standard*, 20 October 1975

11 Bill Gibb, in *Ritz* magazine, No.1, 1976

12 Bill Gibb, in the *Guardian*, 20 May 1982

13 Bill Gibb, interviewed by Ann Chubb for the *Daily Telegraph*, 11 August 1978

14 Ian Jack, *The Sunday Times*, 2 November 1980

15 Bill Gibb, in conversation with Mick Rock, *19* magazine, December 1974

Chapter 4: The collections

1 Bill Gibb, in British *Vogue*, 15 September 1972

2 Bill Gibb, in British *Vogue*, 1 April 1976

3 Bill Gibb, in *19* magazine, December 1974

4 Bill Gibb, in *19* magazine, December 1974

5 Bill Gibb, in *19* magazine, December 1974

6 Bill Gibb, in *Ritz* magazine, No.1, 1976

7 Bill Gibb, in *Flair* magazine, September 1972

8 Prudence Glynn, *The Times*, 12 November 1974

9 Prudence Glynn, *The Times*, 13 March 1973

10 Michael Roberts, *The Sunday Times*, 22 April 1973

11 Bill Gibb interviewed by Hebe Dorsey, *International Herald Tribune*, April 1973

12 Bill Gibb, interviewed by Ann Chubb, London *Evening News*, 12 November 1973

13 Ann Chubb, London *Evening News*, 3 October 1973

14 Quoted from British *Vogue*, 1 September 1974

15 Ernestine Carter, *Magic Names of Fashion*, Weidenfeld & Nicolson, London 1980

16 Prudence Glynn, *The Times*, 12 November 1974

17 Quoted from British *Vogue*, 15 September 1975

18 Helena Matheopoulos, *Daily Express*, 12 April 1976

19 Bill Gibb, in *Flair* magazine, September 1972

20 Bill Gibb, in *Ritz* magazine, No.1, 1976

21 Bill Gibb, in the *Daily Telegraph*, 25 October 1976

22 Bill Gibb, in *Flair* magazine, September 1972

23 Bill Gibb, in the *Daily Telegraph*, 7 November 1977

24 Suzy Menkes, *Evening Standard*, 28 March 1977

25 Michael Roberts, *The Sunday Times*, 3 April 1977

26 Jean Muir, in British *Vogue*, March 1988

27 Bill Gibb, in the Aberdeen *Press and Journal*, 25 October 1972

28 Bill Gibb, in the *Fraserburgh Herald*, 18 September 1970

29 Lesley Ebbetts, *Daily Mirror*, 3 April 1979

Chapter 5: The collaborator

1 Beatrix Miller, British *Vogue*, March 1988

2 Bill Gibb, in conversation with Mick Rock, *19* magazine, December 1974

3 Bill Gibb, in *Ritz* magazine, No.1, 1976

4 Bill Gibb, in *Ritz* magazine, No.1, 1976

5 Quoted from the *Glasgow Herald*, 20 June 1973

6 Bill Gibb, in *Flair* magazine, September 1972

7 Bill Gibb, in *Ritz* magazine, No.1, 1976

8 Bill Gibb, in *Ritz* magazine, No.1, 1976

9 Bill Gibb, in conversation with Mick Rock, *19* magazine, December 1974

10 Bill Gibb, in *Ritz* magazine, No.1, 1976

11 Quoted from the *Financial Times*, 18 September 1976

12 Iain Finlayson, *Glasgow Herald*, 21 September 1976

13 Bill Gibb, in *Ritz* magazine, No.1, 1976

14 *Sunday Telegraph* magazine, September 1979

15 Bill Gibb, in *Menswear*, 29 June 1979

16 Quoted from the *1978 Fashion Guide*, Hodder and Stoughton, 1978

17 Brenda Polan, the *Guardian*, 20 May 1982

18 'The Fall and Rise of Bill Gibb', a Thames TV production, 1978

19 Bill Gibb, in *Over 21* magazine, 21 February 1973

Chapter 6: The artist

1 Bill Gibb, in *Radio Times*, 26 April 1973

2 Bronwyn Cosgrave, *Costume & fashion: a complete history*, Hamlyn, 2000

3 Alicia Drake, *The Beautiful Fall: Fashion, Genius and Glorious Excess in 1970s Paris*, Bloomsbury, 2006

4 Bill Gibb, in *Ritz* magazine, No.1, 1976

5 Bill Gibb, in *Ritz* magazine, No.1, 1976

6 Helena Matheopoulos, *Daily Express*, 12 April 1976

7 Quoted from the *Fraserburgh Herald*, 18 September 1970

8 Bill Gibb, in *Women's Wear Daily*, 25 April 1972

9 Bill Gibb, in *Daily Express*, 30 September 1974

10 Quoted from press release, Kathleen Franklin Publicity, March 1985

11 Bernadine Morris, *New York Times*, 19 March 1985

12 Quoted from the *Washington Times* magazine, 9 April 1985

13 John Russell, 'No place for demarcation', *The Times*, 25 March 1985

14 John Russell, *The Times*, 26 March 1985

15 Brenda Polan, the *Guardian*, 20 May 1982

16 Quoted from the Newcastle-upon-Tyne *Journal*, 8 November 1972

17 Bill Gibb, in the Edinburgh *Evening News*, 20 August 1985

18 Bill Gibb, interviewed by Jeff Banks for BBC TV's 'The Clothes Show', 1985

19 Bill Gibb, in *Ritz* magazine, No.1, 1976

20 Bill Gibb, in the Edinburgh *Evening News*, 20 August 1985

21 Beatrix Miller, British *Vogue*, March 1988

22 Bill Gibb, in *Over 21* magazine, February 1973

23 Bill Gibb, in the Aberdeen *Evening Express*, 6 November 1984

Acknowledgements

This book has been a long journey, so a long list of acknowledgements and thanks is necessary. I am beholden to everyone who talked to me about Bill Gibb, and what he represented, and if your name does not appear in print I apologise but I can assure you that your much-valued input lies between the pages.

I would like to thank the following for their enthusiasm and inspiration: firstly, Kate Franklin, and her daughters Veronica and Sue (without Kate there would be no book), then John Adriaan, Marit Allen, Christopher Bailey, Jeff Banks, John Bates, Robyn Beeche, Manolo Blahnik, Judy Brittain, at Central Saint Martins School of Art Jo Ortmans, and many others including Alistair O'Neil at the CSM Archive, Susan Collier, Jasper Conran, Anthony Crickmay, Wendy Dagworthy, Sarah Dallas, Giles Deacon, at the Fashion Museum, Bath Rosemary Harden, Kaffe Fassett, John Galliano (who took time out from a holiday in Ibiza to speak to me about Gibb, such is Gibb's influence), Brian Godbold, Louise Gray, Avril Groom, Susannah Handley, Steve Harley, Jelka Music, Christian Lacroix, at the Liberty Archive Anna Buruma, Andrew Logan, Nives Losani, Niall McInerney, Beatrix Miller, Max Miller, Chris Moore, at the National Magazine Company Donna Roberts, at the Norman Parkinson Archive Liz Smith and Leigh Yule, Sally Pasmore, Anna Piaggi, Brenda Polan, Zandra Rhodes, Mick Rock, Geoffrey Aquilina Ross, Annie Russell, Alexandra Shulman, Rob Skipper, John Siggins, Peter J. Stone, at the Vogue Picture Library Nicky Budden, Shelley Halperin and Danielle Yeo, Judith Watt, Harriet Wilson, Meg Wynn Owen.

I would especially like to thank Angela Barrett, Fiona Dealey, Susannah Frankel, Felicity Green, Ninivah Khomo, Colin McDowell, Sinty Stemp and Lee Widdows for their continued encouragement.

Praise must go to all the photographers whose inspirational images captured Gibb's fantastic designs on the page and all the unnamed stylists who were inspired to work with his clothes.

A huge big thank you to all at the Aberdeen Art Gallery – Christine Rew, Victoria Ward, Sally MacIntosh and Ann Marie Bojko – for their tolerance and passion, to the British Library (Colindale) and the London College of Fashion Library.

At the Victoria and Albert Museum, I would like to thank Mary Butler, who commissioned this book, and Mark Eastment for running with it; Anjali Bulley, Clare Davis and the team at V&A Publishing, who embraced my maverick style of authorship with good grace, and my editor Denny Hemming, with whom I have enjoyed many discussions dissecting the fashion industry (then and now) and who has helped turn my original text into a bona-fide book.

I cannot thank enough Jacqueline and Robert Clarke for their hospitality in their many beautiful homes, Gregory Davis for use of the bordello suite and Maxine Clarke, who was both my Miss Marple and Parker rolled into one.

I owe huge gratitude to my art director Barney Wan who, throughout the manic panic involved in the production of this book, managed to create an air of transcendental calm wherever he went. I salute you, sir. I would also like to acknowledge the dedication of Rob Skipper at Camden Electric Art, who has worked tirelessly with Barney and myself to realise this book. I am especially indebted to my sister Mary Dunn and my old friend Mikel Rosen, who became my two (unofficial) frontline editors, for their brutal honesty and uplifting inspiration. And I cannot begin to thank Mark Clarke (the Angry Irish) for his enduring patience and love. And, of course, Miss Sissy.

A very special thank you goes to Mr and Mrs Gibb and their daughters Patsy, Janet and Marlyn for inviting me into their home with such openness and warmth. We all loved Bill.

Sadly, during the writing of this book Marit Allen died suddenly. She was one of the first people I talked to about Gibb and her thoughtful understanding of the designer and his place in fashion history provided the foundation for the story. But, more than that, it was Allen (then Marit Lieberson) who encouraged and nurtured my writing skills when I was myself a student at St. Martin's. I am forever indebted to her.

This book is dedicated to Marit Allen, and to my mum and dad.

Select Bibliography

Bates, John, 'Bill Gibb' (unpublished)

Bergé, Pierre, *Yves Saint Laurent (A Fashion Memoir)* (London, 1997)

Boucher, François, *A History of Costume in the West* (London, 1987)

Carter, Ernestine, *Magic Names of Fashion* (London, 1980)

Cosgrave, Bronwyn, *Costume & fashion: a complete history* (London, 2000)

De la Haye, Amy, *The Cutting Edge: 50 Years of British Fashion 1947–1997* (London, 1996)

Drake, Alicia, *The Beautiful Fall: Fashion, Genius and Glorious Excess in 1970s Paris* (London, 2006)

Ewing, Elizabeth, *History of 20th Century Fashion* (London, 1974)

Glynn, Prudence, *In Fashion: Dress in the Twentieth Century* (London, 1978)

Laver, James, *Costume and Fashion: A Concise History* (World of Art series) (London, 1983)

Mendes, Valerie, and De la Haye, Amy, *20th Century Fashion* (London, 1999)

O'Connor, Kaori and Kahn, Farrol (eds), *1978 Fashion Guide* (London, 1978)

Rew, Christine, *Bill Gibb: the golden boy of British fashion*, exh. cat. (Aberdeen, 2003)

Picture Credits

Index